# The Women Who Inspired London Art

*Dedicated to my mother, Helen Marchese Peterson,
who was a journalist at a time when few women made a living
from a love of language and who told me to
write good stories.*

# The Women Who Inspired London Art

## The Avico Sisters and Other Models of the Early 20th Century

Lucy Merello Peterson

PEN & SWORD
HISTORY

AN IMPRINT OF PEN & SWORD BOOKS LTD.
YORKSHIRE - PHILADELPHIA

First published in Great Britain in 2018 by
Pen & Sword History
An imprint of
Pen & Sword Books Ltd
Yorkshire - Philadelphia

Hardback ISBN 978 1 52672 525 7
Paperback ISBN 978 1 52675 172 0

A CIP catalogue record for this book is available from the British Library.

Typeset by Aura Technology and Software Services, India
Printed and bound in India by Replkia Press Pvt Ltd.

Pen & Sword Books Ltd incorporates the Imprints of Pen & Sword Books
Archaeology, Atlas, Aviation, Battleground, Discovery, Family History, History,
Maritime, Military, Naval, Politics, Railways, Select, Transport, True Crime,
Fiction, Frontline Books, Leo Cooper, Praetorian Press, Seaforth Publishing,
Wharncliffe and White Owl.

For a complete list of Pen & Sword titles please contact

PEN & SWORD BOOKS LIMITED
47 Church Street, Barnsley, South Yorkshire, S70 2AS, England
E-mail: enquiries@pen-and-sword.co.uk
Website: www.pen-and-sword.co.uk

Or
PEN AND SWORD BOOKS
1950 Lawrence Rd, Havertown, PA 19083, USA
E-mail: uspen-and-sword@casematepublishers.com
Website: www.penandswordbooks.com

# Contents

# Foreword

On 14 September 2014, I was pleasantly surprised to hear from Lucy Peterson. She told me of her interest in London art and sculpture, and that she felt the story of the Avico sisters was intriguing and would like to learn more. We agreed to meet the next time she was in London.

This was the beginning of what has become a friendship and a journey of discovery into the world of art and artists' models in the 1900s. Over the course of the next couple of years we worked together to learn about the lives of my family at that time, and especially the sisters Leopoldine, Marietta and my mother Gilda.

From as long as I can remember my mother's life as an artists' model was part of my life. I would go with her for sittings and I remember the smell of the paint, the canvases and the huge windows letting in the light to the top floor studios. The artists were always very kind to me, even when I was impatient to go home. One day an artist asked to paint me, and somewhere there is a painting of a little fairy standing on a toadstool catching bubbles!

Thanks to Lucy and her extensive research, I have discovered more of the world in which my mother and her sisters lived. She also introduced me to the sculptures they had posed for; some I had not known existed. As a result of our collaboration, I have learned more about their childhood and how they came to be sought after by the London art world of the early 1900s. Lucy has brought colour to their story and her research has reintroduced me to these strong and beautiful English women of Italian heritage.

Christine Bassett
Daughter of Gilda Avico

# Author's Preface

When I was researching material for this book, I turned a page and a doorway opened. On that page the sculptor Joseph Nollekens recalled a secret his mother had told him as a child in the 1700s – the one place in London from which you could see the entrances to nine streets.

Almost three centuries later, I walked down Moor Street in Soho on a grey November day and stood in the footsteps of a man who had been dead since 1823. I carried his words with me:

> *Stand here, and you will see the entrances of nine streets; my mother showed them to me ... don't turn your head, only your eyes ... There, now look to the left, is not there Monmouth-street? Now let your eye run along over the way to the first opening, that's Great White Lion-street; well, now bring your eye back to the opposite street in front of you, that's Little Earl-street. Throw your eye over the Seven Dials, and you will see Queen-street and Earl-street; well, now look on the right of Little Earl-street, and you will see Tower-street; well, now stand still, mind, don't move, bring your eye back towards you, and turn it a little to the right, and you will see West-street; bring it nearer to the right, and there's Grafton-street; and then, look down at your toes, and you'll find yourself standing in Moor Street.*

If you go to Moor Street and stand with that long-ago child and his mother, you will see that many things have changed since the 1700s. Buildings now obscure the view across the fields to Seven Dials. Many of the streets have been renamed, and Grafton Street, as Nollekens knew it, has vanished completely to make room for Charing Cross Road. Nevertheless, the secret vista is still there. You just have to know which doorway to open.

When I began researching artists' models of the early twentieth century, I questioned whether this was a doorway worth opening. Was it important to shed light on the contributions of anonymous young women in London, or was it sufficient that the famous few had their say? Very quickly I found that there was no real distinction. All of these women were part of the great creative heart

of London – and while they may not seem like feminists to our twenty-first-century eyes, the personal choices they made were uncommonly independent for the time.

It is fitting, then, that the genesis of this book was a moment in Oxford Street when I stood in front of Selfridges and looked up at the face of the sculpture called *The Queen of Time*. I decided in that moment that I would find out who that model was and how she lived. I know that woman now – Leopoldine Avico – due to the generosity of Christine Bassett, her niece.

Christine is the daughter of Leopoldine's sister Gilda, who was also a model. I am grateful to Christine for sharing her recollections about the Avico family's involvement in the arts. Her intuitive pursuit of the past has been personally inspiring to me, and our collaboration has grown into a valued friendship. It is a privilege to bring her family's story to light.

I also want to acknowledge the support I received from the many London archivists who were unfailingly helpful to me in my enquiries. And I am indebted to my friend Deena Maniscalchi for her invaluable advice and her keen eye for nuance in language.

Finally, I want to acknowledge the countless unsung women of London's art history. The practices of the day and the fog of time have conspired to keep these women anonymous. As a result, my work is far from inclusive of all the models that mattered in London, even given the parameters of female models living in the early twentieth century.

The women I have chosen to include reflect my belief that the famous and the anonymous deserve to take their places side by side. They are equal in the sense that they all made bold personal choices at a time when women were still struggling to establish their own identities. I have followed these women down more than nine streets, into studios and schools, police courts and clubs, and home to their families. What I found were women who were often nameless but well worth knowing.

As Virginia Woolf – herself the daughter of a Pre-Raphaelite model – wrote in *Jacob's Room*, 'The streets of London have their map; but our passions are uncharted. What are you going to meet if you turn this corner?'

Lucy Merello Peterson

# Part One

# MODELS AND THE TIMES

# Chapter 1

# Anonymous Lives

'You shall seek my footprints in the Bloomsbury dust and your sole pleasure shall be to burn me in effigy.'
— Artists' model Iris Tree writing to art critic Clive Bell, 1915.

On a cold, bright London day in May 1905, Ellen Stanley Smith left Marylebone Police Court a free woman, acquitted of having stolen ten shillings from her landlord's room in St John's Wood the prior month.

She had been charged, indicted and released upon proving that she was employed as a model by the Royal Academy of Arts, where she earned more than £10 a month. Her good fortune was sealed when the painter Edmund Blair Leighton strode into court, moustache bristling, to declare that the accused was of excellent character.

Thus 21-year-old Ellen Stanley Smith passed in and out of history in the space of three weeks. In doing so, she accomplished something that almost all of her contemporaries failed to achieve – she put a name to her work as an artists' model. We don't know if she had the poignant features of one of Leighton's medieval maidens, prompting him to speak out on her behalf. We only know her identity because she was a woman acquitted of theft.

\*\*\*\*

Anonymity was very much the life of most artists' models in early twentieth-century London. There were exceptions of course: the commissioned portraits of privileged men and women, the notorious models who blazed through Paris, London and New York. And the wives, mistresses, children and friends who posed through loyalty or love – these were known by name.

For the most part, however, the sitters were everyday men and women trying to make ends meet. Many were chosen by chance, or because they were related to a working model. This was particularly true of figure models. If one was fortunate enough to become an artist's favoured sitter it could lead to work with a broader group, but public recognition would seldom follow.

Artists were fickle creatures, and often short of money. This made studio work sporadic. The Royal Academy of Arts, Slade School of Art, Saint Martin's School of Art and other academies were generally more reliable sources of income for models in the new century. A popular young sitter might spend more 'school hours' inside those walls than she did on her own education.

Scrutinised during long hours in the classroom, models became known largely by their attributes – a classic profile, long waist, slender hands or an ability to stay perfectly still. Personal identity was not important. In fact too much information about a model could hamper creativity.

Even the compensation was nameless and faceless. The Slade handled it in typical generic fashion, writing 'Model' or 'Woman' on its pay receipts into the twentieth century. The Royal Academy was an exception, taking the unusual step of recording models by name in large, leather-bound registers. Cursive notations such as 'Sculp. Draped' or 'Painting Nude' documented the model's work next to the payment amount.

Men had a large presence in the modelling profession both before and after the turn of the century; in fact older, more weathered male models were in demand. This was less true for women, at least initially when femininity was idealised. It

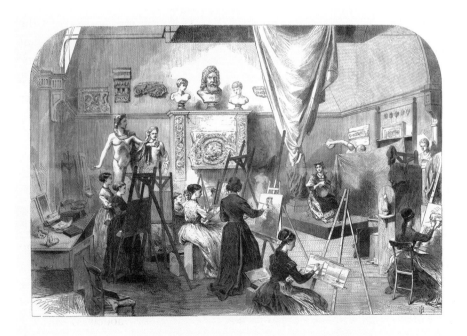

The Female School of Art in London began using clothed models in 1866.

wasn't a perfect solution to subsistence, but in the context of the times it offered freedom from the drudgery of factory work or domestic service.

****

Public recognition – if and when it came – could sometimes be used to advantage, although male models had the upper hand here. A court report in the *London Evening Standard* on 17 January 1901 noted that Antonio Corsi, a well-regarded artists' model, was charged with stealing and pawning two expensive rings. He was shown leniency because 'the man had lately been driven to extremities by domestic trouble'. This was typical of the tolerance exhibited by the courts toward men 'of character' who claimed trouble at home.

For women in the modelling profession in England respect was a slow process, but then that was the case for all Edwardian women who worked. There was no tidal wave of acceptance until the first war; instead, single women were being nudged bit by bit toward employment.

It started in the late 1800s, when middle-class women began moving into clerical jobs with the advent of typewriters. Small keys required dainty fingers. The work was monotonous and poorly paid, but it was seen as a symbol of liberation. The introduction of the modern bicycle was another nudge; it gave women a way to travel safely between home and workplace.

The bicycle was also important in academia and myriad other jobs not always accessible by public transportation. A feeling grew that there might be a better life for the taking – and it was felt most strongly in the lower-middle classes, where women worked to survive.

All of this was encouraging, but not for married women. If you had a husband in pre-war England, you were still expected to be a stay-at-home wife and mother if economically feasible. This idea persisted in even the most unconventional and bohemian corners of London.

The artist and model Nina Hamnett – bohemian to the core – wrote frankly about feeling stifled during her brief marriage to Edgar de Bergen in the early 1900s:

*Edgar had made friends with some people whom I considered dull, common, and boring, so he often went out with them and I stayed at home. He seemed to think that I should always be at home waiting for him and once, when I went out to dinner with an elderly man I had known for years, an awful argument [with Edgar] took place and we threw saucepans at each other. I got so bored with this and being so poor … that I fell in love with a tall dark man whom I had met at the Café Royal.*[1]

Hamnett's story, while a bit extreme, captures the constraints that British society imposed on married women at the time. For an unmarried woman, however, it was perfectly acceptable to contribute to the household coffers. Posing could bring in a couple of pounds a week, and it came with the benefit of being able to say you were 'artistic'. It was flattering and a little bit scandalous to be a model – the ideal occupation to satisfy a young girl's sense of adventure or her empty stomach.

*Chapter 2*

# Colour Lines

'The law demands that we atone, when we take things we do not own, but leaves the lords and ladies fine, who take things that are yours and mine.'
      – Verse from 'The Goose and the Common' protest rhyme, circa 1600s.

Life was a daily struggle for many Londoners at the start of the new century. Edwardian society was a knife-edge between the financially comfortable and the poor, barely softened by the middle class. Millions of servants in Britain supplied a seemingly endless source of labour to the upper classes. The wealthy and the middle class believed the lower classes to be unclean and untrustworthy – an opinion that stemmed not so much from reasoning as from upbringing.

Another prevalent assumption was the correlation between poverty and criminality. A colour-coded poverty map created by Charles Booth in 1898–99[2] identifies seven economic levels of London occupants ranging from '*Upper-middle and Upper classes. Wealthy.*' at the top, down to '*Lowest class. Vicious, semi-criminal.*' at the bottom.

Viciousness apparently took effect one level below '*Very poor, casual. Chronic want.*' and two levels below '*Poor. 18s. to 21s. a week for a moderate family.*' Booth delegated the remainder of London's population to *Mixed* (some comfortable, others poor), *Fairly comfortable* (good ordinary earnings) or *Middle class* (well-to-do).

Booth's maps helped spur widespread social and economic reform in London in the early twentieth century. Two other things are notable about his endeavour. First, he assigned ethics to only the poorest class of Londoners, labelling them vicious semi-criminals – he made no ethical judgements as he moved up the social scale. And second, he proved himself wrong.

Booth originally undertook his mapping to contradict a statement made by Henry Hyndman, leader of Britain's first socialist party. Hyndman estimated that twenty-five per cent of the population of London was so poor as to be living below the level of basic subsistence. Booth felt that number was too high. The reality turned out to be much worse: by 1900, more than a third of London's residents were desperately poor.

Booth would have had a difficult time slotting artists or models into one of his neat little categories. Creative communities tend to blur economic lines. You can see it in the maps: the pale rose and grey cross-hatchings of *Mixed* and *Poor* households in Soho edging north into *Fairly Comfortable* and *Middle Class* in Fitzrovia and east into Bloomsbury. Hidden in Booth's coloured shapes were the artists and models that would put a face to cultural change in Britain and the writers that would give it a voice.

The artists, in particular, were a mixed group. They gravitated toward areas of London that offered the cost of living and creative energy they needed. John Singer Sargent had a fashionable house in Tite Street, Chelsea, with his studio conveniently next door. Sargent, London's favourite society painter, lived quite well compared to most artists of the day. Tite Street itself was an intellectual nexus, home to numerous writers, artists and composers, including Oscar Wilde before Sargent, and Augustus John after him.

Most artists were not so lucky. A London machinist could count on seventy or eighty shillings a week in 1903, whereas an artist without family money would have to scrape by from sale to sale. It was hard to be creative if you were hungry all the time. And so, for sheer artistic density, the more affordable parts of Fitzrovia and Soho beckoned. The formerly elite Bloomsbury area was also a contender.

These were the streets that reverberated most strongly with ghosts restless for one final muse. It was easy to imagine the shade of John Constable walking from his studio at the back of no. 76 Charlotte Street to lean against the whitewashed

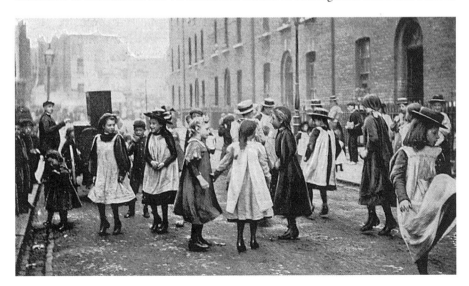

The London streets served as social venues for much of the population (circa 1900).

bricks of the façade. By 1900 Constable was 63 years gone, his heart giving out in an upstairs bedroom.

By the early twentieth century, Constable's ghost was more likely to appear to those who stayed too long at The Hundred Marks pub on the corner of Charlotte and Windmill Streets. No artist worth his salt would stroll by The Hundred Marks without popping in to see if a friend had sold a painting and was in the money. In that case it would be drinks all round, watched over by another ghost – the eponymous windmill of almost two centuries earlier.

This part of London was a fertile hunting ground for inspiration. If an instructor from the Slade or Saint Martin's needed more models, it was a short walk to pavements teeming with potential amateur posers. For a young woman in need of income, that would be a start, and then she might find work in the studios if she proved punctual and uncomplaining.

It was fairly common for an artist to use several different models for an important picture, one for the figure, another for the hands, the facial expression, and so on – even the hair – to help ensure a happy client. In 1904, painter Frank Dicksee reportedly only employed models with copper-coloured hair. It was a case of art imitating life, as the craze for henna tint had hit London with full force.

Brunette, copper, or blonde, female models were often united by circumstance, spotted by chance, plucked from obscurity and anonymous. Few became true muses to the artists they served, but even the most novice posers occupy a unique place in history. They were a source of inspiration at a crucial time in British art, when four remarkable tides were rising in London: internationalism, modernism, feminism and war.

# Part Two

# CHASING BEAUTY

*Chapter 3*

# International Ideals

'I have no hesitation whatever in saying that to me the most delightful and the most interesting sitter is the Englishwoman.'
        – *The Bystander*, quoting a comment made by E. O. Hoppé, 1913.

If beauty is the native language of art, then the advent of internationalism started tongues wagging. Cultural exchanges between England and its European neighbours in the late nineteenth century introduced artists, writers, philosophers and musicians to new thinking about the physical ideal. It all had a great deal to do with immigration.

By 1900, the flood of Jewish emigrants from Europe to London had peaked and the Irish population was in decline. Chinese and Indian families were the new faces of immigration, along with modest influxes of Africans and West Indians. This gave artists new choices. Beauty was passionately debated from the halls of academia to Regent Street, and it was all to the good. Britain's cultural identity was taking on the shape of a new millennium.

In the tearooms of Soho, the models chattered on about maintaining their appeal. One by one, they found themselves in more or less demand depending on their looks. This was most relevant to studio work, where the artist relied on achieving both inspiration and commercialisation. The perception of beauty – always mercurial – was becoming less English.

A small but blatant example of internationalism's influence on beauty appeared in the *London Daily News* on 29 July 1907. In an article entitled 'A Mirror of Modes', the newspaper wrote that kimonos had become a fashion cult from which there was no escape. They were quick to add that, 'for slim and slender figures it is eminently pretty, but, as usual, it is too often annexed by wearers whose slenderness is not their strong point'. Each comment and advertisement of this nature – and there were hundreds of them – was a warning shot across the bow of neoclassic curves.

Is it any wonder, then, that the moment was ripe for a swindle perpetuated on women desperate to become slim? Enter Winifred Grace Hartland, whose image appeared under the advertising banner 'How a Noted Artist's Model

Reduced Her Weight 36 Pounds in Five Weeks'. It seemed that poor Winifred had to give up her calling 'owing to excessive fat' before finding a 'harmless, drugless method' to regain her figure. Presumably this allowed her to return to the profession that had 'made her so popular a model with artists and sculptors the world over'.[3]

Winifred didn't exist. Yet, incredibly, she continued to plug her fat cure from at least 1912 to 1928 in advertisements from London to Yorkshire to Edinburgh. The message seldom varied, although the headline eventually took on a more jolly tone: 'Good News for Fat Folks'. The offer seemed harmless enough: mail

# How a Noted Artist's Model Reduced Her Weight 36 Pounds in Five Weeks

After having to give up her calling owing to Obesity, she discovered a harmless Drugless Method which gave back to her the figure that made her famous.

OFFERS INTERESTING BOOK FREE WHICH TELLS HOW ANYONE CAN EASILY REDUCE THEMSELVES BY THIS METHOD IN THEIR OWN HOME WITHOUT THE KNOWLEDGE OF ANYONE.

## Double   Chin   and   Fat   Hips   Go   Quickly.

Over **20,000** Women have reduced their weight by her method. Isn't this convincing proof of the value of her great Discovery?

You too can reduce yourself even more than this by the same process if you so desire. No Drugs! No Starvation Diet! No tiresome exercises!

The Hartland hoax used a 'model' to prey on British women obsessed with being slender.

two penny stamps to sylph-like Winifred, famous artists' model, and you would receive her book free of charge. The miracle cure was yours.

Eventually Winifred was unmasked as Dave Little and Harry Sweet, two American men who had their finger on the British pulse. Upon receiving the name and address of a gullible woman in the mail, Little and Sweet would convince her to send money for private instruction with Winifred, thus ensuring that maximum weight would be shed. When the hoax came to light, Winifred disappeared from the pages of *The Sketch*, *The Tatler*, *The Sphere*, *The Bystander*, Scotland's *Sunday Post* and other publications eager to take her advertising funds.

The Winifred swindle was notable not because of the societal pressure to lose weight – dieting had been around for centuries in England – but because of the hook. Its genius lay in the use of the artists' model as a believable and yet anonymous symbol of beauty. This made it perfectly plausible that Winifred Grace Hartland was both a famous sitter and, at the same time, completely unknown to readers.

****

As long as figurative paintings remained in vogue, art had an outsized influence on beauty in contemporary life. Paris, which considered itself the authority on aesthetics, was a restless purveyor of beauty in the 1800s. For the first fifty years or so, the dark-haired, dark-eyed model, the *belle Juive* ('beautiful Jewess'), ruled the *ateliers*. Then classic life models regained popularity, fostered by a growing Italian immigration. The lush *Italienne* women and muscular men were perfect for the neoclassic aesthetic of Paris and London, and for academic training.

Strangely, the employability of models of Italian lineage relied in part on a reputation for being instinctively good at posing. Italians were thought to have a proclivity for art due to the Renaissance. This belief persisted despite the fact that most Italian models at the time had little knowledge of the Renaissance and even less art education. It served to keep classical models employed in London as beauty took new turns.

In the late 1800s, a French models' union, L'Olympe, made a play to rid its ranks of what it called 'all foreign elements'[4] and limit its membership to models that embodied the *Parisienne* ideal – a term that was curiously both wide-ranging and elitist. It encompassed professional and occasional models, as well as women who were both models and artists.

It is difficult to frame the *Parisienne* ideal as being anything but racially and nationally charged. The term itself became synonymous with non-ethnic. A model could come from the working class, bourgeois or upper class, as long as she was white, Catholic and had an urban sensibility. Anything un-French was unattractive.

British artists that spent time in the European *ateliers* were not immune to the *Parisienne* influence, but not all were swayed. A few painters continued working in the neoclassic style with Italian beauties; one notable adherent was John William Godward. But languid poses in romantic villas proved no match for the advent of modern art. By 1915, Mediterranean physicality had largely run its course in the studio and ancient references were seen as an anachronism.

From there, however, opinions diverged. Some artists ignored the *Parisienne* ideal in favour of the Englishness championed by art critic John Ruskin decades earlier. In his preface to Ernest Chesneau's book *The English School of Painting*, Ruskin wrote that British artists must guard against becoming 'sentimentally German, dramatically Parisian, or decoratively Asiatic'.

Other artists chose to look beyond the English aesthetic. Mark Gertler, the son of poor Jewish immigrants in London, famously found inspiration in

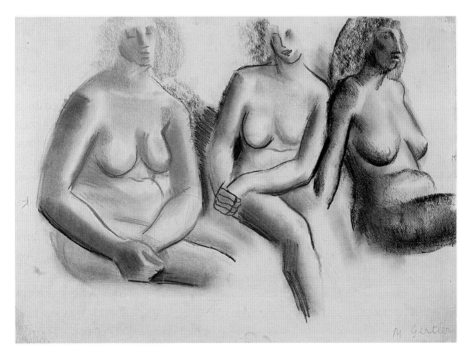

The painter Mark Gertler explored all shapes and colours of beauty (1934).

painting pale French, robust Italian and familiar English countenances, as well as more exotic features. He always used live models, and in his work – as in his life – he sometimes revealed an inability to move past his upbringing. Once, as the guest of honour at an art club dinner, he asked if he could begin eating because he was hungry.

Gertler's troubled life as a child of Spitalfields, toast of the Slade, spurned lover, conscientious objector, tuberculosis patient and sour misanthrope eventually culminated in his suicide, an unfinished portrait nearby. Just days earlier he had reportedly said it would be his finest picture yet. That seems unlikely, given his body of work, but it was a story told by the sitter many times over.

The model was Cecilia Dennis, a twelve-year friend of the Gertler family and a woman described privately by a different artist as having a 'horrid head' but lovely figure, and 'incredibly silly but sits well'. As for public recognition, she was yet another artists' model known almost solely through misfortune.

*Chapter 4*

# Academic Dilemmas

'The women's class seemed rather too much taken up with the art of the movement, the past seemed forgotten, the men's with one or two exceptions, did not appear to be thinking at all.'

– William Orpen's visitor's report on the Royal Academy of
Arts painting school, 1920.

In mid-June 1903, even rain-soaked London could hardly believe the weather. Camden Square saw over fifty-eight hours of continuous downpour, and now the winds were coming from the north. Cosy in his Regent's Park abode, Harry Furniss, the celebrated caricaturist, metaphorically sharpened his pen to match his wit. It was time to put the finishing touches on *Harry Furniss at Home*, the second volume of his autobiography.

The Furniss residence at St Edmund's Place was the scene of numerous literary shots fired at London institutions, most notably the Royal Academy of Arts. Furniss, an Irish-born illustrator, was one of the Academy's fiercest critics. In 1887 he published *The Royal Academy: An Artistic Joke*, and in 1890, *Royal Academy Antics*, which skewered the work of leading 'Rattle on Artists' (his definition of Royal Academicians or RAs). This time he was coming to the defence of models, whom he saw as being underpaid and underappreciated:

*The misinformed mix up the ballet girl with the chorus girls – those inactive masses of humanity whose only place is to 'draw the youth in the stalls', and who have no more to do with the theatrical profession than the members of an audience...*

*And, as the ballet girl is a woman of experience, so is the genuine artist's model, and she should be respected, as her profession is as honourable and necessary as any other; but it is a profession, and that fact is too frequently overlooked, by those who think that to sit for an artist is merely to loll, languidly, about a sumptuous studio, sip afternoon tea, put on fine dresses, and get well paid for doing nothing.*

*I have found that there is a widespread impression, among women of all classes, that no training or qualifications are required, to make a useful model;*

*they could not make a greater mistake than they do when they declare, as one often hears, 'Oh, anyone can be a model', except when they add the utterly unjust and unwarrantable rider, 'that is, any one who has lost her self-respect'.*[5]

Furniss was pushing back against broad misconceptions of posing in general, but the bulk of his ire was reserved for the Royal Academy insularity.

The first women modelled for Academy students as early as the mid-1700s, possibly 1768. Female sitters at that time were socially marginalised relative to their male counterparts. This continued through the early 1800s, when no real distinction was made between models sourced from brothels and those sourced from the 'honest lower classes' of London – although in fairness, all of the London art schools with life classes operated in much the same way.

While male models escaped this stigma from the earliest days, female life modelling began to attain professional stature only toward the end of the nineteenth century. It would be 1920 before the first models' union was founded in London; many decades after Paris had done the same. The Association of Artists' Models gave both sexes a much-needed professional framework for employment.

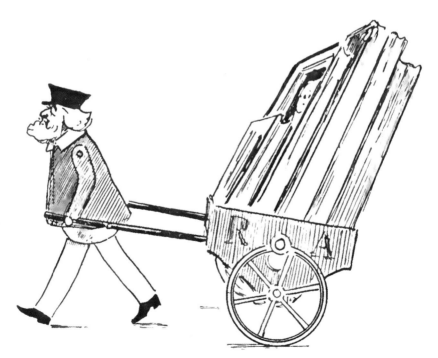

Illustrator Harry Furniss suggested a 'mechanical president' for the Royal Academy of Arts, to cart away RA rubbish.

Ephemera from the mid-1700s suggest that male models at the time were listed on payment receipts by name, while female models were not. London may have adopted this practice from Paris, where the first art academy was founded nearly a hundred years earlier, and Paris from Italy, where the first academy opened in Florence in 1648, the brainchild of Cosimo de' Medici.

The sense of impropriety that clung to female sitters had nothing to do with how the women or students behaved, and everything to do with gender mores of the times. Many female sitters understandably preferred anonymity in light of these unfair strictures. Briefly, some women even wore masks while posing. Thus, the designation 'Woman' in the early account registers may have had a chivalrous origin – to protect the models from insinuation.

As the years went by, the Royal Academy took the lead by degrees. Every model's name was recorded in its ledgers by the turn of the century, although those identified with both a given name and a surname were mostly male. Since female sitters were widely employed by that time, it can be assumed that at least some of the entries that lacked a full given name were abbreviated to shield the women.

From 1838 to 1869, Royal Academy life drawing was conducted in the cupola at the top of the National Gallery, where the Royal Academy was housed. The models marched gamely up those stairs to start each day, pausing to peek through the grillwork to the streets below. As for the students, those attending life classes were solely male until the late 1800s.

Decorum in the life rooms was rigorously maintained by the Academy, even when female models were sourced from brothels. To cool improper thoughts, 18ft of clear space between the disrobed model and the eager student was mandated. It would be 1893 before the Academy allowed its female students to set the plaster casts aside and sketch from a discretely draped nude male model.

There was nothing easy about modelling at the turn of the century. Ropes or slings were sometimes used to hold a model in a pose when muscle fatigue became unbearable. Men were expected to pose stock still for close to an hour without rest, women for almost as long, and children until they grew too fidgety. If a rest break was delayed for some reason, a model would have to stand up bit by bit to unbend painfully stiff muscles.

As the *St James Gazette* noted in 1904, 'It is not an uncommon occurrence for a model to collapse in a fainting fit under the prolonged strain of keeping one position' – although there was a silver lining. 'It is almost unnecessary to mention that no female model wears corsets; she knows too well that an attenuated waist is of no value in studios, however dear it may be to the dressmaker.'[6]

In addition, the successful model had to accept being thought of as an inanimate object by those in the room. In 1909, an anonymous model commented on this exact subject in *The Tatler*, noting that the artists would openly air their private affairs before models as if they were a pet dog or a mistress, while models passed the time adding up the proceeds of the week's posing in their heads.

It wasn't all bad news for the women. The schools often paid female posers more than men, sometimes four or five times more for life classes, in part to compensate them for the implications of the job. Their importance to the teaching process, and the fact they were sourced from outside academia, gave the women a bit more negotiating power. Some male sitters were already on school payrolls as porters or other workers, and modelling was supplemental income for them.

Models who made the transition from the life classes to the studio were often subject to the same physical demands as at the academies. John Thomas Smith, a nineteenth-century keeper of prints and drawings at the British Museum, had some fun with renowned eighteenth-century sculptor Joseph Nollekens in his book *Nollekens and His Times*. As the story goes, a brothel madam angrily confronted Nollekens in his studio, shrieking:

> *Why the girl is hardly able to move a limb today. To think of keeping a young creature eight hours in that room, without a thread upon her, or a morsel of any thing to eat or a drop to drink, and then to give her only two shillings to bring home! ... How do you think I can live and pay the income-tax?*[7]

True or not (Smith had a bone to pick with Nollekens), this tale had its genesis in the real-life experiences of the life model.

In some ways, not much had changed by the early twentieth century. Cold, stiff and often painfully positioned to highlight certain contours of the body, models became adept at blocking out their surroundings. A notation from the Slade School archives describes what must have been a joyous change for its female sitters in the winter months:

> *Electricity arrives in 1928 in a form such as to augment the propulsion of hot water along pipes to be 'applied to that portion of the room near the model'. The Ladies Cloakroom is the beneficiary of this as well, as the accommodation has been 'much improved and extended' into the space of the old heating plant.*[8]

\*\*\*\*

Despite a welcome modernity, modelling brought some of its old traditions into the new century. This was particularly true in Paris, where models' markets formed each day at the Boulevard Montparnasse and at the notorious Place Pigalle. Hopeful amateur models gathered around Place Pigalle's large, hardworking fountain, where residents would wash fish in the basin, do their laundry and dispose of trash.

At night, Place Pigalle was a stew of the bizarre, the macabre and the titillating for those who dared to cross the thresholds of its nightclubs and cabarets. In the bright Parisian mornings, however, the men and women who gathered in Place Pigalle were prospective sitters. Most were Italians willing to pose for a franc less an hour than the French. Some dressed in period costumes to advertise a certain look for genre paintings.

The atmosphere at the models' markets was a high-spirited mix of camaraderie and competition. It was preferable, but not always possible, to contract with the academies for work as a model. If that fell through, a good day at Place Pigalle or Montparnasse offered another possibility of income.

Meanwhile, the academic approach to training student artists – particularly in London – was increasingly under fire. The Royal Academy persisted in

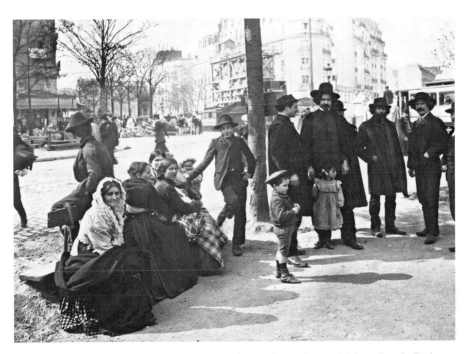

Boulevard Montparnasse (1914) was one of several popular models' markets in Paris.

its practice of using antique subjects, Old Masters and plaster casts to teach draughtsmanship before moving to live models. Some felt that this clashed with the growing importance of natural human forms in modern art, and accused the practices of stifling experimentation. Avant-garde thinkers were particularly harsh in making the Academy a target for ridicule.

The Slade School was more successful at walking the line between the old and new guard. After 1900, the Slade proved open-minded in the way its curriculum used live models, with a focus on realistic anatomical depiction. This was advanced when Henry Tonks took the helm in 1918.

Tonks was a surgeon and a draughtsman who became a Slade tutor in 1892 and an official war artist in 1918, accompanying John Singer Sargent on tours of the Western Front. Later that year he accepted the position of Slade Professor of Fine Art, succeeding Frederick Brown.

Tonks had a long history with the Slade. He instructed William Orpen, Augustus John, Gwen John and others – and did the same after the turn of the century with C.R.W. Nevinson, Mark Gertler, Carrington and their talented contemporaries. He often shook his head in despair at the artists he called his rebellious brood, but he kept in touch with many of them when they moved on.

Tonks did his best to instil the importance of anatomy in his students. His medical background, the sights he saw in battlefield hospitals, and the photos captured by handheld cameras – carried by soldiers for the first time – only deepened his obsession. A friend recalled: 'He read everything that was written about drawing; he listened to all that his friends had to say; he thought about drawing, and he practised drawing, praying that the secret might be vouchsafed to him.'[9]

Only figurative art afforded the precision that Tonks demanded of his students. He had little time for controversial modern movements such as Cubism. In 1910 most Londoners still had not been exposed to modern art even though, in France, some modern movements were decades old by then. An exhibition arranged in part by Slade tutor Roger Fry, entitled *Manet and the Post-Impressionists*, brought paintings by Picasso, Cézanne, Manet, Matisse, Gauguin and Van Gogh to the Grafton Galleries that year. Tonks stopped short of forbidding his students to attend, but he made it clear how pleased he would be if they found something else to do.

Thus Henry Tonks and his passion for anatomy contributed to the demand for well-defined, classic life models at the Slade. It helped maintain economic opportunities for *Italienne* posers in London well into the new century, despite changing tastes in other parts of the world.

Meanwhile, Harry Furniss continued his tongue-in-cheek assaults on the Academy and its most eminent members. Nothing was sacred. Writing in *Royal Academy Antics*, Furniss made a sly commentary about the complex relationship between artists and models – made more gossip-worthy if the artist was a high-ranking Royal Academician.

*Royal Academy Antics* includes an account of Sir Thomas Lawrence, the relentless flirt and acclaimed portrait painter who became president of the Academy in 1820. Furniss wrote about Lawrence:

> ... *when he undertook to paint the portrait of the Princess of Wales, it seems a pity that his zeal in the conscientious study of his royal model should have carried him so far into the privacy of the lady's apartments as to make the subject of a 'Delicate Investigation,' and a world-wide scandal.'*[10]

There is some truth to the account, and in this instance at least, the model may have had a hand in the scandal.

*Chapter 5*

# Modern Realities

'Sitting astride the bow window ledge, smelling the heliotrope – or was it the sea? – half of Kezia was in the garden and half of her in the room.'
    – Katherine Mansfield, in her notes for the essay *That Woman*, 1916.

In the room behind the staircase at no. 44 Bedford Square, Lady Ottoline Morrell stood trembling with nerves as she ran her fingers over the chimneypiece. In a few hours she would once again welcome some of London's most exciting artists and writers to her salon. Steeling herself against her own lack of beauty, she took comfort in her patronage, knowing that they must at least pretend to like her.

It was not easy being Lady Ottoline, a fierce patron of the arts toward the end of the *belle époque*. Later the tidal wave would be dubbed modernism, but in 1905 it felt like a cultural siege. Creative passions ignited tempers and brawls. Conventional thinking was torn apart and scrutinised for its flaws. Nothing was spared, not art, literature, theatre, architecture, music, science, religion, commerce, employment nor morality. Everyone was a revolutionary, and inside the grey stone façade of Bedford Square, art was the battlefield.

The artists who availed themselves of Morrell's hospitality had considerable fun at her expense, even while immortalising her according to their skills. She had her portrait painted numerous times: 6ft of steely resolve with flamboyant red hair and an imperious manner bred of very good connections.

Years later, the writer Nicolette Devas would recall that when she was young, she peeked at Morrell's profile through the rhododendrons and thought she was a witch. The great draughtsman Augustus John refused to soften the jutting jaw and prominent nose, choosing to capture the defiant child inside. While some deemed his portrait an affront, Morrell reportedly liked it very much. It may have helped that they were lovers at one time.

Novelist D.H. Lawrence, who accepted many Morrell social invitations, caricatured his hostess so mercilessly in 1916's *Women In Love* that the two didn't speak again for twelve years. When Aldous Huxley did the same in *Crome Yellow*, she never forgave him. Her protégé Mark Gertler was more kind, sensitive perhaps to his own lifelong role as an outsider.

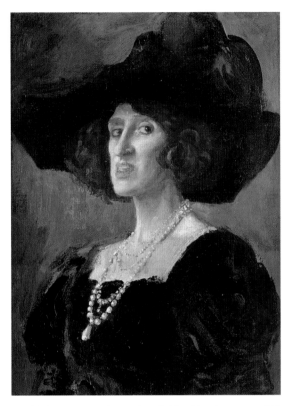

*Lady Ottoline Morrell*: Augustus John painted his friend true to life, formidable and insecure (1919).

Morrell's husband and friends invariably disappointed her – the author Virginia Woolf was one notable exception – and her numerous love affairs with both men and women were short-lived in every case but one. Ultimately, she seemed best at superficial relationships. 'I want more than he wants', she wrote in her journal of one male companion, and 'he holds things back and is never open with me, it's odd!'

While Morrell's sexual behaviour made her the subject of gossip within her social circles, she can be forgiven for seeking emotional relief. Her husband Philip Morrell, a Member of Parliament, was a serial philanderer and may have been mentally ill. He expected his wife to take care of the children he fathered with his mistresses – some reports say two babies were born in one year – and cover for his instability.

No wonder, then, that his wife had a habit of breezing into London studios to see what her favourite artists were up to. The studio atmosphere appealed to

her: air thick with the smell of paint and turpentine, no stuffy London mores, and no husband. If the sitter caught her eye the girl might get an invitation to Bedford Square. This kind of thing was beginning to happen all over London; it reflected an evolution in the social role of artists' models.

By 1914 models had become an accepted part of creative society, as *The Tatler* noted: 'A rather arresting personality, by the way, who seems to prefer artistic to purely social circles, is the Duke of Portland's sister, Lady Ottoline Morrell. At her house in Bedford Square … you may be sure of meeting the newest thing in poets, painters, *poseurs*, and the like …'[11]

History isn't quite sure what to do with Lady Ottoline Violet Anne Morrell. She has variously been described as a desperate eccentric, prescient patron of young talent, self-entitled aristocrat, fierce defender of liberal values and a silly woman to be pitied. She was, in fact, all of these things and more. Her vigorous life and the development of modernism in Britain are forever intertwined.

****

The new aesthetics percolating in London during the *belle époque* had their genesis in the prior century. The modern philosophical movement took root in Europe around 1850, when manufacturing processes started changing life in earnest. Everyday people began to question the traditional order of things.

This gave rise to a restlessness that became pervasive in society, politics, philosophy and the creative arts. Realism was losing ground. Post-impressionism received a boost from the American artist James McNeill Whistler, although he wouldn't live to see London's first exhibition of modern art. The march of modernism was on, and models had a front-row seat, even as they worried about their employability.

The number of art movements associated with the modernist period has been variously described as ranging from ten to over sixty (subsets of the major movements are difficult to define). Prior to 1900, the Impressionists, Neo- and Post-Impressionists in France and the Pre-Raphaelites in England lit the fuse with the first modern breaks from tradition. The Pre-Raphaelites were particularly introspective, with ties to both the past and the future.

From there, the rapid-fire influences of Art Nouveau, Symbolism, Fauvism, Expressionism, Cubism, Orphism, Suprematism, Vorticism and Constructivism shook the London art scene. Twisting across this landscape were common strands: the importance of contemplation, authenticity and social and economic progress. One radical idea was that art should come from within, rather than portray something simply observed. Experimentation was rampant in all forms.

Progressive modernism – that is, modernism of the early twentieth century as opposed to the late nineteenth century – brought with it a sense of urgency. Why wait for obsolescence to run its course if you could move on now? And why not harness tradition for your own purpose in the process? Were the old institutions and values even worth preserving? The past wasn't necessarily to be forgotten, but it could be reshaped into something new, or parodied to make a point.

Fortunately for artists' models, their role in the volatile early decades of the 1900s stayed relatively constant. For one thing, the London art schools remained rooted in anatomical approaches to figure drawing. This required a ready supply of male and female models for life classes. In addition, while realism was steadily losing its lustre, the process of art still required real-life sitters. The interpretation, though, could be dramatically new.

Pablo Picasso's 1907 painting *Les Demoiselles D'Avignon (The Young Women of Avignon)*, shows five nude women portrayed as flat, cut-out shapes. They look out of the canvas with expressions that are simultaneously blank and

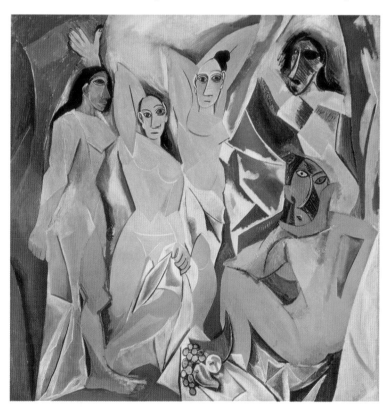

*Les Demoiselles D'Avignon*: Picasso shattered traditional ideas of artistic expression (1907).

angry, turning the traditional dynamic of the male gaze and the female subject on its head. All five models are drawn from sex workers Picasso saw at a brothel on Carrer d'Avinyó in Barcelona, Spain.

Were the five confrontational models truly that fierce when they posed? Did they stare that aggressively at the strangers who stared back at them? Two of the prostitutes appear to wear exotic masks, reflecting the African influence that so engaged Picasso at the time. Even masked, the faces seem to be in harmony with the whole.

The public was shocked and angered by *Les Demoiselles D'Avignon*. Picasso was pleased. He said of his painting, 'I paint forms as I think them, not as I see them.' With those twelve words, modernism's most savage disruptor drove the sharp edge of a wedge straight through traditional thinking about art.

This idea of 'seeing with the mind' was liberating to Britain's young artists. Rules were meant to be broken, and they broke them with abandon. For example, it was more important to value love than it was to practice monogamy or pursue a certain gender. By the early 1920s, Garsington Manor, the country estate owned by Philip and Ottoline Morrell, would acquire a reputation as an *intelligentsia* house of debauchery. Located close to Oxford, Garsington rivalled Augustus John's Alderney Manor in Dorset for sheer lack of inhibition.

Professional models were largely superfluous at these country residences. Writers, composers, poets and philosophers came and went as the spirit moved them. Couples formed and reformed, finding a new freedom in bisexuality. If a model was needed from outside the group, there was always a gardener or housemaid nearby.

Lady Ottoline's social weight remained in full force throughout this seminal time in British art. This gave her the ability to further the careers of the artists she patronised. She reigned over the fluid life at Garsington with a carefree instability, engaging in a longstanding affair with the philosopher Bertrand Russell and taking numerous other lovers. These reportedly included the painter Dora Carrington (described by Morrell as a wild moorland pony), the psychiatrist Axel Munthe and the art historian Roger Fry.

Back in London, the elder statesman of the art world, John Singer Sargent, stayed comfortably above the fray at his Tite Street home. There he continued to translate a keen eye for detail into stunning portraits of well-known sitters, employing his own ideas of beauty. Sargent died in 1925 having confidently explored modern techniques in his own way without undue pressure.

Those who criticised Sargent for saying things such as, 'the painter's business being, not to pick and choose, but to render the effect before him'

failed to appreciate his modern nuance. The effects he saw before him were opportunities to unveil a sitter's inner truth through carefully rendered detail. That in itself was a modern sensibility. It was a masterful line to walk between authenticity and commercial appeal.

As his friend and biographer Edward Charteris noted, when Sargent wasn't committed to a society portrait at his studio,

*He paints here, there and everywhere with a deliberate nonchalance in the choice of his topics, taking things as they come; discovering things as it were by accident, but seeing them with an intensely personal outlook, more nearly concerned, in fact, with how he sees and how he paints than with the associations of what he sees.*[12]

Sargent may have crossed paths with Morrell in London, but they were very different personalities with divergent opinions on art. Life at Garsington Manor would not have appealed to him. In 1929, however, a society columnist enthused over the 'star-scattered grass' at the Morrells' country house, saying:

*One of the women who have been responsible for keeping the young idea going is Lady Ottoline Morrell, who with her husband, Mr Philip Morrell, has entertained at her lovely house, Garsington Manor, all the young writers and painters who in the last ten or twenty years have become famous.*[13]

The 1930s would mark the end of Morrell's reign, and her immense influence on the London art scene was only fully appreciated after her death in 1938.

Morrell's legacy is helped by the fact that she was an avid amateur photographer, and thus hundreds of images exist of Garsington life. Her photographs show a tour de force of artists and writers posing for one of the era's most significant innovations: the personal camera. It was a fitting intersection of the creative *milieu* and modern technology, but it was far from the first.

\*\*\*\*

Photographs and artwork had been exhibited together as early as 1859 at the Universal Exposition in Paris, when photography was just twenty years old. This spurred a new appreciation for the camera that accelerated with Alfred Stieglitz's modernist images in the late 1800s. Suddenly the photograph was no

longer just a tool; it was a legitimate creative medium. Cameras would become a darling of the avant-garde.

Some artists dismissed the use of photography in those early years, some welcomed it and some embraced it in secret. The French editor and critic Ernest Lacan described the relationship of photography to painters as being 'like a mistress whom one cherishes and hides, about whom one speaks with joy but does not want others to mention.'[14]

Photography was a cautious love affair for artists' models as well. Posing for the camera paid more per hour than posing in a classroom or studio – the rate could be two or three times that of a life sitting. However, a photo required just one sitting, whereas a session at the Slade typically lasted for a week or more. Taken on balance, the lure of photography for models was less about the money and more about the chance to emerge from anonymity.

This push-pull of change was a hallmark of the progressively modern 1900s in England. It was a liberating and exuberant time for many, but it could also lead to crippling self-doubt. Lesser-known artists who held fast to realism struggled to sell their paintings. Some found personal introspection unbearably hard and retreated to dark places. Others felt that they had wasted their lives perfecting techniques that were hopelessly out of fashion.

In 1922, the neoclassic painter John William Godward left his studio door unlocked, wrote a suicide note, and closed himself in a lavatory with the gas on. Years later, one of the Slade's most brilliant young talents, Mark Gertler, would also take his life by gas.

Gertler, who once wrote that poverty 'had a beautiful simplicity, which was to be envied', had struggled for decades to feel he belonged. By 1939 four of his close friends were dead: Katherine Mansfield, D.H. Lawrence, Dora Carrington and Ottoline Morrell – the last from an experimental cancer treatment. He was separated from his wife and war loomed again. The heady rush of modernism that had sustained him as a young man was gone. For Gertler, it was an unbearable time in which to be alive.

*Chapter 6*

# Bloomsbury Doorsteps

'How you manage to leave out everything that's dreary, and yet retain enough string for your pearls I can hardly understand.'
— Lytton Strachey writing to Virginia Woolf about her astonishing prose, 1922.

*Will this bloody beast ever stay still?* Edward Wolfe scooped up the yellow cat for what seemed like the hundredth time that afternoon. It was 1918, and Wolfe was in London from South Africa to study at the Slade, where he quickly met the critic Roger Fry. Bonding over a shared love of Fauvist art, Fry invited Wolfe to join his experimental Omega Workshops in Fitzroy Square.

Now Wolfe was at no. 18 Fitzroy Street in Nina Hamnett's studio. Nina, another Omega artist, was thoroughly amused by her two visitors – the Workshops' resident cat and this doe-eyed, dark-haired young man who was determined to sketch his still life. The resulting study shows a self-satisfied, mustard-coloured feline camouflaged by a large bunch of bananas in the foreground. Wolfe noted his victory on the back of the picture: *My first studies – Edward Wolfe – painted 1918 in Nina Hamnett's studio, Fitzroy Street.*

Wolfe and Hamnett were not part of the so-called Bloomsbury Group – that loose association of privileged writers, artists and intellectuals based in London in the early 1900s – but they were in the Bloomsbury orbit. Both were beneficiaries of the sweeping influence that Roger Fry and his Bloomsbury colleagues exerted on rising young talent. To someone like Wolfe, who was unfamiliar with London, Fry's invitation to the Omega Workshops must have been welcome indeed. As for the cat, it was no stranger to being immortalised; it had posed just as disdainfully for the sculptor Henri Gaudier-Brzeska in 1914. Like so many other models, the cat is anonymous.

Well before Wolfe's arrival in London, the creative footprint of the metropolis was changing shape. Chelsea's reputation as a home base for the arts was giving way to Fitzrovia, Camden and Bloomsbury – the heart of unconventional London. The squares in this part of London had became signposts for young talent: Fitzroy, Brunswick, Tavistock, Bedford, Mecklenburgh and Gordon.

Fitzrovia would become nearly synonymous with the visual arts, but it had some competition. Clive and Vanessa Bell, Bloomsbury stalwarts, lived at no. 44 Gordon Square until 1917, their front door painted bright vermillion. In fact, the Bloomsbury Group called many places home in the first half of the twentieth century, and formed strong attachments to the studios, houses, squares and gardens where they spent their most creative years.

Town or country, location provided the essential spark that British author Rumer Godden would later describe as grit:

> ... *something large or small, usually small, a sight or sound, a sentence or a happening that does not pass away leaving only a faint memory – if it leaves anything at all – but quite inexplicably lodges in the mind; imagination gets to work and secretes a deposit round this grit – 'secretes' because this is usually an intensely secretive process – until it grows larger and larger and rounds into a whole.*[15]

The Bloomsbury experience was both full of grit and surprisingly insular. The members looked to each other for inspiration; few of the artists used professional models on a regular basis. They found each other endlessly fascinating, amusing, annoying or arousing by degrees. The bonds they formed would last throughout their lives and imbue, for better or worse, the lives of their children.

The first Bloomsbury connections are generally attributed to the London-based Stephen siblings, Thoby, Adrian, Vanessa (Bell) and Virginia (Woolf). Vanessa began hosting Friday Club gatherings for artists and intellectuals in 1905 soon after her brother Thoby initiated Thursday Evenings for his writer friends from Cambridge University. Thoby died in 1906.

In this way, the Stephen sisters were instrumental in bringing together the creative community that would become the nucleus of the Bloomsbury Group. Most who attended had not yet found fame. The Club originally met at members' homes, but quickly sought an impartial battleground as it grew. As Vanessa Bell wrote to a friend at the time, 'We can get to the point of calling each other prigs and adulterers quite happily when the company is small & select, but it's rather a question whether we could do it with a larger number of people who might not feel that they were quite on neutral ground.'[16]

Around the same time, the artist Walter Richard Sickert began holding Saturday Afternoons At Home in his Fitzroy Street studio. A spirited debate at the Friday Club could be continued on Saturdays for those willing to rise above a hangover. Sickert's Fitzroy Street gatherings would evolve into the

Camden Town Group in 1910, about two years ahead of the less formalised Bloomsbury Group.

Despite the labels, none of these groups had hard edges; most had hangers-on and common members. Bloomsbury insisted they weren't a group at all, although they were united by a deep intellectual interest in liberalism, pacifism, sexuality and the philosophies of G.E. Moore. They believed that their ideas were intrinsically good and valuable without the need for definition or proof.

By most accounts there were ten original members of 'Old' Bloomsbury (any list is subject to dispute). Joining Vanessa and Virginia as founders were eight men: the art critics Clive Bell and Roger Fry, who was also a painter; writers E.M. Forster, Lytton Strachey and Leonard Woolf; journalist Desmond MacCarthy; economist John Maynard Keynes; and the painter Duncan Grant. All but Grant knew each other through Cambridge.

The ten Bloomsbury originals were meeting regularly by 1912, along with other Friday Club members, and arranging art exhibitions. Not everyone who attended the meetings continued on with the Friday Club. The painter Henry Lamb spent more time with the Camden Town Group and its later permutation, the London Group. Vanessa Bell, Roger Fry and Duncan Grant began exhibiting with the Grafton Group in 1913, although they retained their Bloomsbury connections.

Forming part of the broader Bloomsbury constellation were others who added to the group's mystique. There was pudgy, naïve Carrington, a mess of contradictions with her blonde pageboy and stubborn chastity. Mark Gertler, who wrote heart-wrenching letters to Carrington begging for the 'beautiful bondage' of her love. Nina Hamnett, who had an affair with Roger Fry, and Wyndham Lewis, who had a falling out with Fry. Adrian and Karin Stephen, Saxon Sydney-Turner, Molly MacCarthy, Katherine Mansfield – all these and more became part of the Bloomsbury periphery in different ways.

Angelica (Bell) Garnett holds a unique place in the group's second generation. Garnett grew up thinking that Bloomsbury founder Clive Bell, Vanessa's husband, was her father. She was devastated to learn that she was the daughter of Duncan Grant – a man whose many homosexual affairs reportedly included his cousin and fellow Bloomsbury founder Lytton Strachey. In a storyline worthy of Thomas Hardy, Angelica would go on to marry one of her biological father's other lovers, the adventurous David 'Bunny' Garnett.

In posing, as in so much else, the group was complacently self-sufficient. This was emotionally satisfying, as they were often sleeping with, or pining for, each other. Strachey would sit in his lawn chair and read, oblivious to

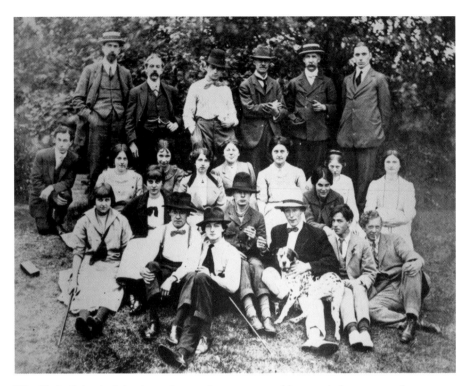

The Slade School of Art brought together many notable twentieth-century talents, most of them pre-fame. Front row, left to right: Dora Carrington, Barbara Hiles, Richard Nevinson, Mark Gertler, Edward Wadsworth, Adrian Allinson (with dog) and Stanley Spencer. Dorothy Brett is behind Nevinson and Gertler; Isaac Rosenberg kneels at left. Back row: David Bomberg (shirtsleeves) and Professor Fred Brown. Positions unconfirmed: Muirhead Bone, Henry Tonks, Howard Gilman, Augustus John and Paul Nash (circa 1912).

Carrington sketching away. Duncan Grant made good use of Bloomsbury subjects, but in other ways diverged from the norm. Virginia Woolf may have modelled the character of Bernard in her novel, *The Waves*, as a composite of Desmond MacCarthy and Roger Fry.

The group's members often rivalled professional models for sheer amount of posing. Lady Ottoline Morrell – although not technically Bloomsbury – had close ties to the group. The ubiquitous Morrell is represented in almost 600 portraits (art and photography) at the National Portrait Gallery and is associated with a staggering 1,700 others. Vanessa Bell, Clive Bell, Duncan Grant, Dora Carrington, John Maynard Keynes, Mark Gertler, Lytton Strachey, Virginia Woolf, Roger Fry, Wyndham Lewis, Bertrand Russell and E.M. Forster are each represented by eighteen or more portraits, some exceeding fifty.

Despite their London roots, the Bloomsbury members would become inexorably tied to Sussex. In 1916, Vanessa Bell, now separated from her husband Clive, moved to Charleston Farmhouse in East Sussex with her two small sons, Quentin and Julian, Duncan Grant and Grant's lover David Garnett. Charleston would become the soul of Bloomsbury in the country – it brought fresh grit to the creative process. Secret gardens, mismatched lawn chairs, frenetically patterned carpets and book-strewn shelves became characters in their own right. Bloomsbury members drifted from London to Sussex and stayed for weeks or months. Bell, with her quiet humour, often served as unpretentious muse and model to this ménage.

In Vanessa Bell's painting, *Interior Scene, with Clive Bell and Duncan Grant Drinking Wine*, painted at Gordon Square, the amount of detail in the room tells the viewer everything necessary about the connection between Bell's husband and her former paramour: a shared love of books, fine wine, modern art, good conversation and cosy slippers. This same use of detail would become a hallmark of works created at Charleston Farmhouse, where the artists were responsible for much of the decor.

****

Meanwhile, back in London, the staid Georgian façade of no. 33 Fitzroy Square marked another location important to the group: Roger Fry's experimental Omega Workshops.

Omega Workshops were a unique creative outlet that added another dimension to the Bloomsbury Group. Started by Fry in 1913, the studio functioned as an artists' collective with an emphasis on domestic design. Radical experimentation was encouraged. The resulting textiles, furniture, screens and housewares shocked what remained of Edwardian England.

Fry's use of a commercial venture to nurture artistic development was years ahead of its time. Goods designed and produced at the Workshops were sold to consumers brave enough to put them in their homes. The artists earned a modest income and the right to use the studio space at set times. Fry enlisted his Bloomsbury friends Vanessa Bell and Duncan Grant as co-directors of Omega, and encouraged Mark Gertler, Edward Wolfe, Nina Hamnett, Wyndham Lewis, Cuthbert Hamilton and Winifred Gill to contribute.

Omega Workshops debuted to a mix of awe and ridicule. Vanessa Bell, in particular, had taken to decorative art with a vengeance. The results were astounding. Virginia Woolf described her sister's textile colours as wrenching

her eyes from their sockets, and threatened to retreat to dove grey. A kinder reviewer called them fierce and fascinating.

One biting critique focused on the depiction of the models:

> *... the Omega Workshops in Fitzroy Square continue to ply the brushes and bobbins of discord and disorder. Facing the door is a screen on which are painted figures distorted with the obvious intention of doing violence, not only to the generous elasticity of the human anatomy, but to man's yet more elastic conceptions of what may be attractive. The screen is 'anti-tradition' and nothing else ... the man who makes such a screen is, even while he denies it, shackled to the things he abhors ... the screen needs a screen.*[17]

For the six years that it lasted, Omega Workshops was a microcosm of the tangled relationships that defined the Bloomsbury Group. Bell, Grant, Garnett, Hamnett and others continued to produce work for sale during the First World War, sometimes acting as models for each other. The venture was hard-hit by the war economy, and despite Fry's best efforts it never recovered.

The Omega Workshops experiment was yet another of Roger Fry's profound encouragements of modern art in London. His first was the landmark exhibition of Post-Impressionist paintings that had so dismayed Henry Tonks in 1910. Tonks, who once advised Vanessa Bell to take up sewing, apparently felt that it was best not to comment on her creative output at the Workshops, at least not publicly.

****

Duncan Grant's fascination with male and female nudes differentiates his body of work from other Bloomsbury artists. His stature as an artist and his unconventional sexuality produced a steady stream of potential subjects, mostly male. When he was starting out, however, and for specific commissions throughout his life, Grant did engage professional female models.

In 1908, a young Grant was working in his first floor studio at no. 21 Fitzroy Square in London. He had just returned from France, and was eager to paint everyone he encountered. Grant often asked friends and relatives to pose, thus saving the expense of professional models. He also worked from photography, and a substantial number of his nude photographs of both men and women still exist. This was a dangerous activity under English law at the time.

Grant soon came to realise that he had trouble capturing the essence of a posed sitter. This was driven home when Virginia Woolf sat for him with

poor results. The solution came when he was allowed to sketch Woolf at work over several hours in her home. The idea of seizing the moment with a subject who paid him little or no attention fit perfectly with Grant's exploratory style, and he developed it brilliantly throughout his career.

One artist–sitter who lived in the same avant-garde manner as Grant in London was the irrepressible Nina Hamnett. Hamnett was carefree about her body, and once danced naked on a café table in France out of sheer lack of inhibition. She was an ideal candidate to pose for some of Grant's nude stylisations for Omega Workshops.

Hamnett would later write that, aged 16, she had seen nudes in her art school classes but had never looked at herself naked in the mirror:

> … *my Grandmother had always insisted that one dressed and undressed under one's nightdress using it as a kind of tent. One day, feeling very bold, I took off all my clothes and gazed in the looking-glass. I was delighted. I was much superior to anything I had seen in the life class and I got a book and began to draw.*[18]

One step removed from the Bloomsbury coterie, four types of women can be seen in their work: lovers, sitters for commissioned portraits, women who epitomised a social or creative force, and – to a much lesser degree – staff and strangers. Their children also served as models.

Lydia Lopokova first sat for Duncan Grant in 1923, two years before marrying John Maynard Keynes. The Russian-born prima ballerina was a famous name in London in her own right – a cult figure who danced with Nijinsky, knew Stravinsky and posed for Picasso. She and Keynes met at a party for the Diaghilev *Ballets Russes*, and she spent the next five years as his lover while he sorted out his sexuality.

The Bloomsbury circle barely tolerated Lopokova at first. Lytton Strachey likened her to a half-witted canary. Vanessa Bell urged Keynes, who had been a committed homosexual up until then, to avoid the altar and keep her as a mistress. Virginia Woolf wrote that the woman who became known as the 'Bloomsbury Ballerina' had the soul of a squirrel.

At Charleston Farmhouse, 'Loppy' soldiered on in her quest to win over Keynes's friends. When it all became too much, she would recharge by dancing naked in the fields in the dawn hours. Despite a nine-year age difference and a considerably wider social gap, she and Keynes were a true love match that lasted until his death in 1946.

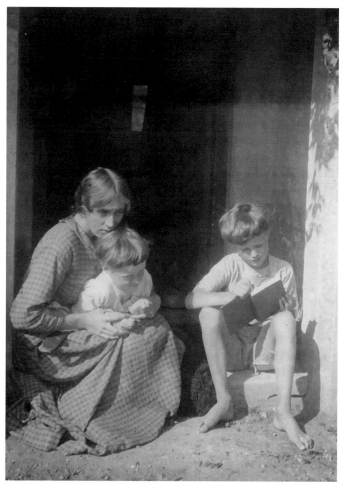

Bloomsbury matriarch Vanessa Bell with sons Quentin and Julian at Charleston (circa 1916).

Lydia Lopokova is thought to have sat for more than twenty portraits in total, including multiple works by Duncan Grant, Ambrose McEvoy and Picasso – who reportedly danced with Lopokova in front of her London house in 1951 on his final trip to England. She remains one of the most under-acknowledged models of the time.

By contrast, Sarah Margery Fry was related to Bloomsbury by blood instead of marriage. The sister of Roger Fry was an imposing presence on canvas. An infrequent sitter for the group, she had a busy professional life. She had portraits painted by her brother and by Claude Rogers, and was compellingly sketched by Charles Haslewood Shannon in 1915. Shannon was an Academy-trained

portraitist in the classical style. His choice of pastels suits his subject, who seems caught between introspection and action.

Margery Fry merits attention not as a frequent sitter, but because she was a catalyst for social reform. This resonated with liberal Bloomsbury thinking. Her brother Roger felt that she had promise as a painter, but she chose to attend Oxford University instead. The progressive siblings from a Quaker household lived together for a while immediately following the First World War.

In 1921 Fry was appointed one of the first women magistrates in Britain; a year later she became education advisor to the female inmates at Holloway Prison in London. In the 1930s she travelled to China on a lecture tour and returned to London determined to raise awareness of China's inhumane prisons and factories.

Margery Fry remained connected to the Bloomsbury Group through her brother Roger, Leonard and Virginia Woolf, and Duncan Grant. The five were lifelong friends despite having very different temperaments. After the Woolfs and Frys visited Greece together in May 1932, Virginia expressed her exasperation in a letter to her sister. She wrote that Margery and Roger would,

> 'buzz and hum like two boiling pots. I've never heard people, after the age of 6, talk so incessantly … it's all about facts, and information and at the most trying moment when Roger's inside is falling down, and Margery must make water instantly or perish, one has only to mention Themistocles and the battle of Plataea for them both to become like youth at its spring.'[19]

In her later years, Margery Fry's house at no. 48 Clarendon Road in West London would become a mirror of her wide-ranging interests. Modern pictures, Duncan Grant carpets, Chinese ornaments and ancient pots lived side-by-side with her brother's artistic endeavours and bookshelves full of Forster and Strachey. It is her fierce curiosity about the human condition, not her face or form, that qualifies her as a Bloomsbury muse.

****

For all their progressive thinking and left-leaning ideals (particularly second generation Bloomsbury), the group seldom turned to the working classes for models. Most members came from well-to-do families and retained a sense of privilege. Servants, nannies, shopkeepers and labourers were seldom portrayed in their works. *The Nurse* by Vanessa Bell is an exception of sorts –

however, Bell chose not to pose a real nurse as a model. Instead, she used a woman associated with the Guinness dynasty.

Carrington, with her merchant father, had no such pretentions. She painted *Annie Stiles* (housemaid) at Tidmarsh Mill, the country house Carrington shared with Lytton Strachey from 1917 to 1924. Her painting of *Mrs Box* (farmer's wife) is another exception to the Bloomsbury insularity.

Inarguably the most prominent Bloomsbury domestic worker who sat *in situ* is Grace Higgens (née Germany). Higgens worked primarily as a cook for Vanessa Bell and Duncan Grant in London and at Charleston Farmhouse. Her relationship with Bloomsbury spans more than fifty years – first as housemaid, then as a cook and housekeeper, and occasionally as a nurse.

The high-spirited Norfolk teenager began her Bloomsbury tenure with Vanessa Bell in 1920 at no. 50 Gordon Square. Higgens became a loyal friend and travelling companion to her employer, and the moral compass of Charleston Farmhouse below stairs. After Bell's death in 1960, Higgens stayed on another ten years to take care of Duncan Grant. She attended his funeral in 1978, watching the simple coffin pass by with his straw hat on top.

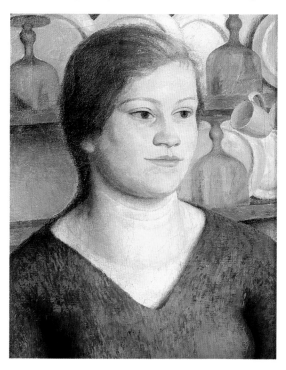

*Annie Stiles:* Dora Carrington painted the housemaid in the kitchen at Tidmarsh Mill (1921).

The most famous canvas of Grace Higgens still hangs in Sussex – *The Kitchen* (1943) by Vanessa Bell. The cook's bent head and neutral clothing relegate her to second position behind the piled vegetables and strong diagonals of the table's edge. Higgens is more prop than persona under Bell's brush, but she and her surroundings are in perfect harmony, which is perhaps what the artist wanted to convey. Five years later Higgens served as the focal point in Bell's work *The Cook*, although her face is in flat silhouette against a sunlit window. A third painting, *Interior with a Housemaid*, circa 1939, may depict Higgens as well.

Unlike some of his friends, Duncan Grant had no problem engaging with household staff. As early as 1902 he painted his own version of downstairs life, *The Kitchen*, in which a cook looks directly out at the viewer from deep within her domain. Higgens would sometimes model for Grant after Bell's death, and his *Seated Model*, with Charleston decor in the background, may depict an older Higgens. The look on the sitter's face seems to coincide with a diary entry from that period in which Higgens wrote: 'Sat for my portrait after lunch. My eyes keep watering, as Mr Grant insists on me taking off my glasses, I had a peep & think I look a peevish woman.'[20]

Charleston Farmhouse was not much distance from Monk's House, where Leonard and Virginia Woolf were often in residence. There were many comings and goings among the two residences and London, all of which Higgens handled with aplomb (she wrote in her diary about beating back two young men who tried to climb through Grant's window at Charleston).

Higgens found the Woolfs amusing, if sometimes too eccentric, writing in her diary that the two looked like 'absolute freaks' riding their bicycles around the country lanes in tattered old clothes. But there was also a fondness there – when Virginia Woolf sent a postcard praising the cook's sponge cake recipe, Higgens saved it as a keepsake.

Given Woolf's loathing of domestic help, her sponge cake note indicates just how valued Grace Higgens was at Charleston. There was a great divide between Woolf, who grew up in a household with servants, and those who were hired to wait on her. This was evident in Woolf's relationship with her own cook, Nellie Boxall. Woolf was consumed with giving Boxall the sack for eighteen years, a goal she finally achieved in 1934.

The irony of Woolf's domestic situation was her dependence on the servants she abhorred. These included Boxall and a fun-loving housemaid named Lottie Hope, both of whom had previously worked for Roger Fry. Woolf saw herself as a feminist and a strong, independent, modern woman, yet her mental fragility cast her servants in the role of caregivers.

By contrast, Grace Higgens truly possessed the autonomous mindset that Woolf sought her entire life. This was appealing to the Bloomsbury members, who promoted feminism and independence in all forms.

Higgens was just 20 years old when she wrote in her diary in 1924 that she had a terrific argument with Mrs Harland, the Charleston cook at the time,

> *about my awful Socialist views ... Mrs Harland thinks, that the poorer classes, never ought to be allowed to raise themselves up ... Mrs Harland also thinks that if a wealthy man offered to make advances towards a poor girl, she should be honoured & allow him to do whatsoever he liked with her, for the sake of a few miserable shillings ... & also she should be able to brag about it, that she had been mistress for one night or a few weeks or months of a man with money. Also she thinks I am mad because I said if a rich or poor man wanted me he would have to marry, for if I was mistress of a man & he turned from me to another woman, I would kill him. & she also says I am mad, because I said I do not want to get married, as I would lose my independence.[21]*

Photos exist of all three women – the combative Nellie Boxall, the lively Lottie Hope and the independent Grace Higgens – but only Higgens is known to be on canvas. It helped that she was striking in appearance. Duncan Grant found himself attracted to her more than once, although nothing ever came of it beyond the occasional posing. Nevertheless, she remains a formidable figure in Bloomsbury history and holds a singular position as a sitter.

In the early 1940s, Grant was selected to paint murals at St Michael and All Angels Church in Berwick Village, Sussex. The church was close by Charleston, and Grant made a family affair of it with Vanessa Bell. Two Bell half-siblings, Angelica and Quentin, served as models, along with Angelica's friend Chattie Salaman. Salaman was a personable actress from an old Anglo-Saxon family who had posed for Augustus John and other artists.

Later, Vanessa Bell's son Quentin would write about his frustration with the familial bias at Charleston. He told of committing an act of defiance as a young man while on a break from his studies at the Slade.

> *I felt the need for a model – models not being available in Sussex – I made my way to the Euston Road. I was in a sense venturing into enemy territory ... The model was old and hideous, she had the face of a camel ... Duncan remarked when he saw the thing, 'Well, you have made her a dreaming beauty!' I suspect it was a very bad picture.[22]*

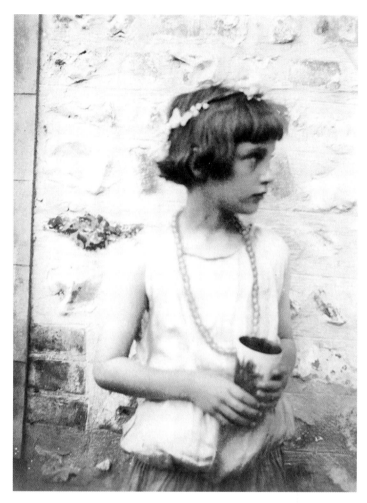

As an adult, Angelica Bell Garnett struggled to come to terms with her unconventional childhood.

Despite his committed relationships with men, Grant's admiration for women and the female form never waned. Perhaps it was nurtured by his forty-year creative alliance with Vanessa Bell and the unconventional fling that produced their daughter Angelica.

In a short story, *When All The Leaves Were Green, My Love*, Angelica Bell would make a thinly veiled reference to her upbringing at Charleston as being like a hall of mirrors where she saw only reflections of herself. Certainly, as Charleston's golden girl-child, she must have felt like she was the centre of an incomprehensible universe.

For her father, Charleston was a hall of Duncan Grant mirrors: a confluence of his daughter, her mother Vanessa and his other former lovers, Lytton Strachey, John Maynard Keynes and David Garnett. Quentin Bell reportedly said, looking back, 'I love my parents – and I had more than the usual number to love.'

Angelica Bell Garnett, daughter of Bloomsbury, had four talented daughters: Henrietta, Amaryllis and the twins Nerissa and Frances. Henrietta also had a daughter. Grant could hardly escape three generations of female influence even if he wanted to.

# Part Three

## UNCONVENTIONAL WOMEN

# Chapter 7

# The Quiet Canvas

'Ordinary women never appeal to one's imagination. They are limited to their century.'

– Oscar Wilde, writing as Dorian Gray, 1891.

The bitter English cold was no match for the warm look Patricia Preece gave Dorothy Hepworth. It was December 1935, and Hepworth's homemade Christmas toffee was boxed for gift-giving. Preece, the future Lady Stanley Spencer, was preparing to ingratiate herself with all the usual suspects: the benefactors who were keeping her art career afloat. The toffee was a holiday tradition – and *maybe this time*, Preece thought, *I'll fib and say I made it myself*.

That bit of subterfuge would have been fine with Hepworth if history is any indication. The two women were artists, housemates and closeted lovers. Hepworth, the better painter, was the more reticent of the two. She gladly allowed her paintings to be signed by her partner and exhibited as Preece originals.

During the years leading up to her marriage to Spencer, Preece – and Hepworth by proxy – received substantial support from the influential Bloomsbury circle. They had come to the attention of the group while they were both training at the Slade. Preece and Hepworth later spent four years studying in Paris at Roger Fry's urging, where they found an acceptance of lesbianism that was lacking in Britain.

This came at a time when women were finally moving beyond the nineteenth-century cubbyhole of portrait painting. The New English Art Club, Fitzroy Street Group and London Art Group were all useful catalysts. Female artists were increasingly being asked to participate in group and solo exhibitions.

The Vorticists allowed women members from the start, raising the profiles of Dorothy Shakespear, Helen Saunders and Jessica Dismorr. This was the polar opposite of the Camden Town Group, whose founder, Walter Sickert, wrote, 'the Camden Town Group is a male group, & women are not eligible. There are lots of 2 sex clubs, & several one sex clubs, & this is one of them.'[23]

In 1928, Roger Fry arranged a show for Preece at the edgy Warren Gallery at no. 39a Maddox Street in London. Gallery owner Dorothy Warren had been raised

in the arts – her aunt was Lady Ottoline Morrell and her godfather was the author Henry James. She opened her doors day or night to anyone interested in seeing her modern collections. Thanks to Fry, this included the best of Preece–Hepworth.

After Fry's death in 1934, Vanessa Bell arranged for Preece to paint Edith Smyth, the suffragist leader and composer, as a way of helping out financially. Bell offered the use of her own studio for the sitting, apparently unaware that she was recommending a phantom artist. Preece stalled and the commission fell through.

Two years later, Bell again stepped in. She convinced the Lefevre Gallery in Mayfair to give Preece a solo exhibition. Once again Preece dodged an awkward situation, claiming she was too ill to prepare for the opening. Even this was not enough to discourage Bell, who hung the pictures herself.

It speaks to Patricia Preece's talent for manipulation that the astute members of the Bloomsbury Group failed to sense something was wrong until one more exhibition and two more toffee holidays had passed. Even Augustus John was fooled; he declared Preece one of Britain's best living female painters, ranking her above his own sister, Gwen.

Preece was certainly not without talent, but her legacy is more as a seductress and a model than as an artist. Blonde, busty and ruthlessly ambitious, Preece would convince a naïve Stanley Spencer to divorce his first wife, Hilda Carline, and sign over his house. Immediately after their wedding in May 1937, and without consummating the marriage, Preece took Hepworth on the honeymoon, leaving Spencer to follow later. Spencer's appalling personal judgement would irreparably damage his family, even as he grew in stature as an artist.

Within months of the sham wedding, Spencer poured his mixed emotions into *Double Nude Portrait: The Artist And His Second Wife*. The canvas shows Preece as an annoyed vamp past her prime, oblivious to the husband who examines her like some kind of curious bug. The raw conflict depicted in his portraits of Preece and of first wife Hilda are a stark contrast to two themes in female portraiture at the time: emotional nuance and contemplation.

The idea of contemplation was a natural fit with modern psychology in the new century. Introspection and personal authenticity were of ultimate value. Female artists proved particularly adept at stripping down scenes to quiet moments. This was at a time when the phrase 'artist and model' continued to imply 'male artist and female model' – a stereotype ingrained by centuries of social thinking. Increasingly, however, women artists were exploring the nuanced lives of real-life women in domestic settings.

Hepworth, Preece and Spencer all used a model by the name of Sonia Redway, local to the village of Cookham where they lived. The stolid-looking Redway

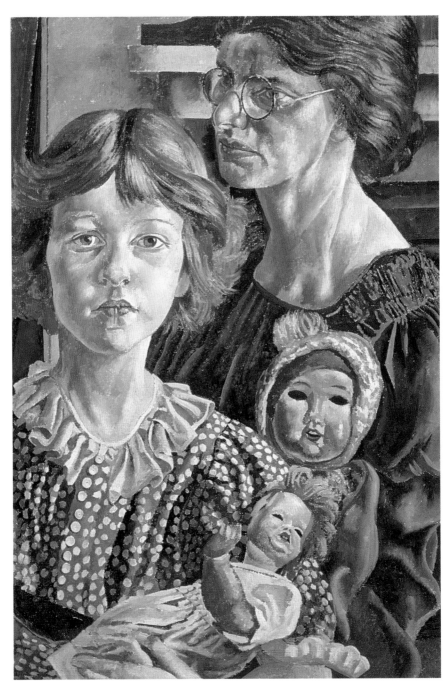

*Hilda, Unity and Dolls*: Stanley Spencer painted a grim family portrait the year Hilda sued for divorce (1937).

appears in numerous paintings reading, knitting, fixing her hair and striking contemplative poses. *Anna and Hairbrush*, attributed to Preece, uses a different model, likely also local. She seems to have been struck by a thought midway through her morning routine.

Preece herself, the antithesis of contemplation in her husband's portraits, appears calm at home with Hepworth. In *Self-portrait* she sprawls back in a chair, nude from the waist up, eyes half shut in thought. This picture, attributed to Preece, is most likely the work of Hepworth.

Other female artists of the time had a less contemplative bent. Hilda Fearon, for example, painted her models in a pretty, impressionist style that held genuine emotion at bay. Thérèse Lessore, third wife of Walter Sickert, painted with a kind of technical brevity that defied introspection. Mary Potter and, more broadly, Elinor Bellingham-Smith preferred still life arrangements and landscapes. The work of the Vorticists and Futurists was anything but pensive.

****

Female artists in Britain continued to incorporate small, true moments into their work through 1939, when war loomed again. Edna Clarke Hall often captured amateur models in daily routines. These included her children and their German governess, Carola Schmidt. Vanessa Bell turned to a variety of available sitters in Charleston and London, posing them in domestic settings. Hilda Carline, Stanley Spencer aside, was a very good artist in her own right. She often used female family members as subjects.

The extent of Carline's talent was never fully realised due to a bad marriage and poor health. Her successful early showings with the London Group, the New English Art Club and the Royal Academy took place before she married Spencer in 1925. After that, she had little time to paint until her divorce in 1937. Some poignant portraits of her mother and her children exist from that time, as well as a masterful painting of the family's maid, Elsie Munday. Carline was deeply unhappy for much of her adult life, and for her, contemplation may have been the enemy.

The polar opposite of Hilda Carline, temperamentally, was the muralist Mary Adshead. Adshead was a steadfast proponent of figurative art imbued with humour and wit. The most famous examples of this were the eleven murals she designed for the dining room walls of Lord Beaverbrook in 1928.

Beaverbrook was a business titan with a house in Newmarket, the epicentre of British horseracing. Adshead was commissioned to paint scenes depicting life at

Newmarket. She designed a concept called *An English Holiday* – it showed famous Lord Beaverbrook acquaintances on their way to meet their host at the racecourse.

The murals for *An English Holiday* included Winston Churchill on an elephant, the writer Arnold Bennett dallying with gypsies, and an elegant lady next to a punctured tyre. The model for the tyre scene was Lady Louise Mountbatten. She was prone to road mishaps and later, as Queen of Sweden, allegedly would carry a card printed with 'I am the Queen of Sweden', in case she was found unconscious in the street. Lord Beaverbrook, ever the political animal, got cold feet about the murals and returned them to Adshead. They were later displayed at the Peter Jones store in Sloane Square before being lost in a fire while in storage.

The sitters for Adshead's easel paintings included family members and friends, as well as traditional portrait subjects. Her 1935 *Portrait of Daphne Charlton* captures a fellow Slade artist in a moment of solitude. Under Adshead's brush, Charlton's pale silk top and cool skin tones make her seem untouchable, as if underwater.

Charlton went on to sit for a number of artists, including Stanley Spencer, with whom she had an affair after Preece walked out. One of Charlton's own paintings shows her lover glumly propped up with a pillow, an unhappy man in an unhappy bed of his own making.

Models were also important to the surrealist Eileen Agar, although not to the point of forcing a result. Agar used models in her Bramham Gardens studio, but was always open to last-minute adjustments.

When creating her sculpture *Angel of Anarchy*, Agar admitted that the bust started out as a portrait of the sitter, but 'sundry other persons and distractions' intervened. This was confirmed by a society reporter for *The Sketch*, who penned a humorous account of the exhibition 'Surrealist Objects and Poems' in 1937. After attending a midnight showing at the London Gallery, he wrote:

> *I felt mighty proud of myself for picking out the sitter for Eileen Agar's Angel of Anarchy, a really good bit of classical portraiture, with what we might call added interest in the shape of unnatural decorations and additions. When challenged, this gentleman admitted he was the original model for the head, but said that, since that time, other people had arrived in the studio and their characteristics had been added to it.[24]*

The original 1937 sculpture was lost, but the definitive version of *Angel of Anarchy,* with even more 'unnatural decorations', has survived.

*Portrait of Daphne Charlton*: Mary Adshead captured the calm of the interwar period (1935).

Thirty years before Agar envisioned *Angel of Anarchy*, two sisters in Glasgow were already distorting the human form. The highly imaginative work of Margaret and Frances Macdonald had its genesis in academia before the turn of the century. Their training with nude models served them well when they decided to reinterpret the human body.

The eerie, attenuated shapes the sisters produced disturbed some viewers, and their talent was underappreciated until the 1920s. Margaret was also over-shadowed by her husband, Charles Rennie Mackintosh, who was a giant in the

world of architecture. Mackintosh is known to have said that he had talent but his wife had genius.

While the Macdonald sisters were being largely overlooked, Laura Knight embarked on a career that would make her a household name in early twentieth century British art. Known as an eccentric, Knight was immensely popular, in part because she avoided modernist extremes. She was made a Dame in 1929 aged 52, and in 1936 was elected to full membership of the Royal Academy – the first woman to be so honoured since the Academy was founded in 1768.

As a girl, Knight was prohibited from attending life classes at Nottingham Art School due to her gender. In 1913, she used that experience as a reference point in one of her most-recognised works. *Self Portrait* shows Knight with her back to the viewer, while artist and model Ella Louise Naper commands both the dais and the canvas-within-a-canvas. By depicting herself painting a nude female, Knight was making it clear that she would proceed with her art on her own terms. It was a bold statement that some critics found vulgar.

Knight would go on to become a prolific portrait painter and a war artist. A favourite model was the elegant printmaker and designer Eileen Mayo. Many of Knight's portraits were of women who were stars of the theatre, the ballet, the opera or the arts. She painted the famous ballerina Lydia Lopokova in her dressing room, but she also sought out marginalised groups such as gypsies and circus performers and used amateur domestic models. The portrait *Susie and the Wash Basin* shows a Cornish girl keeping her thoughts to herself.

As Knight built her legacy, the artist Dod Procter was taking contemplative moments to a new level. Procter sometimes worked with nude female models, which was still unusual for a woman in the 1920s. Her big moment came in 1927, when her painting *Morning* was shown at the Summer Exhibition of the Royal Academy and was awarded Picture of the Year. The model dozing in the silvery dawn is Cissie Barnes, a 16-year-old fisherman's daughter. Barnes reportedly posed for *Morning* every day for five weeks.

Procter continued to refine her simple, almost sculptural style, influencing the London art scene while working in other parts of England. In *Lilian* [Gilbert], *The Tall Girl*, *The Pearl Necklace* and her self-portraits, Procter's subjects are so lost in thought that the viewer instinctively wants to speak in whispers. In *Portrait of a Lady with a Parrot*, even the parrot seems to be holding its tongue while its elderly owner pauses in contemplation.

\*\*\*\*

Despite the societal changes underway, many creative women – particularly female artists – still had their identities tied to the men in their lives. This was almost never to the woman's advantage, whether she was a wife, daughter, mother or sister to the man in question. Thus was the case with the John siblings.

It takes some effort to imagine siblings more different than Gwendolen and Augustus John. Where Augustus was looming, loud, drunk and ribald, his older sister was often seen as a shadowy background figure living in France – and yet she would become one of the most respected painters of the early twentieth century.

More than a decade after Gwen John's death in 1939, the author Nicolette Devas would visit the Manor House of Hugo and Reine Pitman in Odstock, Salisbury, where Augustus John's masterpiece *Lyric Fantasy* was displayed in a room upstairs, and write:

> *The light from four tall windows on either side, suffuses it with a soft, bright radiance without a glare ... between the windows, which act like a colonnade ... there are paintings by Gwen John – small, serene canvases, chaste, muted, withdrawn in convent peace. These paintings are such an antithesis to those of Augustus that it is impossible to imagine how brother and sister got on when they shared digs while studying at the Slade.*[25]

In truth, the siblings didn't get on. Augustus had married Ida Nettleship, Gwen's friend from the Slade, in 1901, complicating the siblings' relationship. Things got worse when another school-friend, Dorelia McNeill, caught Augustus's eye just two years into his marriage. Shortly after Gwen John exhibited with her brother at the Carfax Gallery in 1903, she and Dorelia left England for a walking adventure in France – a country Gwen had grown to admire while studying at James McNeil Whistler's Paris academy five years earlier.

Although Gwen John would live in France for more than half her life, she never found a true affinity with modernism. Her figurative portraits are deeply intimate and filled with emotions kept in check. She initially supported herself and her art by working as an artists' model, and was a favourite of expatriate English female artists in Paris.

John first posed for the French sculptor Auguste Rodin in 1904; she would subjugate her talent to his during a decade as his muse. She did continue to paint sporadically, and returned to it with more energy after her relationship with Rodin ended. Converting to Catholicism, she longed for what she called a 'more interior life'.

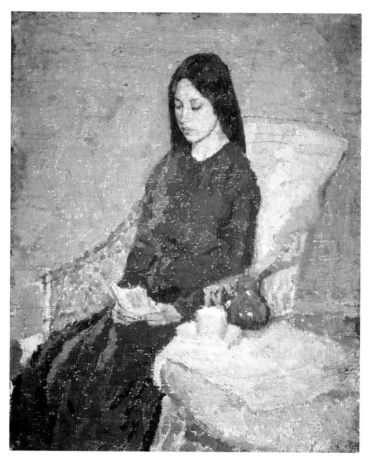

*The Convalescent*: Gwen John painted this model dozens of times in some of her finest contemplative works.

John Quinn, an American collector, bought many of Gwen John's works from 1911 to 1924. His patronage meant that she no longer had to make a living as a model. Following Quinn's unexpected death, John held her only solo exhibition at the Chenil Gallery in London in 1926 – it was a bittersweet success because it was born out of a need for money.

John painted women almost exclusively. The identities of most of her models are unknown; even the dark-haired woman who appears in *The Convalescent* and dozens of the artist's other paintings is a mystery. Instead, the titles state the obvious and are therefore inconsequential, perhaps deliberately so: *Girl with Cat, The Precious Book, Young Woman with Black Cat, Girl with a Blue Scarf, Girl with Bare Shoulders, The Student,* and so forth.

The few named sitters are typically women in John's circle. *Chloë Boughton-Leigh* and *Dorelia in a Black Dress* are both friends from the Slade days. The works show that if relationships were important to John, she would take pains to maintain them, essentially choosing quality over quantity. Although John's friend, Dorelia McNeill, would become Augustus's mistress while he was married to Nettleship, the three women maintained a deep love for each other.

Gwen John also had an affinity for children, sketching orphans at the Convent at Meudon near Paris, where she became friendly with the Catholic nuns after her conversion. Other young sitters were simply children at hand; the drawing of the girl called *Annabella* is actually Marie Hamonet, a local resident of the Brittany coast where John went to recover from Rodin's death.

Gwen John's palette remained remarkably consistent over time. Image after image is infused with serene, nuanced colours and soft light. The subjects look down, to the side, out a window – anywhere to avoid confrontation. Few of the models make eye contact with the viewer; even the cats turn their heads.

The confrontation-loving Augustus, upon being shown his sister's paintings after her death, declared that history would remember him as Gwen John's brother. He expanded on that sentiment in an essay for *Burlington Magazine* in 1943: 'Few on meeting this retiring person in black, with her tiny hands and feet, a soft, almost inaudible voice, and delicate, Pembrokeshire accept [sic], would have guessed that here was the greatest woman artist of her age, or, as I think, of any other.'[26]

Gwen John seems to have stopped working as an artist about six years before her death aged 63. She collapsed in a Dieppe street on a trip to the sea and was presumed a pauper because she had no luggage. That turned out to be a conscious choice on her part. In her will, which she carried with her, she left almost everything to her nephew Edwin with a provision for the care of her beloved cats.

\*\*\*\*

It must have been a daily challenge for these female artists to balance their personal and artistic lives given society's expectations of them as women. Hilda Carline forewent a promising career to nurture the genius of Stanley Spencer until Preece stepped in between them. Laura Knight had no children with her husband Harold, who was also an artist. Had she been a mother, she might have had to make some difficult choices.

Even after years of artistic production, the supremely talented Laura Knight and Dod Procter failed to escape being defined by the men in their lives. How they must have sighed in 1929 when reading this in *The Sphere:*

> *A little woman with Spanish side-whiskers and a rather serious face – Mrs Dod Procter. She started painting when she was six, quite serious painting, too and she was encouraged to continue, so that when she was twenty-five she had become one of the leaders of the little Cornish colony of artists that makes Newlyn its headquarters. When she married Mr Ernest Procter they formed an artistic partnership which is only paralleled by the case of Mr Harold and Mrs Laura Knight.*[27]

That was written in the year Laura Knight was made a Dame, and two years after Dod Procter was fêted for having painted Picture of the Year. Only the most unconventional female artists of time – Vanessa Bell and Nina Hamnett, for example – seem to have lived lives so far beyond the norm that society threw expectations of male influence to the wind.

*Chapter 8*

# The Club Scene

'One of the first effects of the war was to raise the price of many valuable medicines ... Cocaine rose from a little over 4s. to 10s. an ounce.'
    – *The Globe*, lamenting the wartime price of fine chemicals, 1914.

A diva, a monkey and a music-hall Botticelli walk into a bar ... thus could be written the story of the club scene in London in one of its most experimental years, 1913.

The Botticelli was Lilian Shelley, a tiny, raven-haired model and chanteuse at the Cave of the Golden Calf. At 10.30 every evening, Shelley stood in a cul-de-sac with the club at her back and thought *I could do this in my sleep*. Behind her, the strains of a tango filtered up from the basement. In front of her lay a familiar path: down Heddon Street, right onto Regent Street, and then almost two miles to the Strand. A wave to the doorman at the Savoy hotel, and then upstairs to feed Madame Strindberg's monkey. *The things I do for that ridiculous woman!*

No one would dispute that Shelley's employer, Frida Uhl Strindberg, was a diva. It took that kind of temperament to divorce her Swedish playwright husband, August Strindberg, threaten her lover with a gun, move from Vienna to London, and open a scandalous nightclub in Mayfair. The draper's basement she leased at nos. 3-9 Heddon Street in 1912 housed both the Cave of the Golden Calf and the Cabaret Theatre Club, the front for her nightclub memberships.

Strindberg and her collaborators were not shy. The *Aims and Programme of the Cabaret Theatre Club* acknowledged that the Golden Calf borrowed from the German cabaret model, while staking out a place on English soil: 'We do not want to Continentalise, we only want to do away, to some degree, with the distinction that the word 'Continental' implies, and with the necessity of crossing the Channel to laugh freely, and to sit up after nursery hours.'[28]

The avant-garde of London were easily tempted by the hedonistic Golden Calf. The very look of the place invited pagan thoughts. Camden Group devotee Eric Gill designed the phallic bas-relief symbol of the calf at the entrance and the huge, golden statue in the hall below. Wyndham Lewis transformed the stairwell with explosive Vorticist paintings that propelled visitors downstairs with a fury.

Spencer Gore and Charles Ginner painted exotic jungle murals. Jacob Epstein's brightly plastered pillars needed only a little absinthe to come to life.

The Cave of the Golden Calf opened on 26 June 1912. It had been a rare sunny afternoon, and the weather was perfect for an evening out. Strindberg's talent for persuasion was paying off. One by one, the cultural elite and the up-and-comers descended the stairs. They took their seats in a low-ceilinged room the likes of which London had never seen before. Some would still be there at dawn.

The Golden Calf was not Frida Strindberg's first foray into business. She was intensely interested in commercial enterprise and the arts. Had she been born at a later time, she would have had access to the training necessary to support both passions. As it was, the Golden Calf survived only two years. Nevertheless, it was a watershed in the evolution of London nightclubs, in part because of Strindberg's incorporation of modern art as decor.

A number of factors contributed to the club's bankruptcy in February 1914. Strindberg cultivated the excuse that she had been overly generous in her support of the arts, but she may not have been above-board with the records. War was closing in, and the Golden Calf had become the target of repeated police raids. London police were dealing with an increase in public disturbances from the women's suffrage movement that year, and they had little patience with Strindberg's disrespect for licensing hours.

To make matters worse, boring businessmen and silly toffs began to filter into the club, driving away luminaries such as Ezra Pound. One of the nightclub's most famous patrons, Augustus John, joined a friend in founding the Crab Tree Club in Greek Street. John was known to make women faint when he walked into a room – why not capitalise at his own establishment? Where the artist went, models followed.

Models didn't kill off the Cave of the Golden Calf, but they didn't help. Strindberg's original idea had merit: artists' models attracted artists, artists attracted writers, and artists and writers got press. She hired the most alluring and talented model-performers she could find for the cabarets that the Golden Calf staged on most evenings.

The problems emerged as the night wore on and the models began to compete with each other. There was a distinct lack of decorum at the club in the wee hours. In 1914, *The Times* reported the sad case of Mr John Bouch Hissey, a hapless petitioner for divorce. Mr Hissey had pinned up Oscar Wilde's poem *The Harlot's House* on a wall of his own home to make a point to his wife. Mrs Hissey had been widely reported in the London papers as being like 'one of the women of the Cave of the Golden Calf'. This was not the kind of attention Strindberg wanted.

London police had little patience with recalcitrant nightclub owners in 1914; they were busy with suffrage protests like this one at Buckingham Palace.

Despite their late-night antics, or perhaps because of them, the identities of most of the artists' models at the Golden Calf are relegated to the shadows of that hedonist basement. There were a few whose performances attracted followings to the club. Lilian Shelley, the Strindberg monkey-feeder, was the largest draw in 1913.

Shelley was a popular music-hall performer who would trill 'My Little Popsy-Wopsy' before trekking to the Savoy each night. The associations she made at the Golden Calf undoubtedly furthered her career, as she would go on to pose for Augustus John, Jacob Epstein and others.

Another model that performed at the club was Dolores, a Londoner who was relatively unknown in her native city. Born Norine Schofield, Dolores began using her stage name while living in Paris. There she made the acquaintance of Sarah Bernhardt and Anna Pavlova, strutted in the Folies Bergère, and sang in opera. She dressed solely in black to highlight her luminous skin.

Dolores had returned to England just as the cabaret frenzy went into full swing. She embarked on a series of failed marriages and was unable to replicate her Paris showgirl success. Like Shelley, she saw an opportunity to raise her profile by performing at nightclubs, and she favoured venues habituated by artists to further her modelling career.

The final nail in the coffin of the Cave of the Golden Calf came on 11 January 1914 in the form of a raid by Customs officers. Three months later Strindberg and club secretary George Edward Shaw were convicted of selling liquor and tobacco without a license. The prosecution noted the high price being charged for drinks after closing hours (the raid was at 4.10 in the morning), implying embezzlement. They pointed to a bottle of champagne priced at twenty-five shillings and whiskey at one and two shillings a glass, versus Shaw's salary of £3 weekly.

Strindberg was fined £160 or two months' imprisonment, and Shaw £40 or one month imprisonment. These were heavy penalties. By the time the ruling was issued by the court, it was moot for the club. The Cave of the Golden Calf had closed its doors for good.

****

Following the lead of the Golden Calf, a number of after-hours clubs debuted in London. Jazz was in full swing by the interwar period. The 43 was a late-night club on Gerrard Street run by the notorious Irish import Kate Meyrick. Meyrick was involved in several nightclubs, assisted by four of her eight adult children. In photographs of the Meyrick family, one of the daughters repeatedly hides her face in her fur coat.

Artists had their own preferences when it came to the club scene – the Ham-Bone Club in Soho was a particularly popular spot. It had a restaurant overlooking the dance floor below, and sported an oak beam with the inscription *Hush! There is no need to be coarse.* The club opened in 1922 – an occasion marked by the display of C.R.W. Nevinson's painting *Zillah, of the Hambone*, a striking portrait of London stage actress Zillah Carter. Much later Nevinson would add the date 1935 to the painting, perhaps to mask the fact that it had remained unsold for over a decade. The Ham-Bone Club lasted a dozen years, and it is a measure of its notoriety that its demise merited a mention in the Brisbane, Australia, *Courier-Mail*.

These clubs, and dozens like them, owed a lot to Frida Strindberg's vision. They defined the flapper era. A decade earlier however, Strindberg's chief competition for the arts clientele she craved came in three shapes: Murray's Cabaret on Beak Street, the Restaurant de la Tour Eiffel on Percy Street, and the Café Royal on Regent Street.

The 1913 opening of Murray's Night Club trailed the Cave of the Golden Calf by just over a year and capitalised on the cabaret boom popularised by Strindberg. Murray's staged elaborate cabaret productions that attracted

young models eager for exposure. Its proprietors rode the tango craze that was sweeping both sides of the Atlantic ('an obsession' declared *The Sphere*), and the club became known as a showplace for the newest dance steps.

The owners of Murray's Night Club were Jack May and Ernest Cordell. Cordell was an Englishman; May was an enigma – an American from Chicago, and a rogue, genius, criminal, pioneer or vulgarian, depending on whom you asked. One thing is certain: he was a natural-born talent at the club business.

Murray's received its share of press coverage, both positive and negative. 'Six Lovely Peaches Grew Upon a Tree', proclaimed a caption in *The Bystander*, under a photo of Murray's cabaret girls holding hands, and 'A Bevy of Beauty in Beak Street'. But the peaches may have fallen into Jack May's basket at a price. There was talk that the proprietor lured young women into compromising situations, although this remained largely speculative.

The police definitely had an eye on May. But it is questionable how many tips from the public they acted on, versus bribes they took. Murray's wasn't alone in this – by late 1914, with war a reality, club owners found that it was less expensive to pay the police to look the other way when it came to things like licensing hours under the new Defence of the Realm Act.

One tipster who didn't mince words was Captain Ernest Schiff, a dubious character himself. Schiff wrote to police accusing May of enticing girls to smoke opium, ending with, 'He is an American and does a good deal of harm.' It is unclear whether Schiff was inferring that opium or Americanism was May's worst offence, but in any case nothing came of it. May's contacts in high places served him well and Schiff himself ran afoul of the law soon afterward.

Compared to Murray's, the Restaurant de la Tour Eiffel was a much safer haven for models. The Eiffel Tower, as it was familiarly called, was located at no. 1 Percy Street just off Tottenham Court Road. Its chef and owner was Rudolph Stulik, an Austrian, and like so many other venues, the Eiffel Tower owed its metamorphosis to Augustus John.

John stumbled across Stulik in the 1890s and decreed that his restaurant would be an artists' rendezvous. It had a French menu that featured the designs of Wyndham Lewis and art-themed dining rooms. It was also more intimate and relaxed than the nightclubs, and free of wealthy patronage. An artist who needed a meal relied on personal finances or Stulik's generosity. Lytton Strachey, Jacob Epstein, Nina Hamnett, Marie Beerbohm and others would often end their late nights there.

The Eiffel Tower served as a kind of clubhouse for the Corrupt Coterie, a dubious group founded by the models Iris Tree and Nancy Cunard. The two

Augustus John was an eclectic genius who moved with ease among all classes.

women shared a flat in Fitzrovia and would organise meetings in an upstairs room at the restaurant. The Coterie was composed of well-to-do, well-educated, young people, primarily aristocrats, who were interested in modern ideas. They also engaged in questionable personal behaviour.

Lady Diana Manners (later Cooper) penned this confession about her Corrupt Coterie days with a sense of regret: 'Our pride was to be unafraid of words, unshocked by drink and unashamed of 'decadence' and gambling – Unlike-Other-People, I'm afraid.'[29] It was an attitude that would come to define the desperate frivolity of the flapper social set. The First World War decimated the Coterie's ranks, and the remnants became known as the Bright Young People.

Unsurprisingly, a number of Coterie members were directly involved in the arts. Marie Beerbohm was part of the large Beerbohm family of literary and stage fame, as was Iris Tree – both had experience as artists' models. Nina Hamnett – a good friend of Marie's – became acquainted with Marie's sister Agnes and all three served as models for Walter Sickert, whose studio was directly across the street from Hamnett's flat.

Sickert once caught a bleary-eyed Marie Beerbohm bringing Hamnett a half bottle of champagne to cure her hangover. The painter admonished Beerbohm in the street on the disgrace of young girls drinking in the morning – and promptly confiscated the bottle. A lecture from Sickert was a rare thing indeed; he thought nothing of serving Hamnett cigars with breakfast, or of posing a life-size dummy in a compromising position to shock visitors.

****

*Absinthe, anyone?* From the moment the Café Royal opened in 1865, it became known for its clientele and for the intoxicating, emerald green drizzle from its absinthe fountain. Its reputation was a two-sided coin.

Absinthe was a creative stimulus for Picasso, Van Gogh, Degas and others who produced major works under its influence. In the last half of the nineteenth century, the drink was blamed for widespread moral decay in Europe and North America. It was believed to be highly addictive and produce an effect similar to cocaine or opium. It was also cheaper than wine at the time, which contributed to its appeal.

In 1868, the *American Journal of Pharmacy* warned of absinthe, 'You probably imagine that you are going in the direction of the infinite, whereas you are simply drifting into the incoherent.' The hysteria would reach a fever pitch in the first years of the new century, but absinthe was never banned in England. The Café Royal continued to thrive, bolstered by the legendary exploits of its patrons.

The relationship between the Café Royal and its most famous patron, Oscar Wilde, was tinged bright green at every turn. One story has Wilde being guided out of the Café Royal's bar area at closing time and hallucinating that stems of tulips were brushing his pant legs. In reality, a green-aproned waiter was ushering Wilde past red velvet chairs.

Following Oscar Wilde's footsteps into the Café Royal was a parade of famous patrons. Augustus John, Walter Sickert, Aubrey Beardsley, Noel Coward, D.H. Lawrence, Virginia Woolf and the Duke of York barely scratch the surface. Wilde didn't live to see the Café Royal at the height of its twentieth century fame (he died in 1900), but he may well have been thinking of his favourite haunt when he wrote that there are three things the English public never forgives: youth, power and enthusiasm.

What made the Café Royal truly unique in the early twentieth century was the collision between high society, high commerce and bohemia. The atmosphere was an intoxicating mix of philosophers, socialists, immigrants, politicians,

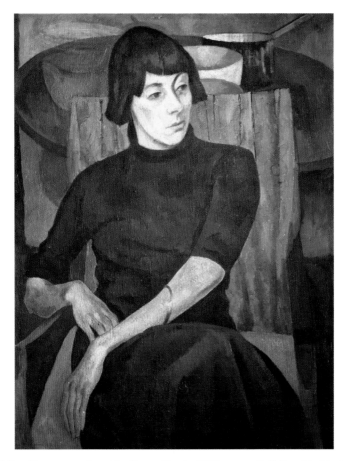

Nina Hamnett, painted by Roger Fry in 1917, was a Café Royal habitué.

business titans, royalty, towering creative talents and unapologetic eccentrics. It was see-and-be-seen, and the models came in flocks.

Hamnett wrote about the lengths she and a friend would go to every evening to be seen, nursing a fourpenny coffee for hours before walking home to Camden Town because they lacked bus fare. The painter Henry Lamb met his wife, Nina Forrest, in the Café Royal, renamed her Euphemia and encouraged her over-the-top affairs as a model. Bloomsbury's David Garnett wrote that in the Café Royal he had found a world where respectability was a dubious virtue.

The tête-à-têtes of the Café Royal were the subject of some excellent paintings, most notably by William Orpen, Charles Ginner, Harold Gilman and Doris Zinkeisen. There has been some speculation that the man speaking with a dishevelled Augustus John in Orpen's painting, *The Café Royal, London*, is meant

to symbolise the coming together of bohemia and the business class. While that was true of the Regent Street establishment, the dapper man in Orpen's painting is more properly identified as the artist James Pryde, a friend of John.

When the Café Royal began to close early for wartime licensing hours in 1914, the artists continued their evenings at the more accommodating Eiffel Tower. Hamnett recalled the chanteuse Lilian Shelley coming to the restaurant as a guest of Horace Cole, a famous prankster. By that time, Shelley was established as both a performer and an artists' model:

'She was the craziest and most generous creature in the world. If she had a necklace or a bracelet on and anyone said that they liked it, she would say, *Have it!*'[30] When Orpen painted his interior scene of the Café Royal in 1912, he sat Shelley, whom Augustus John called Bill, in the rear centre frame.

Of the many other clubs that opened and closed from 1913 to 1930, the Cave of Harmony has a unique history. Its name connects nineteenth-century Victorian rakes to twentieth-century nonconformists.

The Cave of Harmony was actually two different clubs. The first operated in a cellar in Gower Street in the mid-1800s. It became notorious for indecencies and a fair share of ruffians; then it got an upgrade of sorts in the last half of the century. Its clientele toward the end had a strong whiff of privilege, including Members of Parliament and young bucks out for a good time. Eventually the club and the name disappeared from the London scene, to be resurrected in the 1920s.

The second Cave of Harmony was the purview of the bohemian actress Elsa Lanchester and her partner, Harold Scott. Lanchester (née Elizabeth Sullivan) came from Socialist stock and grew up in an environment that encouraged a free spirit.

Lanchester and Scott opened the Cave of Harmony nightclub in 1924 at no. 107 Charlotte Street, Fitzrovia. Soon the artists and models came, and with them Evelyn Waugh, H.G. Wells, Aldous Huxley and others. The late hours and loud music caused problems with the neighbours, and everyone was happier when the Cave of Harmony relocated to the Seven Dials area of Covent Garden. Lanchester closed the club in late 1928.

By and large, the club made good on the claim in its tenancy application: it was 'for theatrical and artistic people who would present no trouble'. The divide between unconventional mores and proper English behaviour was narrowing, and Lanchester epitomised that bridge.

As one journalist was inspired to pen in genuine admiration of her audacity: 'I may be fast, I may be loose, I may be easy to seduce. I may not be particular to keep the perpendicular. But all my horizontal friends are Princes, Peers and Reverends. When Tom or Dick or Bertie call, you'll find me strictly vertical!'[31]

## Chapter 9

# Wives and Mistresses

'I am going to climb an apple tree – and never have another baby.'
– Ida (Nettleship) John, on giving birth to the third of five children
with Augustus John, 1904.

Walter Sickert did his best to keep from laughing out loud. It was June 1904 and the artist had just returned to his house in Dieppe, France, from Italy. In his hand was a month-old newspaper. Sickert turned to his mistress and model of half a decade as she sat at the kitchen table and teased, 'If you shoot me, Augustine, you better hit your mark or no one will know your name!'

Augustine Villain, the stunning fish-stall keeper known as *La Belle Rousse*, was not amused as Sickert read the police report:

> *Two artists' models in Paris, who had quarrelled over a gentleman friend, met recently in the Boulevard St Illmain and commenced firing at each other with revolvers. Their shooting, however, was so bad that they missed each other entirely, but seriously wounded four people who were at a distance. Frightened at the damage they had done, the rivals fainted, and in an insensible condition were carried to the office of the police.[32]*

Sickert was no stranger to the *femme fatale*. Before sharing a house in Dieppe with the divorced Villain and her children for several years, the artist had lived for a time in Venice, where his favourite models were the prostitutes La Giuseppina and Carolina dell'Acqua. They sat cheerfully 'to amuse me with smutty talk while posing like angels,' he wrote to fellow artist Jacques-Émile Blanche.

Not long after that letter was written, Sickert returned to architectural landscape painting in Dieppe. But within three years he was back in London working on the sensationalist paintings that would become known as the *Camden Town Murder* series. Sickert despised the idealised portrayal of female nudes; instead he posed fleshy, recumbent models in positions of fatigue or disenchantment. He seemed to prefer anonymity in his models, often reducing the features to smudges of light and dark.

The French artist Edgar Degas had had an enduring influence on Sickert's use of models. Sickert met Degas when he was 23, and Degas became his mentor and friend. The relationship would stimulate Sickert's interest in the portrayal of low-lit, seedy scenes of music halls and circuses. The influence of Degas crept into some of Sickert's café scenes as well, and later into his depictions of prostitutes and domestic poverty.

When Degas's painting *Dans un Café* debuted in London in 1893 with the title *L'Absinthe*, Sickert defended it against widespread moral outrage. The painting, he argued, should be judged on artistic merit and not as a comment on the evils of absinthe. The café in the painting is La Nouvelle Athènes in the Place Pigalle, the models' market and meeting place for bohemians in turn-of-the-century Paris. The inclusion of this locale was a deliberate choice by Degas; the models were actually painted in his studio.

*L'Absinthe* took a terrible toll on its models. The sitter for the female figure was Ellen Andrée, a French actress and model who also posed for Manet and Renoir. The male sitter was French painter and printmaker Marcellin Desboutin. After *L'Absinthe* debuted, both models were tarred by the assumption that they were drunkards. Degas, one of the world's worst self-promoters, dismissed all the hubbub by sneering, 'Art critic! Is that a profession?' He did, however, issue a statement saying that the models were not alcoholics.

Sickert, by contrast, was the consummate self-promoter. He was also a serial husband, a serial adulterer and an opinionated man who spoke and wrote his mind. Once, in Dieppe, he looked at the work of a young Paul Gauguin and suggested Gauguin stick to selling insurance.

Sickert's evocative portraits of unknown and well-known female sitters are a testament to his versatility as an artist. His technique seems to defy the weight of his brushstrokes in capturing even the most delicate features. Portraits such as the mysterious *Mrs Barrett* come across as acts of resistance against what he called the wriggle-and-chiffon school of portraiture.

As Sickert well knew, the relationship between artist and model can be a complicated one, made more so when the model is a mistress or a wife. His sitters in London included his mistresses Wendela Boreel, Nina Hamnett and Agnes Beerbohm, and his three wives – Ellen Cobden, Christine Angus and Therese Lessore – as well as prostitutes, servants and aristocrats.

In 1906, in postcards sent to yet another mistress, Sickert identifies two of his models as the Belgian sisters Jeanne and Hélène Daurmont from Soho, and calls Mrs Barrett 'a London dressmaker'. These sitters bridge the gap between the artist's personal relationships with well-to-do women and the everyday people

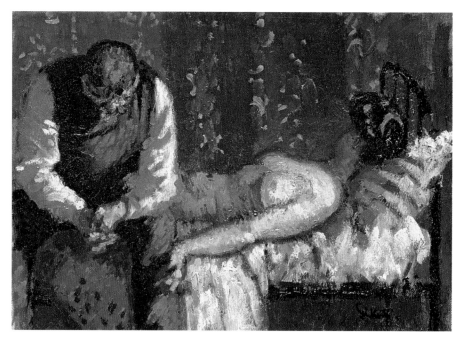

Murdered or sleeping? Walter Sickert gave this painting two different titles to keep the public guessing.

he gravitated toward as models. In his depiction of *The Miner*, an emotional wife kisses her coal-streaked husband in absolute anonymity, which is what the artist preferred.

Sickert's studio was a moving target in London. He frequently rented rundown rooms as temporary studio space if he liked the play of light and shadow. One of his most memorable models, a London teenager and occasional chorus girl named Emily Powell, was the daughter of his landlady at no. 26 Red Lion Square where he had a studio. Sickert called his model 'Chicken'.

Trained by Whistler to paint from nature, Sickert would begin using sketches as source material for his paintings as he aged. By 1912 he was painting sparingly from photographs while cautioning others that only artists who could do without photographs should use them. By 1929 he had fully embraced the camera as a tool and was painting under his middle name, Richard. This was several years after suffering what is generally thought to have been a stroke.

Sickert was too old to serve in the First World War, but he would worry daily about the fate of his beloved Dieppe. As with Bloomsbury's Charleston Farmhouse and the grounds at Garsington Manor, Dieppe was a model in its

own right. Venice, Paris, Rome, Sicily and Madrid lured English artists with a breathless sophistication, but Dieppe in Normandy was the golden muse.

****

Dieppe was a fashionable French resort town that held great appeal for artists and writers in the first decades of the twentieth century. Sickert met Spencer Gore there in 1904; it was at Gore's urging that Sickert returned to London to become part of the English modernist movement. The two men continued their friendship at Fitzroy Street and toasted Gore's jungle scenes at the Cave of the Golden Calf in Heddon Street in 1912.

From the late nineteenth century, to the mid-twentieth century, many of the world's greatest talents continued to seek out Dieppe as their muse. These included Alexander Calder, Georges Braque, Eugene Delacroix, Edgar Degas, Claude Monet, Camille Pissarro, Auguste Renoir, Paul Gauguin and Felix Vallotton. The British were well represented, with Sickert, J.M.W. Turner, Aubrey Beardsley, Oscar Wilde, William Orpen, Max Beerbohm and Ben Nicholson leading the way.

Dieppe took on a legendary status as the stories about it mounted. Wyndham Lewis sat up all night in a kitchen in Dieppe killing dozens of bugs with a hammer. Vita Sackville-West stayed near Dieppe with her lover, Virginia Woolf. Gwen John fell ill and died there. Picasso visited Georges Braque at nearby Varengeville-sur-Mer and spoke of the light on the Dieppe cliffs as if it were his favourite mistress.

And Augustus John? His tangled life of wives, mistresses, models and flings would stretch from the cliffs of Normandy to the streets of London, to the *ateliers* of Paris and the commune at Alderney Manor in Dorset.

Eighty kilometres west of Dieppe, the town of Vaucottes sat tucked away on terraces above the cliffs. It was at Vaucottes that 21-year-old Augustus John first stayed with his friends, William and Alice Rothenstein, in 1899. Joining them were the artists Charles Conder and William Orpen.

William Rothenstein was a man who married his muse. His actress wife posed for many of her husband's interiors, as well as some of his portraits. One can only imagine what this happy couple thought of their friend Augustus, whose sexual shenanigans were in full roar by the time he got to Normandy. Rothenstein apparently had no misgivings; he seized the opportunity of Vaucottes to pose his wife Alice and his friend Augustus together for *The Doll's House*, creating what would become one of his most famous paintings.

With William Rothenstein happily married in Normandy and Augustus John happily single, what of Conder and Orpen? They were something of a morality tale. Conder was a troubled man and a decent artist. Reckless and fun-loving, he was free with his sexual favours. He married late for financial security and died eight years later of syphilis contracted in his youth.

Orpen married Alice Rothenstein's sister Grace, had three children, and was miserable but never divorced. Instead, he had a serious affair with a wealthy American, Evelyn St George. Their relationship would produce his fourth child, Vivien, and some of his finest paintings. These included annual portraits of St George's older daughter, Gardenia – the pretext the artist and his mistress used for spending time together. Later, Orpen would live for some years with Yvonne Aubicq, a young Red Cross nurse he met in 1917. She ended up marrying his chauffeur.

Orpen frequently used his mistresses, and occasionally his wife, as models. He also projected his own sexual bonhomie on others. He once wrote to a favourite Irish model, Beatrice Elvery (Lady Glenavy), to enquire about his friend, the art dealer William Sinclair: 'How is Zink? – and the French maid? – and the model? All news of that great champion of sex gratefully received.'[33]

Despite taking very different approaches to life, the four men – Rothenstein, John, Conder and Orpen – would continue to visit Normandy for inspiration, and John, the most outrageous of the quartet, would embark on a truly herculean experiment of wives and mistresses. Whereas artists such as Walter Sickert often hid the identity of their mistress-models, Augustus John was more akin to Picasso. He publicly acknowledged his muses in his life and art.

****

Ida Nettleship was just 24 years old in 1901, the year she married Augustus John. A Slade student from the age of 15, she met her future husband through her classmates Gwen John and Dorelia (Dorothy) McNeill. McNeill would become John's most famous muse.

Much has been written about the complicated relationships of Augustus, Ida and Dorelia. McNeill lived with the couple for a while, with the first of her four children fathered by John. The marriage itself lasted just six years – Ida John died of puerperal fever in 1907 following the birth of their fifth son. After her death, McNeill would grow in importance to the artist as both his muse and his common-law wife.

The women and their children frequently served as models for John, as did his other mistresses. One mistress that was outside the immediate household, but very important to him, was the charismatic Alexandra (Alick) Schepeler. Schepeler was working as a secretary for the *Illustrated London News* when she met the artist, who admitted to becoming obsessed with the Russian-born beauty. For a while they became inseparable.

Ida John was a prolific letter writer who found solace in admitting her isolation. Clearly, it was stressful for her to care for a large family while her husband was off to Normandy or Paris with a model in tow. Taking her letters at face value, one has to wonder whether she might have foregone children completely in a different age. She wrote to Augustus of Alick, 'I often dream of you & the Schep. Such ridiculous dreams. Last night you were teaching her French in the little dining room while I kept passing through to David who had toothache and putting stuff on his tooth.'[34]

And even more directly to McNeill in 1905: 'You are the one outside who calls the man to *apparent* freedom & wild rocks & wind & air – & I am the one inside who says come to dinner & whom to live with is *apparent* slavery.'[35] And yet, even here, there is too much intelligence in her choice of words to dismiss her as a victim.

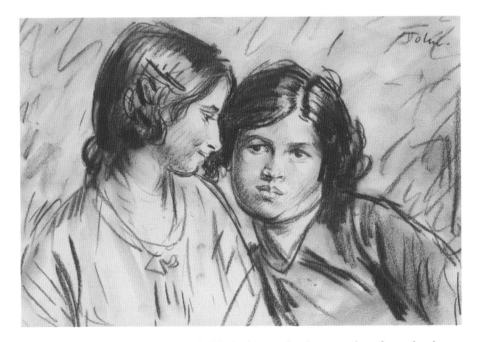

Dorelia McNeill (left) and Ida Nettleship had a genuine but wary love for each other as Augustus John's mistress and wife.

Despite Ida John's desire to make her husband happy at her own cost, it is questionable how long the marriage would have lasted for this exhausted young woman had she not died so young. As a model, however, the connection between husband and wife was palpable. Her complex feelings for McNeill are equally clear in the dual portraits created by the man who bound these two women together.

Augustus John was profoundly affected by his wife's death. McNeill stepped in and ended the affair with Alick Schepeler, and in August 1911, John and McNeill moved their blended brood to Alderney Manor. They would remain there for almost sixteen years seeking a more carefree life, hosting artists and hoboes and mistresses while John made forays to London and Paris. It was at Alderney that the child Nicolette would peer through the rhododendrons at Lady Ottoline Morrell and think she was a witch.

In 1927 Augustus John moved his family to Fryern Court in Fordingbridge. The household once again became a magnet for bohemians and the creative coterie of London. Henry Lamb came to visit, and McNeill, a long-time friend and sometimes model for Lamb, reportedly had an affair with him at Augustus's urging.

In her book, *Two Flamboyant Fathers*, Nicolette Devas provides a record of what may be the only time a female ran away from Augustus John. Visiting Fryern Court aged 15 or so, she saw the artist she thought of as a father figure watching her during an evening of dancing. When he broke his silence it was to tell her that he would draw her 'interesting lines' in the morning. 'This meant in the nude,' Devas wrote.

*The others never minded, he drew them often; sitting for Augustus was just another job, like making the beds or washing up. I hardly slept all night and got up at seven in the morning to walk the two miles into Fordingbridge and catch the first bus home. I was never asked again.*[36]

\*\*\*\*

Among the many partners to genius were the artists Hilda Carline and Dora Carrington. Carline remained a muse to Stanley Spencer both during and after their marriage. At various times he was in love with her, bored with her, disrespected her, wronged her terribly and begged forgiveness – but he always needed her as a model. The fact that she continued to sit for him despite her obvious annoyance speaks to her admiration for the talent, rather than the man.

Carrington, the conflicted painter linked to the Bloomsbury set, charmed the artists C.R.W. Nevinson, Paul Nash and Mark Gertler, who painted a well-known portrait of her. Gertler reportedly sent Carrington a letter listing five reasons why she should marry him, starting with: 'I am a very promising artist – one who is likely to make a lot of money.'

Carrington herself was a promising painter who lacked the confidence to exhibit. She painted almost as a hobby, dabbled in a few affairs and married once (not Gertler), but was at her most passionate with the American socialite Henrietta Bingham. Bingham modelled for Carrington's *Reclining Nude with Dove in a Mountainous Landscape* at the height of their affair in 1924. That relationship led the model Iris Tree to comment that Carrington's messy love life was like a tin of mixed biscuits.

Carrington came to a sorry end after her companion, the writer Lytton Strachey, died of cancer in the winter of 1932. Strachey, a homosexual, was Carrington's long-time platonic love, mentor and kindred spirit. She kept him comfortable and well fed. He taught her French and Shakespeare. If she was not exactly his muse, she was much more than an acolyte – irreplaceable in his life, as he was in hers.

Two months after Strachey's death, Carrington put on his purple dressing gown and shot herself. In her diary was a quote she borrowed from the statesman Sir Henry Wotton three centuries earlier: 'He first deceased; she for a little tried, to live without him, liked it not, and died.'

# Part Four

---

# WAR AND ART

## Chapter 10

# Echoes from the Front

'Duchesses wash dirty dishes in canteens; munitions workers, at so much a week, have their portraits painted. The world is upside down.'
    – *The Graphic*, wishing readers a Happy New Year, 1918.

Two hundred miles northwest of London, Edward Carter Preston narrowed his eyes in thought. He was used to challenges as a sculptor, but he had never been faced with amending an entire gender. As Marie, his wife and model, looked on, Carter Preston made one tiny revision to his design for Britain's next-of-kin memorial plaque – a change that would make room for the 600 women who had died before the next English spring.

Liverpool, like all of England, was on the long road back from war in December of 1918. Edward Carter Preston, known as ECP, had been declared unfit to serve due to an earlier bout of rheumatoid arthritis. A bright spot came in March when *The Times* named him the winner of Britain's memorial plaque competition to honour its fallen heroes. ECP had submitted two entries anonymously, as required, under a pseudonym.

More than 800 entries had poured in from across the British Empire, including designs produced by men in combat. The judges included members from both houses of Parliament, the secretary of the War Office, the director of London's National Gallery, and the director of the Victoria and Albert Museum, as well as the museum's keeper of coins and medals.

ECP's winning design showed Britannia, possibly modelled by Marie, with a trident in her right hand and two surrounding dolphins representing Britain's dominance at sea. A laurel wreath in her left hand stretched out above a panel for the soldier's name (ranks were not cast, to convey equality in valour). The sculptor placed a roaring lion at Britannia's feet, with a smaller lion below tearing into a winged surrogate for the German Imperial Eagle. The large bronze medallion would become commonly known as the Dead Man's Penny.

All was well until pre-production work started over the summer. First, *The Times* received a letter from a zookeeper in Bristol criticising the main lion for being feeble-looking and implausibly small next to Britannia. Then technical

conflicts arose between the requirements of mass production and the need for artistic integrity. Heated tempers ensued.

This was followed by a challenge as old as Adam and Eve. As a condition of the competition, ECP had put the words HE DIED FOR FREEDOM AND HONOUR in a curved inscription, starting just above the lion's back leg. But the government had not specified, and thus ECP had not produced, a version with the inscription SHE DIED FOR FREEDOM AND HONOUR.

And so ECP showed his approving wife a second version, one where the H of HE was made narrower, allowing room for a narrow S. A supply of 1,500 bronze medallions was struck before the S was removed from the mould. The narrow H remained for the balance of production – a silent reminder of the female nurses, cooks, clerks, drivers, typists and mechanics whose work freed thousands of men for combat as the casualties mounted.

****

The story of the missing S is one of countless small intersections between British artists and the First World War. Edward Carter Preston wasn't a household name in London, but his initials would end up on medallions in almost a million British homes. It is a small but insightful story about the role of art in conflict.

The bigger stories, of course, are attached to the more prominent names: Britain's official war artists. These include Wyndham Lewis, Paul Nash, C.R.W. Nevinson, John Singer Sargent, Stanley Spencer, Augustus John and William Orpen. The government wanted to create a record of the war through paintings, and was willing to embrace styles ranging from the figurative to the modern to the truly avant-garde. Most of the artists they chose had the courage to capture the truth of war first-hand.

In addition to those with official standing, hundreds of unknown artists endured the war as common soldiers. For these men, classrooms, studios and models were a distant memory. They were free of commercial and academic constraints, but shackled to a war that threatened to consume them. In the absence of any creative exchange with fellow artists, the soldier-artists took their inspiration from their military units. They learned to work with scant materials that could be mobilised quickly and carried long distances.

No mention of artists at war would be complete without the exploits of Augustus John. John was at the Café Royal when the start of hostilities was announced; subsequently he was attached to the Canadian forces as a war artist and an officer. His status allowed him to keep his beard, and he and King George V

were the only bearded army officers among the Allies. John got into a brawl after only two months in France. He was shipped back to London in disgrace, but managed to fulfil some of his responsibilities as a war artist to brilliant effect.

Between conscription with its ever-widening parameters, gallery closings, German raids and a general tightening of belts, the demand for artists' models in London declined from 1915 to 1918. The art schools continued teaching, but the number of males aged 18 and older was shrinking. Exhibitions were hung, but the public was not particularly interested in buying art.

A great many models of the anonymous variety joined the ranks of women moving into the workforce. They volunteered as nurses or teachers, or found work in the munitions factories. The 'munitionettes' received attractive wages but risked their health and even death from the toxic substances they handled. In 1917, an explosion at the Silvertown manufacturing plant in London's East End claimed over seventy lives.

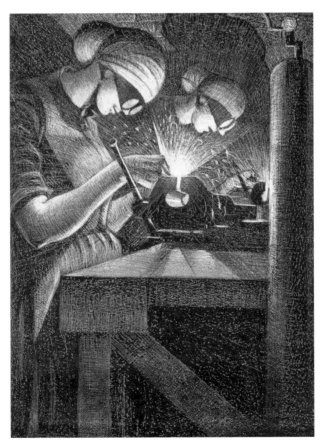

C.R.W. Nevinson depicted confident female welders during the First World War (1917).

Female factory workers became a favourite subject of artists on the home front, as painted by C.R.W. Nevinson, Edward Frederick Skinner, Flora Lion and others. Some of the same young women that had been posing as models in Chelsea and Fitzrovia just months earlier were now crafting ammunition shells or cutting files for the cause. It is questionable how many munitions workers went back to modelling after the war, with skin and eyes yellowed by jaundice and beauty drained by the poison of 'doing their bit'.

The other type of model at the time, and one far less at risk, was the entitled socialite. For that, look no further than Lady Cynthia Asquith, daughter of an earl, daughter-in-law of Prime Minister H.H. Asquith, wife of the poet Herbert Asquith, personal secretary to J.M. Barrie of *Peter Pan* fame, and a prolific writer herself. She spent some of the war years wondering whether to pursue a career as a model or an actress, interspersed with a genuine desire to volunteer at London hospitals.

Asquith (née Charteris) was an arresting beauty. She sat for portraits by Edmund Dulac, Augustus John, Ambrose McEvoy, John Singer Sargent and numerous others. Money and emotional distance shielded her from many of the horrors of war. Her socialising and her posing proceeded unabated while men of her acquaintance died inconveniently abroad. From her diaries:

On Friday, 18 January 1918:

> *We lunched at Cavendish Square. Margot, in another gorgeous new dress, was going off to thé dansant at Lord Curzon's. I sat beside Eric Drummond and we talked of the growing comedy of rations. He claims to already be suffering the pangs of hunger.*

On Tuesday, 5 March 1918:

> *I have never known D.H. Lawrence nicer. He crashed on to the war, of course, complained that it is fighting one machine with another and, therefore, futile in result beyond expression. I gave him a photograph of my Augustus John.*

And on Tuesday, 17 September 1918:

> *I was to have dined with Moira but at 7:15 Willie told me on the telephone that Alex had been killed, and I was much too upset to go. I'm miserable about it, and feel completely sickened and discouraged about life. He had come to be a real alleviation to me and I was relying on him more and more ... I feel bitterly bereaved and oh so weary and bored.*[37]

In the interest of fairness, Asquith had many redeeming qualities. She was good at writing fiction of the spectral, high-Victorian genre and better at non-fiction about the Royal Family. She was also an excellent editor of anthologies who used her literary connections to attract illustrious contributors. Initially a member of the Corrupt Coterie of young aristocrats, Asquith would come to despise their use of drugs and the 'insidiously corruptive poison in their minds'.

Considering the way London high society continued apace, it is no wonder that the British Government felt the need to close nightclubs at 10.30 p.m. under the Defence of the Realm Act – a failed attempt to get London's upper class to set a better example during wartime. On 12 March 1918, Asquith wrote of going to a 'dash to the throne' dance attended by the Prince of Wales and many eager young women. While Asquith declined to dance because her husband was at the Front, she did not stay home either. It was amusing to get dressed up and go out, by her admission, in search of poker.

This kind of thing fed a misconception in later years that the upper class found ways to avoid combat through privilege. In fact that was made nearly impossible by the advent of conscription with the Military Service Act of 1916. The Act formalised the position of the conscientious objector and established the tribunal process. All others who were fit and of age were expected to serve, regardless of wealth.

The reality was that British casualties were disproportionately skewed toward the elite. Junior officers were appointed from the upper-middle and upper classes, and were expected to expose themselves to danger to lead their men by example. Seventeen per cent of officers died in the conflict, far higher than the average for ordinary army soldiers.

Another misconception had to do with conscientious objection. British men who qualified for military service, but sought exemptions, had their fates decided by the war tribunals. A man might be exempted from service if he performed work of national importance on the home front, such as mining, farming or specialty manufacturing.

The majority of the men who sought exemptions through the tribunals were not conscientious objectors – most were caring for large families or working in what were known as 'reserved' occupations. Fewer than 18,000 conscientious objectors registered at the 2,000 tribunals set up in Britain. Many more than that number supported Britain entering the war but were against forced conscription. In the spring of 1916, almost a quarter of a million people demonstrated against conscription in London's Trafalgar Square.

Those conscientious objectors who did exist found that the patriotic British public did not take kindly to them. The hyper-nationalism of the war effort was fuelled by homophobia and encouraged by government propaganda. One cartoon poster entitled *The Conscientious Objector at the Front* mocked an effeminate-looking young man being prodded by a German's bayonet. The text simpered: 'Oh, you naughty unkind German – really, if you don't desist I'll forget I have a conscience and I'll smack you on the wrist!'

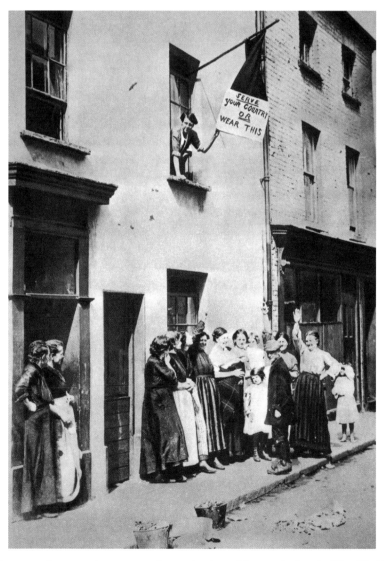

British women flaunt petticoats to mock conscientious objectors during the First World War.

A substantial number of conscientious objectors came from within the intellectual communities and from the performing arts. The painters Mark Gertler, Duncan Grant and Alix Strachey were objectors, as was Dorothy Eugénie Brett, a society painter who knew Bloomsbury members from the Slade. London's literary circles contributed Lytton and Ray Strachey, Clive Bell, David Garnett, Aldous Huxley, D.H. Lawrence, Harold Begbie and others: politicians, philosophers, ministers, educators and social reformers.

Lady Ottoline Morrell and her husband, both pacifists, opened Garsington Manor's farm to their friends who were conscientious objectors. Farm work for the greater good was a useful way to avoid prosecution by the tribunals. Duncan Grant and David Garnett similarly worked for Vanessa Bell on the home farm at Charleston. But purists such as Bertrand Russell were imprisoned for refusing to support the war effort in any way. Russell, who lost his lectureship at Trinity College over his pacifist activities, felt that war was contrary to the interests of society.

Mark Gertler, another bred-in-the-bone pacifist, was spared the tribunal because of his Austrian parentage; this made him ineligible to serve. Instead, he painted a 6ft-high masterpiece entitled *The Merry-Go-Round* in 1916 after the start of forced conscription. The painting, which D.H. Lawrence described as 'the best modern picture I have seen ... terrible and soul-tearing obscenity', would come to symbolise the public horror of war.

Gertler was more fortunate than most. Hundreds, if not thousands, of little known British artists and art students were conscripted or enlisted to fight for King and Country. Some joined the Artists Rifles, a nineteenth-century regiment of the British Army Reserve that was pressed into service. Others drilled in the courtyard of the Royal Academy of Arts wearing cricket whites as part of the all-volunteer United Arts Force. They were split up by the army and shipped to the Front.

The death and injury of fledgling artists in the First World War was arguably the greatest loss to the arts in early twentieth century Britain. The advent of modernism had flung the doors wide open, but these young artists would never attain anything near their potential.

****

Another intersection of war and art came in combat – it exposed artists to anatomy with more ferocity than any life class could hope to muster. Soldiers, living and dead, became unintentional models. Bodies sprawled in the snow or

huddled in the trenches were opportunities to memorialise experiences that, for many, defied conversation.

Occasionally a nurse or other female figure would be included in sketches from the field; these were depictions of reality and not models per se. The nurse Edith Cavell, who was executed by a German firing squad in 1915 for aiding the Allies, is well represented in paintings and sculpture. The modest Cavell sat for none of these – they were all created after her death.

Back in London, Walter Sickert understood that the trenches were only a starting point for the impact of war. Sickert, born in Munich, was appalled by the German killing machine and would have enlisted if he could. While the young artist-soldiers were feverishly sketching fallen comrades at the Front, Sickert was painting cheerless, fraught images of those who were expected to get on with the business of living back home.

Sickert used models prolifically in London during the war years. In *The Little Tea Party*, his brushstrokes are a ruthless commentary on the marriage of the artist Nina Hamnett and her partner at the time, Roald Kristian. In *Suspense*, a famous painting of the war period (circa 1916), the watchful girl is thought to be a Cockney laundress by the name of Lottie Stafford. Stafford was prized as a model for her graceful neck and self-assured sensuality. Her fine reputation as a model is understandable, but Sickert never strayed far from anonymity, and in gritty music hall scenes inspired by Degas, he returned to nameless sitters.

The war is often described as taking a terrible toll on the English people, but in fact it took many different tolls, each incomprehensible in its own way. Two youthful artistic talents can be said to symbolise the cataclysm of war in strikingly different manners: the sensitive Paul Nash and the audacious Henri Gaudier-Brzeska.

Nash was a talented painter who enlisted with the naïveté of someone in his twenties, broke a rib falling into a trench, and lobbied to return to the Front as a war artist. He executed powerful, nightmarish paintings reflecting the death of his enthusiasm and the horror of what he witnessed.

In November 1917, Nash wrote to his wife Margaret from the trenches in France, describing himself as a messenger of 'a bitter truth, and may it burn their lousy souls'. He survived the Front but returned to England a haunted man. Death had become his muse. Nash's salvation was his love of nature, but he was never again fully at peace, as his surreal landscapes attest.

Henri Gaudier was a visionary. His death was a wrenching loss to his friends and to the development of modern British art. A native of France who moved to London, Gaudier hyphenated his last name when he took up with an unstable

young woman named Sophie Brzeska. He enlisted with the French army at the start of the war and was killed in the trenches aged 23 on 5 June 1915.

Gaudier-Brzeska's death, perhaps more than any other, brought home the mortality and immorality of war to his friends in London. On 17 March 1915, Ezra Pound had written to an American colleague that 'if you touch art, even *en passant*, [Wyndham] Lewis and Gaudier-Brzeska are great artists though their stuff is still so far from public comprehension that I don't expect many people to believe me when I say so.' Three months later, a distraught Pound wrote, 'Gaudier-Brzeska has been killed at Neuville-St-Vaast, and we have lost the best of the young sculptors and the most promising. The arts will incur no worse loss from the war than this is. One is rather obsessed by it.'[38]

On a wall of the portico at Burlington House in Piccadilly, home of the Royal Academy of Arts, is a plaque that hundreds pass by every day. It lists thirty-five students who 'fell in the Great War'. None of the names are the least bit familiar to the average person. These students came to the Academy prepared to make their mark on art, and that is what they did – they left behind thirty-five question marks about what they might have been.

# Chapter 11

# The Distaff Side of War

'Her grave is the sixth from the left in the back row.'
— An Allied Bureau letter to M.I.5. about Edith Cavell, enclosing a
photograph of seventeen white crosses, 1917.

December 1917 was one of the coldest months in recent memory in Lancashire. A hard frost had come overnight, turning the ground white outside the Dick, Kerr and Co. factory in Preston. Still, there they were, kicking a football around on their dinner break – the women who were sending Britain's troops 30,000 artillery shells a week.

From inside the office, administrator Alfred Frankland watched a dark-haired teenager named Lily send the ball sailing through a cloakroom window. Frankland leaned out over the courtyard, his shout carrying on the wind: 'Goal! Pay up, mates. That's a Five Boys for the ladies!'

The factory's male workers knew when they were fairly beat. But win or lose, football made them feel more connected to their friends deployed in France and Italy. There, too, men were kicking a ball around in the bitter cold, practising for rag-tag matches in the precious peace of the holiday ceasefire.

On Christmas Day, as the guns fell silent, the women from two Preston factories took the field at home. Dick, Kerr beat Arundel Coulthard by 4-0 in a match that drew 10,000 spectators and raised almost £500 for wounded soldiers. Propelled by the showmanship of Frankland, 'Dick, Kerr's Ladies F.C.' would become the most famous name in women's football in wartime England. The sport was one of thousands of threads that connected the lives of women on the home front with men yearning for home.

Football was hardly an earth-shaking advance for female workers, but it was emblematic of social changes that had been percolating since the late 1800s. Now war had turned up the heat. Many of the women that had taken up jobs in factories, public transport, farms, nursing and civil service would become unemployed in 1919 when the soldiers returned home. But for the time being, both their wages and their sense of liberation were on the rise.

Not everything changed for women *en masse*. Women of the middle and lower classes remained largely anonymous in their wartime roles, while female aristocrats were named on the society pages and lauded for their selfless war efforts.

****

Millicent Fanny Leveson-Gower (née St Clair-Erskine), Duchess of Sutherland, was a woman who deserved every bit of the newspaper attention she received. Born into privilege in 1867, she was a society doyenne, writer and social reformer. Manufacturers called her Meddlesome Millie due to her campaigns for better working conditions in factories. The death of her first husband, 4th Duke of Sutherland, left her a widow in 1913 and she took on the outbreak of war as a fresh challenge.

The Duchess was no stranger to the artist's canvas. She posed for a stunning portrait by John Singer Sargent in 1904; in it she wears a blue silk gown that would have kept the ladies of Dick, Kerr in football jerseys for decades. Sargent sketched and painted her more than once, as did others, but it is a little-known French artist by the name of Victor Tardieu who captured her inner beauty.

On 8 August 1914, four days after England declared war on Germany, the Duchess travelled to Belgium to establish the Millicent Sutherland Ambulance unit. She set up operations in the provincial town of Namur together with eight nurses, a doctor and a stretcher-bearer. Like many aristocratic women, she was used to running a large household and made short work of organising her staff. She also enlisted the help of the local nuns.

The Duchess saw more action than she anticipated in August. It started with a harrowing, five-day siege of Namur that trapped her behind the German line. Although she escaped to England, she went to France less than two months later to help direct field hospital operations there. Her bravery earned her Red Cross medals from Belgium and Britain and the Croix de guerre from France.

It was in France, in 1915, that soldier Victor Tardieu painted ten scenes documenting the tent hospital set up by the Duchess at Bourbourg near Dunkirk. Tardieu's subjects are notable for making unflinching eye contact with the viewer. The settings look almost cheerful, as in *Tents with Stores and Flower Tub*. The Duchess looks stoic and the men are clearly damaged, but Tardieu changes the atmosphere with a pitcher of fresh geraniums.

Across the bottom of one painting is an inscription that reads: *a Madame la Duchess M de Sutherland / Hommage respecteux et tres reconnaisant / d'un simple*

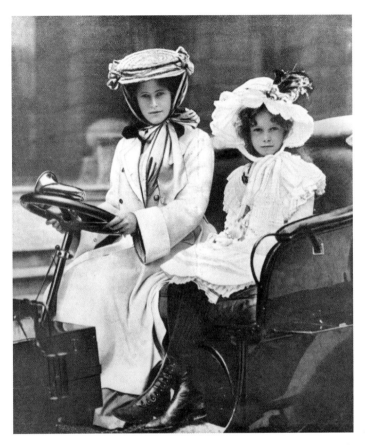

Millicent, Duchess of Sutherland with her daughter at the Ladies Automobile Club (1903).

*soldat*. Tardieu chose not to compliment the Duchess on her beauty, rank or wit – the things held dear by British society – instead expressing respect, esteem and gratitude 'from a simple soldier'.

The Duchess of Sutherland was not the only woman of her class to go to war. Siblings Marcia and Juliet Mansel left their wealthy family to nurse soldiers close to the Front. And Lady Dorothie Feilding volunteered as a nurse and ambulance driver in Belgium, becoming the first woman awarded the English Military Medal for Bravery in the field. A drawing by General Hely d'Oissel shows a curious scene of Lady Feilding and a dog watching a bomb explode overhead, while an officer with a camera stands by.

But it was the Duchess of Sutherland who captured the sad confusion of the war ordeal most poignantly. She penned these words about time spent in a Namur cellar after the Allied support failed to materialise: 'We had taken refuge

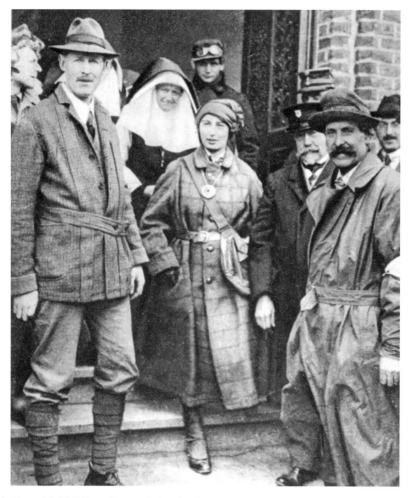

Lady Dorothie Feilding after receiving the Order of Leopold from King Albert of Belgium for services to the wounded (1915).

there with all the schoolchildren, who were very frightened ... The German shells had been whistling ominously over the Convent for 24 hours ... I was so tired of the discouraging refrain 'Où sont les Anglais?'[39]

Four months to the day after that frightful experience, an item appeared in *The Sketch* in London:

> *Millicent Duchess of Sutherland ... came back from Dunkirk to attend the annual Christmas sale at the New Bond Street depot of her Potteries Cripples Guild. She looked yet another of her successful parts – a graceful and beautiful*

*leader of Society; then she spoke, and proved herself the true orator who speaks*
*simply and from the heart. Pleading that the heroic men at the front who come*
*home disabled in any way should be given permanent employment, she suggested*
*handicrafts and enlarging such schemes as the P.C.G. Very charmingly did her*
*dress of black stamped velvet, the coat edged with black fur, suit her also the*
*black hat, with its cluster of silver and white grapes at one side.*[40]

Set side by side, the Duchess's diary and the newspaper article illustrate
war's uneasy marriage with the British upper class, and with its women in
particular. It was more comfortable to reveal what an aristocratic woman
was wearing, than what she was thinking. As the conflict dragged on, more
women would put aside their world of fine dining, fancy dress and *patisseries*
to do meaningful work. Their experiences created a seismic gap between
how society saw them and how the women came to see themselves. Art began
to close that gap by portraying wealthy women in new roles.

The Marchioness of Londonderry (née Edith Helen Chaplin) is a case in
point. The Marchioness was a distinguished society hostess who held strong
political views and was a vocal supporter of women's suffrage. She was also a
lifelong sitter for portraits, starting as a child with her brother Eric, later 2nd
Viscount Chaplin.

The Marchioness found her stride in war. She was named Colonel-in-Chief
of the Women's Volunteer Reserve force in 1914 and established an officers'
hospital in Park Lane at Londonderry House, her London home. Three years
later she became the first Dame Commander of the Order of the British Empire
in the Military Division – all before the age of 40.

The evolution of the Marchioness of Londonderry was best captured in three
portraits by Philip de László, the talented Hungarian painter who made a name
for himself among aristocrats. De László married into the Guinness dynasty of
Dublin and was a newly minted British subject when war commenced.

In his first portrait of the Marchioness, completed in 1913, de László shows a
relaxed-looking woman in full dress in the Irish countryside. Her face is turned
partway toward the viewer; one hand holds the leash of her dog Fly. By 1918, de
László's vision could not be more different. In this portrait, the Marchioness's
military uniform and tightly gripped hands make no attempt at femininity. Her
face looks directly out of the frame with an expression of absolute command.

A third portrait, completed in 1927, was painted by de László in his model's
sitting room at Mount Stewart House in Northern Ireland. By then an interwar
peace had settled over Britain, and the Marchioness had returned to her role as

society hostess. On her head is the famous 'all-around diamonds' Londonderry Tiara. In this portrait, the Marchioness stares off into the distance with no pretence of engaging the viewer – a woman uninterested in trivialities.

****

Female artists in Britain did an admirable job of documenting the First World War on the home front, which in turn elevated their influence. The government saw value in bearing witness to war with a woman's eye. In 1918, the short-lived Ministry of Information commissioned two works from Flora Marguerite Lion, giving her special access to factories in Leeds and Bradford to paint women doing wartime work.

Lion was a painter who studied at St John's Wood Art School and the Royal Academy. Her landscape training served her well in the cavernous factory environments. She was 35 years old at the time of the commissions, and had achieved prominence as a society portrait painter. She drew on both genres in her factory paintings, depicting the anonymous women as often weary but never bowed – a tribute to the more than a million female workers who kept the British munitions industry going during the war.

Other notable British artists who looked at the war with a woman's eye include Olive Mudie-Cooke, Anna Airy, Clare Atwood, Norah Neilson Gray and Victoria Monkhouse.

Olive Mudie-Cooke was just 26 years old in 1916 when she joined the First Aid Nursing Yeomanry (FANY) with her sister, Phyllis. They travelled to France together. Mudie-Cooke was one of the few women with access to the Front due to her skills as an ambulance driver. Shortly after the end of conflict she was commissioned by the Imperial War Museum to depict the British Red Cross providing aid to soldiers in France.

Mudie-Cooke worked primarily in watercolours with a fluid, sometimes murky technique. Her subjects show great humanity. In one painting, medics comfort an injured peasant; in another, an aide lights a cigarette for a soldier in the dim interior of an ambulance. Mudie-Cooke's war experiences might have coloured her perspective as an artist for many years to come had she not died in her thirties.

London-born Anna Airy also received a commission from the Imperial War Museum in 1918. Airy trained at the Slade School at the same time as future war artist William Orpen and his contemporaries. The museum's commissioning committee hedged its bets with Airy – they built a right of

refusal and non-payment into her contract, but ended up purchasing four large factory scenes from her.

Airy must have welcomed that income at a time when many London artists were still struggling. The war's effect on the art market had been widely recognised – on 15 May 1916, Her Majesty Queen Mary attended an exhibition of female artists at the Georgian Gallery of Waring and Gillow. The *Sporting Times* noted that the queen, 'showed her practical interest and sympathy in women artists who have been badly hit by the war.' The queen acquired a number of works when touring the exhibition, displaying a deep interest in the women's points of view. One of her purchases was a painting called *The Golden Plum Tree* by Airy.

Other female artists found work through international sponsors. Clare Atwood was born in London and studied at the Westminster School of Art and the Slade. She was a member of the New English Art Club and exhibited at London's Carfax Gallery – but it was the Canadian Government that gave her a commission as a war artist in 1917. Atwood was offered access to a military camp in Kent to gather ideas for the work. Instead, she chose to paint troops waiting in a London railway station for trains to the Front. She later secured commissions from the Imperial War Museum to produce works both during and after the war.

The Scottish artist Norah Neilson Gray was treated to a first-hand look at how government support for female war artists could be subject to influence. Gray volunteered as a nurse in France with the Scottish Women's Hospitals; she subsequently submitted a painting entitled *Hôpital Auxiliaire* to the Imperial War Museum. It was rejected for depicting only nurses and returned to her with a request that she show a female doctor instead. Gray's second attempt was set at the same venue, the Cloister of the Abbaye at Royaumont, but depicted *Dr Frances Ivens inspecting a French patient*. It was finally accepted in 1920.

The artistic skills of Victoria Monkhouse were put to use more directly on the home front. Monkhouse worked for a Cambridge University publication as an illustrator. In 1916, the Imperial War Museum asked her to create portraits of working women in England. Monkhouse took a unique approach to this request in that she used amateur sitters for one-on-one depictions of women in jobs previously held by men. The only drawback was that her models were busy women and seldom had time to sit.

Monkhouse's watercolours of female ticket collectors, bus conductors and window cleaners had a storybook-like simplicity that became immensely popular with the general public. In some ways they echoed the poster and

cartoon art that had become a morale-boosting staple of wartime England. But the drawings were also explicit illustrations of modernity, showing women asserting themselves in the workforce.

In depicting the realities of war, artists of both genders were in competition with the meteoric rise of photography. In 1915, the Eastman Kodak Company inserted itself in the middle of the war effort by advertising, 'The gift he will appreciate most is a Soldier's Kodak ... Every incident in camp, aboard ship, foreign ports, or at the front, makes an interesting subject for a Kodak snapshot.'

Cameras had their place both as a novelty and as a connection to home. Nevertheless, it is difficult to envision how the conflict would have shaped humanity's perception of war without the lens of art. To paraphrase Picasso, the artists painted war as they thought it, not as they saw it.

*Chapter 12*

# A Brief Return to Order

'… the last thing Mr Fry takes off & the first he puts on, before & after taking a swim, is his hat.'

<div style="text-align: right">– Diary entry by Bloomsbury's Grace Germany listing things<br>she noticed in St Tropez, 1921.</div>

The year was 1938, and Britain's interwar peace was approaching an end. In a home movie theatre in Bavaria, one of Disney's biggest fans sat watching seven dwarfs parade across the screen. *Such a wonderful accomplishment,* he thought, *and yet such an embarrassment. Why does it take an American company to master our fairy tale?* Almost without thinking, he began to sketch: Sleepy … Doc … Dopey … one by one, the characters took shape in meticulous detail.

Before long, the artist would tuck his sketches behind the cardboard backing of a framed aquarelle – a pretty landscape that was technically correct but utterly forgettable. The painting epitomised why the artist had twice been rejected at the Academy of Fine Arts Vienna. Now the self-styled artistic genius was focused on war, and America was an enemy. Unwilling to destroy his drawings, the Führer hid the evidence.

But first, for nineteen precious months, England would continue to enjoy its hard-fought serenity. *Snow White and the Seven Dwarfs* was released at a time when people yearned for stability and simple pleasures. It was the first full-length film to use animation, and its success was seen as a triumph of creativity.

A storyline about a beautiful young woman and her seven funny friends was just what the public needed in early 1938. Comfort had been hard to come by in the years following the First World War. The hardships of food deprivation and property destruction were followed by a general strike that strained the economic system. Attention turned inward toward the safe haven of the British home.

*Le rappel a l'ordre* (the recall to order) was a phrase coined by the French poet and artist Jean Cocteau in 1926 to define the post-war nostalgia that prevailed not just in Britain, but throughout Europe. Interestingly, artists were on board with this idea. Pablo Picasso, Georges Braque and André Derain, all famous disruptors, tempered their fractured styles in favour of a more realistic aesthetic. Artists in Germany, France and Spain adapted to figurative art in various ways.

In Italy, Futurism, with its love of machines, sputtered on through the 1920s but lost its teeth. The Futurists' celebration of war as a way of shedding the past was out of step with the times. Futurism became memorable not for its avant-garde perspective, but for its blatant appeal to the Fascist right.

British artists had come late to modern painting and sculpture before the war – now they found themselves cast as adopters, adapters or rejecters once again. It was clear that the idea of a return to order held overwhelming appeal for the art-buying public. London's longstanding exhibiting society, the New English Art Club, was at an advantage; its members had never strayed far from the influences of impressionism and realism.

Even Percy Wyndham Lewis, London's most credible claim to the avant-garde, could hear the death knell of his Vorticist movement. Lewis fought back with a perturbing post-war painting, *A Reading of Ovid,* before returning to portraiture to pay the bills.

The representation of the human form during this time was shaped by themes of maternity, innocent family life, a neoclassic Greek phase, and the androgynous garçonne style that was not so much homosexual as asexual. All of these trends, coupled with realism, supported a demand for figure models. Once again, the perceptions of beauty were changing.

Two themes in particular – the new mother and the boy-like woman – were the final stakes in the heart of the corseted aesthetic. Most female figure models had discarded the garment long ago, and now war nurses and factory workers had shed their corsets to move about more freely. As corsets became an anomaly in London, very few mourned their passing. As if further impetus was needed, the *Illustrated Police News* trumpeted a caution with a June 1922 headline: 'Bride's Corsets Cause Her Death at Church Door'.

As for outer fashion, a model might slip into a gypsy tunic or a feathered headband for a night on the town, but when it came to the studio, artists preferred to work with a clean slate. London-born model Marguerite Kelsey is an example of a professional sitter whose clean lines, serene face and languid form projected an unflappable English calm. Kelsey managed this without sacrificing femininity, which led to a long and successful career. Her beauty rode the crest of the new classicism and inspired artists ranging from Augustus John and William Russell Flint to John Lavery, Laura Knight and Meredith Frampton.

Frampton was an interesting painter whose mix of good fortune, genuine skill and odd quirks dovetailed with the times. He had the benefits of an affluent family and an artistic gene pool – the painter Christabel Cockerell was his mother, and his father was the distinguished sculptor Sir George Frampton.

Meredith Frampton was purpose-built for the prevailing return to order. He had an obsession with order that extended to every detail – sometimes buying dresses for his models to ensure that light was cast on the exact fabric he envisioned. Fortunately for his finances, the results were impeccable.

While it can be said that Frampton used his connections to foster his career, he was also a very good portraitist. Three of his most famous paintings depict Kelsey: he honoured her by name in the 1928 work *Marguerite Kelsey*, and without attribution in *Portrait of a Young Woman* (1935) and *A Game of Patience* (1937), although she was never truly anonymous. True to form, Kelsey commands each canvas. She is the English ideal personified: eternally sleek and devastatingly beautiful, with a face that gives nothing away.

Another important theme in the return to order, the mother-child bond, was one that Picasso explored numerous times in paintings entitled *Maternidad* ('Maternity' or 'Motherhood'). Picasso's works moved from a pervasive sadness in the pre-war period to a neoclassic solidity after the war. Perhaps his perspective was altered by his visits to Italy between 1917 and 1924, or by becoming a father to his son Paulo in 1921. In any case he was not alone in celebrating maternal moments.

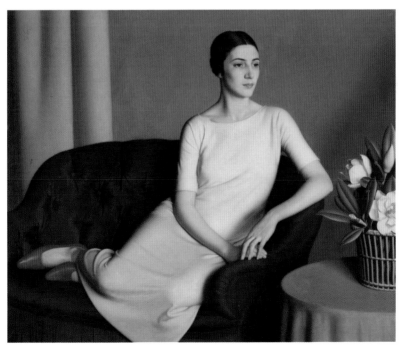

*Marguerite Kelsey:* the model connected with an English public longing for post-war serenity.

The interpretations of mother and child produced in Britain during the 1920s and 1930s span every possible sentiment. They show mothers reading, playing, bathing and tending to their children, babies clasped by women in Madonna poses, and nursing mothers in contemplation. In the late 1920s, during what would become known as the Art Deco period, there was a tendency for these images to slip into sugary cliché.

Professional models rarely factored into the maternal genre with the exception of allegorical works. Some mothers and children sat for commissioned portraits, but inspiration was largely provided by the artists' personal relationships. Just as death had become a muse for artist-soldiers, and locations served as models for the Bloomsbury Group, family became a muse for artists in the 1920s.

The weight of family is poignantly evident in *Design for a Portrait Group*, a 1929 work by Herbert James Gunn. Gunn was a popular portrait painter of the time. He was divorced from his first wife Gwen, who had run off with Sir Arthur Whinney, one of Gunn's sitters. Gunn was barred from seeing his three young daughters, and they were wrongfully told that he had abandoned them. When he came upon the children by accident at the London Zoo after two years apart, he cajoled their nurse into bringing them to Regent's Park in secret for arm's-length sittings.

In the painting, the nanny bows her head over her knitting, perhaps concerned with her mistress's wrath. Two of the girls play on the lawn while the third stands facing the artist, studiously avoiding eye contact. This child is old enough to recognise the man who 'abandoned' her and she is the only figure that appears approachable. One feels that had Gunn and his subject been a pace or two closer to each other, the pull of family would have bridged the gap.

Gunn started a new family with his second wife Pauline – it was a happy union, and Pauline gladly served as his model. The artist finally reunited with his three daughters when they were grown and kept *Design for a Portrait Group* with him in his studios for the rest of his life.

\*\*\*\*

One of the most predominant features of the return to order was a renewed interest in classical elements. This was not so much an art movement as a cultural seep that had its roots in philosophy and flowed outward to music composition, literature, art, theatre, cinema and architecture.

Psychoanalysis had its place as well. Sigmund Freud, whose beliefs astounded people in the interwar years, repeatedly wrote about the powerful influence of the past on the present. Virginia Woolf was among the novelists who took

offence at this concept, at least initially. Freud's inference that past experiences shaped current behaviour meant that a character's history had to be considered in story development. This was seen as limiting the author's creative power.

In London, Wyndham Lewis pushed back in his own way against the seep of classicism. Venus in her most perfect form held no interest for the avant-garde Lewis. The body of work he exhibited at the Leicester Galleries in April 1921 drew heavily on those closest to him. His models included his long-suffering live-in companion, Iris Barry, and his brief lover, Iris Tree, as well as his friends in the cultural elite.

The centrepiece of the exhibition was a fearsome portrait of Barry entitled *Praxitella*. Lewis showed the mother of his two children ensconced in an armchair as a giant, futuristic insect. There were also five pictures of disturbing male figures Lewis called Tyros – imaginary creatures from the artist's tortured imagination.

Tyros were important to Lewis. He described them as, 'These immense novices [that] brandish their appetites in their faces, lay bare their teeth in a valedictory, inviting, or merely substantial laugh. A laugh, like a sneeze, exposes the nature of the individual with an unexpectedness that is perhaps a little unreal.' He wrote these words in 1921 in the inaugural issue of *The Tyro*, successor to his Vorticist publication *Blast*.

As editor, Lewis unexpectedly leaned on the classics to explain his vision for *The Tyro*:

> *A paper run entirely by painters and writers, the appearance of the 'Tyro' will be spasmodic … one further point. The Editor of this paper is a painter. In addition to that you will see him starting a serial story in this number. During the Renaissance in Italy this duplication of activities was common enough, and no one was surprised to see a man chiselling words and stone alternately. If, as many are believing, we are at present on the threshold of a Renaissance of Art … [then] kindred phenomena, in letters, science or music, to the painting of such pictures as this paper is started to support and discuss, will be welcomed and sought for in its pages.*[41]

Six of Lewis's works were purchased from the exhibition by the novelist Sydney Schiff. In one, a self-portrait, the darkly charismatic Lewis chose to depict himself as a leering, evil-looking Tyro with razor teeth and skin tinged a poisonous yellow-green. This was marginally better than the description of Lewis offered by Ernest Hemingway, who described the artist in *A Moveable Feast* as having 'a face that reminded me of a frog, not a bullfrog, but just any frog'. In any event, shortly

after the Schiffs hung their friend's self-portrait in their home, guests brought an infant son to visit. The child was so traumatised by the sight of *Mr Wyndham Lewis as a Tyro* that he screamed non-stop in terror.

The Tyros, unsettling as they were, represented a return to figurative art for Lewis. They showed that London's angriest voice was not immune to the prevailing return to order. This can be seen even more clearly in the artist's recognisable portraits of interwar sitters such as Violet Schiff, Ezra Pound and Edith Sitwell.

Ultimately, order proved anathema to Lewis. He wrote to his drinking companion, the Irish novelist James Joyce, that his life in interwar London was depressing and dull. Soon he was back in Paris discussing lofty ideals with Joyce, the two sitting in a rain-soaked gutter after a night of drinking. Lewis liked Paris for liking him; it was there that a dealer told him he created 'the only things being done in England today' that would arouse any interest in Paris.

Although Wyndham Lewis would fail to mount the explosive exhibition he envisioned as 'setting the Seine on fire', his meetings in Paris in 1922 were emblematic of the renewed cultural interactions between Britain and the rest of Europe – particularly France, where Surrealism was taking shape. The end of the war had reopened the Channel, and Paris was waiting.

****

Be it Paris, Dieppe, Saint-Tropez or Provence, France held a definite allure for artists and writers. The British had been chafing under the travel restrictions of the First World War and were ready to pick up where they left off. What they found in France was a damaged country rising from the rubble of conflict, where recuperation would take time and many foods were still scarce. Paris was more determinedly creative than ever, but with less of an appetite for extremes, and thus in line with the return to order.

In 1919, Walter Sickert returned to his beloved Dieppe with his second wife Christine after a five-year wartime absence. A year later they bought a house in nearby Envermeu with the idea of a permanent move from London. But Christine died of tuberculosis in October, and the house, a former inn, was a bitter reminder to the artist of his loss.

It is difficult to say whether Sickert would have stayed in Envermeu permanently had his wife lived. Surely, he would have missed the murky venues he pursued with such a passion in London. The light flooding the French coast was inspiring to him, but this was a man who was equally comfortable in tawdry back rooms. Undecided about his next move, he painted still life subjects: arrangements of cheese, asparagus and salmon that celebrated simplicity and kept his emotions at bay.

Sickert had little use for professional models in France during this time. Under the daring influence of Surrealism and the photographer Man Ray, Parisian models were more sophisticated and liberated than those in London. Some of the women cultivated extreme identities of the 'new modern type', whereas Sickert preferred anonymity in his models. He avoided Paris, moved out of Envermeu and found places to stay in Dieppe for another eighteen months before returning to London in 1922.

It was in London that Sickert and a contemporary of his, Alan Beeton, separately raised eyebrows by using mannequins (lay figures) as subjects in paintings. This was the antithesis of the life model. Artists had been using mannequins for centuries as a studio tool; full-size figures were especially useful for keeping cloth or limbs absolutely still so the artist could study the effect. But Sickert and Beeton are examples of British artists who took mannequins from the realm of props or tools and brought them into use as models.

Sickert bought his mannequin – an eerie, dark wood figure with a face resembling a death mask – in 1929. Supposedly, it had belonged to noted editorial cartoonist William Hogarth. As the story goes, the sight of the mannequin being carried into his studio so inspired Sickert that he begged a local undertaker for a shroud and posed his 'model' for *The Raising of Lazarus*, a painting in which he humbly cast himself as Jesus Christ.

Alan Beeton was a witty, wealthy artist who amused the master of his prep school with caricatures before moving on to Cambridge where he designed theatre posters. Bored with Cambridge, he left for Paris before settling in London. Beeton was in demand for society portraits but became bored with those too, and he could afford to be selective. He decided to forego commissions and focus on subjects of his own choosing.

Beeton's mannequin graduated from prop to model in 1928 and would enjoy enduring fame as the subject of four lay-figure paintings produced in 1928 and 1929. The idea of using an undisguised mannequin as a sitter – rather than as a stand-in for a sitter – was novel enough to garner immediate attention. In *Composing*, the mannequin is bent over a writing desk. In *Posing*, it strikes a stance. In *Reposing* it appears to doze in an armchair.

But it is Beeton's painting *Decomposing* that radiates intrigue with its sinister implications of a sordid, headless victim. When the Royal Academy purchased *Decomposing* in 1931, using funds from the Chantrey Bequest, *The Sketch* noted that despite the figure 'lying in a somewhat derelict attitude' Beeton had received high praise from critics for his handling of light, akin to that of the master Vermeer.

Deliberate or not, Beeton's uncanny twist on reality gave his lay-figure paintings Surrealist overtones. Certainly the artist would have been aware of

*Posing:* Alan Beeton set London talking when he used a mannequin as a model (1929).

André Breton's 1924 *Surrealist Manifesto* in Paris. Breton advocated expressing thought in a way that was free of all controls – even the basic controls of reason and morality – four years before the mannequin series was painted.

Surrealism was a mind-bending concept that took more than a decade to put down roots in London. It would cause artists to rethink the human form. In the catalogue for the International Surrealist Exposition of June 1936, the art historian Herbert Read wrote that, despite the exhibition being held in London, the English contribution was comparatively tentative, 'but our poets and painters have scarcely become conscious of this international movement'.

The International Surrealist Exposition took place at New Burlington Galleries, and those in attendance displayed a practised blasé demeanour – so much so that when the Spanish painter Salvador Dalí presented his slides upside down, no one in the audience blinked. This was after Dali flailed around in a vintage scuba diving suit that started to suffocate him mid-speech.

It made for a good story over drinks at the Café Royal. But Londoners would need every ounce of that English self-possession four years later when the bombs came in earnest.

# Part Five

## FREEDOM AND FAME

*Chapter 13*

# The It Girl Arrives

'The flapper is *au naturale* below the neck. Above the neck she is the most artificially and entertainingly painted creature that has graced society since Queen Elizabeth.'

– Helen Bullitt Lowry, writing for *Nonsenseorship*, 1922.

David seriously considered bringing an umbrella. It was pouring with rain and bound to be chilly before dawn. But weather was passé, an old-fashioned concern for his parents' generation. He was determined to be one of the Bright Young People even though he was on the wrong side of thirty. And so in the early hours of 2 August 1924, he paid a sovereign 'fee' into the pool and took the wheel.

This was how the best treasure hunts always started, or so he had heard, with dozens of smart motorcars roaring off in pursuit of clues. This particular chase began at Claridge's Hotel just after midnight. The cars were full of spirited society girls, gallant officers of the Guards and louche young bucks bored with the clubs. It was David's first hunt.

Someone shouted, 'Go!' and the game was on. Exhaust smoke trailed them down the empty London streets as they puzzled out one clue after another. Policemen looked the other way. From the Adelphi Theatre to the Bank of England, Fleet Street and Kensington, then on to Norfolk House, St James, where a decadent champagne breakfast awaited. But first there was one final challenge.

One by one the cars purred up to the finish line, a chalk mark in a back alley. The treasure hunters, giddy with exhaustion, were ordered to crawl on all fours. Dresses were ruined in the rain, hair came unpinned and trousers were torn at the knees. Disoriented by the filthy surroundings, David hesitated. For the first time all night, His Royal Highness Prince Edward Albert Christian George Andrew Patrick David, Prince of Wales – David to his family – was having second thoughts.

This was the ferment of London's privileged youth in the 1920s, the first decade of the interwar period. The public was appalled and fascinated by the young hedonists of the upper crust and their bohemian friends. The city's tabloids feasted on tales of debauchery and jazz, led by frivolous young people

such as the socialite Elizabeth Ponsonby. Evelyn Waugh's book, *Vile Bodies*, would describe the wasted lives with painful accuracy.

A ten-hour Red and White Party turned out to be the last straw of extravagance for the British public. Hosted by art gallery owner Arthur Jeffress on 21 November 1931, it was attended by nearly 400 of London's social elite in red or white fancy dress. The guests dined on red and white foods in rooms draped in red velvet and white silk at Holford House in Regent's Park.

The timing couldn't have been worse. It was the start of the Great Slump of the British economy, when the unemployment rate was in the range of fifteen to twenty per cent – worse in the North and Wales. Unemployment benefits were essentially non-existent; the loss of a job almost always meant absolute poverty.

Shortly after the backlash of the Red and White Party, the Bright Young People began to wind down or self-destruct. A new kind of 'what does it all matter' mood settled over Britain with the sinking economy. Desperate fun had run its course, but for a handful of champagne-soaked years, the Bright Young People's *carpe diem* behaviour flew in the face of the interwar return to order.

Something else grew from those seeds of notoriety. A transatlantic cultural phenomenon took shape in London and Hollywood: the birth of the It Girl. The It Girl was famous for being famous. It was an idea fostered by the Bright Young People and propelled by the popularity of novelist and screenwriter Elinor Glyn and the actress Clara Bow.

Glyn would never be touted as a great novelist, but she was the first writer to use the term It Girl in the sense of 'It' being an indefinable magnetism (not merely beauty or sex). She cemented the concept in popular culture by writing a novella entitled, appropriately, *It*. This was adapted for a silent film of the same name in 1927–1928. The film established Clara Bow as Hollywood's reigning star.

Both the Bright Young People and the It Girls that followed were flawed as cultural icons, but their time had come. In tamping down decadence, London created space for a new culture of public celebrity.

****

Among those caught up in the heyday of the Bright Young People were two young artists who found their way onto gallery walls with surprising speed. Edward Burra and John Banting had friends in common. Burra was born into a centuries-old Westmorland family and suffered from crippling arthritis. He trained at the Chelsea School of Art and the Royal College of Art, and was given his first solo exhibition at the Leicester Galleries in 1930. Banting was

from a middle-class family. He studied at the Westminster School of Art and was briefly associated with the Bloomsbury Group. Initially a Vorticist, Banting became influenced by Surrealism in 1930.

The two men were products of different upbringings and training, but they shared something important – an aversion to racial prejudice. This was unusual in their social circles. Burra and Banting were emblematic of a certain faction of the English social scene that felt prejudice was abhorrent. Both artists used Negro models in their art, and Banting in particular was close to the inimitable Nancy Cunard.

Cunard was an interwar It Girl with a fierce sense of social justice. Had she lived in the eighteenth century, she would have been called a woman of parts. She was an English shipping heiress until her entitlement was stripped away – disinherited by her family for her lengthy relationship with the black jazz musician Henry Crowder.

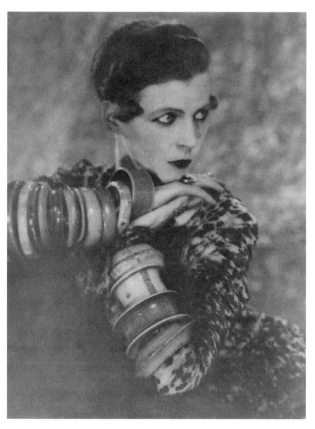

Shipping heiress Nancy Cunard was a cultural icon in the 1920s and 1930s.

Cunard easily could have lost her young self in absinthe or champagne (that would come later). Instead she rebelled by becoming an activist, model, muse, publisher, poet, editor and newspaper correspondent, all while raising a glass. In between trips to Venice, London and New York from her base in France, she found the energy for a legendary number of paramours, including many prominent writers who immortalised her in their works.

A precocious child, Cunard began devouring books at an early age to fill the hours of parental neglect. At 11 she was caught reading Elinor Glyn's erotic novella *Three Weeks* with its tiger-skin sex scene. By the time Cunard was 31 years old she had set up The Hours Press in Normandy to encourage experimental young writers.

Cunard was born to be a muse. Modernism, Surrealism, Dadaism, no *ism* was off-limits to the enigmatic young Englishwoman who turned her back on privilege. Fiercely individualistic, she would pile on her trademark ivory bangles and enhance her penetrating gaze with kohl – an effect made more dramatic by mannishly short hair.

The creative community embraced Nancy Cunard. Man Ray photographed her over and over again. Cecil Beaton posed her against polka dots that would have overpowered a lesser presence. Alvaro Guevara painted her as an imperious young woman, red turban blazing. Constantin Brâncusi sculpted her and Wyndham Lewis drew her ramrod straight, hand on hip, in front of an upper window.

Cunard was not alone in championing racial equality, although she was in somewhat limited company. In the art world, Jacob Epstein was the most prominent sculptor to use black models in Britain at the time. John Banting, who travelled with Cunard to Harlem in America, interpreted African motifs with a surrealist's eye. Edward Burra painted compelling dark-skinned figures in urban settings, and the Jamaican-born Ronald Moody used sculpture to explore his heritage. Ronald was the brother of Harold Arundel Moody, a London physician and civil rights activist who established the League of Coloured Peoples. They were the exceptions, not the norm.

Of the anonymous sitters of colour used by British artists in the interwar period, few would attain any kind of public recognition. Many were amateurs trying to pick up extra money during a dock strike or solve other impediments to employment. The art schools were a source of income for those willing to pose in life classes, but again the work was largely anonymous.

Rebecca and Esther were dark-skinned sisters who sat for Jacob Epstein in the 1930s. Esther reportedly performed in nightclubs and worked as a professional model. Despite posing for artists of note, the sisters' surname is lost to time.

It didn't help that Epstein's portrait bust of Esther would eventually become known as *Betty (Esther)* – a label that was intended to avoid confusion with other Epstein busts of the artist's daughter Esther. Unfortunately, this only served to further obliterate the model Esther's identity by confusing her with another Epstein model, Betty Peters.

Amina Peerbhoy (née Devi) was an Indian immigrant and one of the few escapees from anonymity. Epstein met Peerbhoy in 1924 at the International Exhibition at Wembley where she was selling exotic items with her son Enver and her sister Miriam Patel. Both women had left their husbands and were working in London.

Before long all three were living in Epstein's house, where Amina and Miriam were answering to the names Sunita and Anita and modelling for Epstein. Sunita became one of the most celebrated models of 1920s and early 1930s Britain – not exactly an It Girl, but a celebrity sitter who transcended anonymity despite the prejudices of the day.

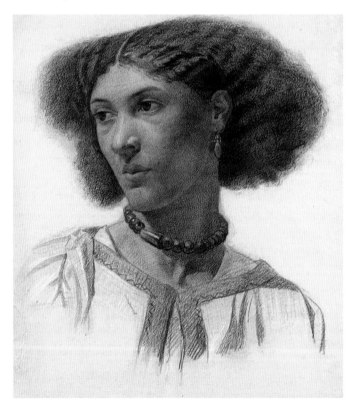

Fanny Eaton's work as a Pre-Raphaelite model paved the way for other models of colour.

It is possible that none of these women would have been accepted into studios if not for the inroads made by a Jamaican-born, Pre-Raphaelite beauty that modelled from 1859 to 1867. Fanny Eaton (née Antwistle) came to England with her mother in the mid-nineteenth century at the age of 16. She found work as a domestic servant and married a horse cab driver from Shoreditch. They had ten children together, and the near impossibility of putting food on the table convinced Eaton to try modelling in her twenties as a way to make ends meet.

Eaton made a large impression in a short time as a model, beginning with work as a portrait sitter at the Royal Academy. She rapidly came to the attention of Pre-Raphaelite painters such as Dante Gabriel Rossetti and Simeon Solomon. Rossetti was married to his muse, Lizzie Siddal, and he knew a thing or two about beauty. When an artist of Rossetti's stature praised Eaton's pulchritude people took note, because dark-skinned women were generally not considered beautiful enough to be depicted in Western art.

Eaton stopped modelling before the twentieth century. However, she was undeniably important to women of colour as London's most celebrated Victorian, Pre-Raphaelite sitter of African descent. Sunita, Anita, Rebecca, Esther and other women of colour who worked as models in the twentieth century were walking the path that Fanny Eaton had cleared.

As for celebrated beauties of the purely Caucasian variety, the American Evelyn Nesbit held pride of place as the first It Girl of the early 1900s. She became ubiquitous as an artists' model, a chorus girl and an actress. By the interwar period Nesbit had survived a national scandal and retired to California with her three cats, Stumpy, Alley Kahn and Weirdie. Along the way she inspired women of other nationalities to strive for celebrity.

The It Girl baton was picked up in England by some women who had ties to America, including the British actress Dorothy Mackaill, the photographer and model Lee Miller, muse of Man Ray, and the bewitching American socialite Henrietta Worth Bingham, paramour of Dora Carrington. Bingham was irresistible to both men and women and happily obliged both. When she modelled for artist Stephen Tomlin, another of her bisexual Bloomsbury lovers, he confessed that a mere letter from Bingham let loose 'the dogs of longing' inside him.

London produced its own brand of It Girls, such as the melodramatic Dolores. Dolores was the rare model that Jacob Epstein didn't rename. Her face and form obviously enthralled the sculptor, who described her as the Phryne of modern times. One has to wonder whether Epstein referred to Dolores as Phryne, an ancient Greek courtesan, when he informed his wife that the model would move in with them in 1922, a year after he met her.

Dolores became a staple of the bohemian scene, sitting for C.R.W. Nevinson, Jacob Kramer and others. According to Epstein she tended to strut around when posing, arms folded protectively across her body, looking both tragic and aloof. Her dedication to modelling helped her transition to the stage in 1922 and then to fashion in 1924, when she created a stir by wearing gold shoes and no stockings. Epstein would stay in touch with her throughout her life.

Madame Dolores, as she liked to be called, was not without controversy. In 1926 she secretly married the African-American lawyer and sports manager George Lattimore. Three years later she became entangled in the suicide of a young artist and admirer. The proceedings surrounding the death did nothing to elevate Dolores's reputation, as it came to light that the artist, Frederick Atkinson, had gassed himself when Dolores left him after his money was spent.

An art dealer by the name of Mabel Fredericke had introduced the pair. She gave testimony at the inquest that Atkinson lost all interest in his work after being deserted by his love, and that she believed the model was living with two artists at one time. Fredericke suggested that when Atkinson 'became alive to this state of things' the revelation tipped the scales.

Dolores lived just forty years, dying of cancer in a Paddington basement. In later years, Epstein admitted to being annoyed by the way Dolores had used his name as an attention-grabber ('she married a coloured gentleman and sent the invitations to the reception in my own name'), but he and the girl from Doughty Street had a true fondness for each other. Without Epstein, Dolores may never have been an It Girl of *la vie de bohème* and she knew it. She called him her shield against the world.

****

For every It Girl of 1920s Britain, there were hundreds that reached for the golden ring and failed. One curious instance took place in 1924, when the Pallant House Gallery in Chichester served up a literal take on neoclassicism. The gallery sponsored a competition to find a 'Modern Venus' in London to promote the British launch of *The Temple of Venus*, an American silent film.

A call went out for young women with measurements that closely matched those of the Greek sculpture of Aphrodite known as the Venus de Milo, housed at the Louvre Museum. The thirty finalists had their measurements checked by a panel of female judges. The judging was led by Dolores and championed by Jacob Epstein.

Stella Pierres emerged victorious with the winning measurements. Pierres was an aspiring model and actress from Southampton with pretty Irish features. Her victory launched her as a beauty queen. She posed in a soundproofed glass room in the Pears Palace of Beauty at the British Empire Exhibition, which ran through October 1925 at Wembley. She was joined by models dressed as Helen of Troy, Cleopatra and other beauties, including the Spirit of Purity. It was a living display meant to associate cleanliness with a pure life for the 750,000 potential soap buyers who filed by.[42]

Despite being lauded by Epstein, Pierres failed to achieve enduring fame as a model or actress. Most of her parades and revues took place from 1924 to 1930. She did parlay her title into on-going appearances, serving as a fashion mannequin in Nottingham in 1933, and as a judge at a Hendon dog show in 1937, where she was assigned the canine category of Most Soulful Eyes.

Pierres became used to having her measurements displayed side by side with those of the Venus de Milo for the world to see. In addition to the typical metrics of waist, bust and hip, she won with half a dozen other body parts, including a wrist of just under six inches that was slightly smaller than the Venus de Milo's.

Even Epstein would be hard-pressed to explain how an armless statue produced a wrist measurement, but the public loved the competition too much to quibble. Stella Pierres joined the ranks of pretty, vivacious young women who made a bid for fame and landed somewhere between It Girl and anonymous.

*Chapter 14*

# Footlights and Fancy Dress

'I always remember one night at the Chelsea Arts Ball … when I got terribly drunk and I had the sensation that everything was going far away from me.'
– Alfred Hitchcock, on being inspired to create the camera effect for the 1958 movie *Vertigo*.

It was the Chelsea Arts Ball of 1910, the first held at the Albert Hall, and over 4,000 revellers in fancy dress were crowded onto the parquet floor. Lady Constance Stewart-Richardson wiped away some unladylike perspiration from under the kerchief of her cowboy costume. The organiser, George Sherwood Foster, had outdone himself, but the temperature was rising. *Who can dance in this human jungle,* Lady Constance thought, *and why did I wear long sleeves? At least that big chicken over there is hotter than I am.*

Granted, the poultry was a stroke of genius. The novelist Arthur Applin was strutting by in head-to-toe black feathers as Chantecler, the magnificent rooster protagonist of Edmond Rostand's play of the same name. It was all the rage in Paris. Behind Applin came the actress and model Viola Tree dressed as the Ballad In E Flat. Viola was the very image of propriety, staying close to her father Sir Herbert Tree. But where was younger sister Iris? The black cat perhaps, certainly not the elephant. The beautiful, bohemian Iris Tree, eccentric artists' model, would never choose a baggy pachyderm disguise.

The newspapers were quick to dub the event a triumph, 'the greatest fancy-dress ball ever held in London'. Later, the narcissistic Bright Young People would host Impersonation Parties (Elizabeth Ponsonby came dressed as Iris Tree), and later still the Chelsea Arts Ball would be called 'the most scandalous event on the social calendar'. But in March 1910, a bold young lady could tuck her hair under a cowboy hat for some harmless fun.

In the early twentieth century, the Chelsea Arts Balls were widely attended by the three types of working models at the time: sitters (in academia and studios), performers (in music halls, nightclubs and theatre), and fashion mannequins.

The love affair between models and the stage flourished in the early decades of the new century. Music halls, a nineteenth-century offshoot of pub theatres

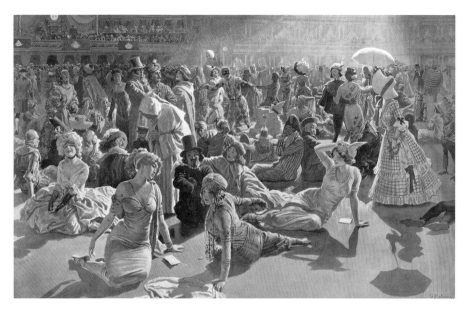

Revellers are depicted resting between dances at the Chelsea Arts Ball, Albert Hall, London (1912).

and supper rooms, charged a low admission. A few precious minutes of stage time offered exposure to a large crowd. The public could enjoy a Cockney sing-a-long or a performance of 'singing swells' for a pittance.

Music-hall entertainment had one criterion – fun – delivered through humour, dance and song. Over time, fun was interpreted to include a farrago of variety acts: jugglers, cancan dancers, midgets, educated elephants, illusionists, hot air balloons and other wonders of late-Victorian and Edwardian times. As Charles Dickens Jr. (son of the novelist) wrote in his *Dictionary of London*, 'nothing comes foreign to the music proprietor'.

Models began to participate in English music halls in earnest at the turn of the century when women became more prominent on stage. The goal was to graduate from the chorus to a role as a featured singer or dancer. For the beautiful but less talented, there were the popular 'living pictures' of models posing in classical or patriotic tableaus. Some models found this preferable to London's nightclub scene, and equally effective as a way to catch the attention of artists and earn extra money.

A rare few went on to cinema or legitimate theatre, where modern women were asserting themselves in contemporary productions. 'We have our new woman, it is true,' wrote a reviewer in *The Globe* in June 1912, after seeing

*The Amazons* at the Duke of York's Theatre. 'The 20th century variety that does not regard it as a necessary part of the game to wear bloomers.'

The dream of being a great stage beauty was further ignited when the sensational Evelyn Nesbit secured a contract to appear in the British musical revue *Hullo, Rag-Time!* in 1913. Nesbit was the Gibson Girl ideal come to life. Her appearance drew raves, and when Oscar Hammerstein caught her act at the London Hippodrome, he immediately offered her $3,500 a week to perform in New York. What Soho model toiling in a chorus line could resist imagining herself in Nesbit's shoes?

****

Despite being largely anonymous as individuals, artists' models as a group had become 'a thing' by the turn of the century, due in no small part to the theatre. The idea of a desirable young woman trying to get by in a man's world had been intriguing the public since 1895. That was when *An Artist's Model*, a two-act musical comedy, was first staged. It was followed by light comedic fare in the same vein – *A Gaiety Girl*, *The Shop Girl*, *The Circus Girl* – all of which were more respectable than old-style musical farces.

In 1913, the prolific Nita Rae wrote a play entitled *Only An Artist's Model*, making the transition from comedy to drama. It enjoyed success in London and on tour. When the production travelled to Glasgow, management's dissatisfaction with certain cast members resulted in a succinct advertisement for three replacements: 'Wanted, through disappointment, good Juvenile Leading Man; young, must have power and pathos; also tall. Dramatic Chambermaid with plenty of dash and go. Fast Woman part. Age, height, recent photo, and last three refs.'[43]

While the storylines on stage were pure fiction, there was just enough real-life success to keep hope alive for young women thirsting for the footlights. One notable success was Meum Lindsell-Stewart, a young typist who crossed over from modelling to theatre, song and dance. In 1918 she appeared as 'Envy', one of the Seven Deadly Sins, in *As You Were* at the London Pavilion. That same year Lindsell-Stewart bore a child with the sculptor Jacob Epstein, for whom she also modelled. Epstein's wife Margaret accepted her husband's affair and agreed to raise the child, Peggy Jean, in their home. The artist would complete more than a dozen studies of the little girl.

As a side note to 'Envy' – if the irony didn't strike a chord with Mrs Epstein during Lindsell-Stewart's tenure, it surely did in 1920 when her husband's

next great love came along. Kathleen Garman was an intellectual flapper half Epstein's age. She would become the artist's 'second wife' – his mistress until his death – and bear him three children. It was a rough start in the Epstein household. After six months of seething, Epstein's wife locked Garman in a room and shot her. Fortunately it was just a flesh wound in the shoulder.

Although Epstein moved on from Lindsell-Stewart, the one-time typist didn't suffer from her association with the sculptor. She had a stellar professional arc as a model and an actress (she was called 'one of the best of the younger brigade'), and as an editor of women's poetry in the 1940s. Lindsell-Stewart was much more than just a pretty face – and yet without the Epstein connection, she may have struggled to find fame.

Lilian Shelley had a similar arc at a similar time in history. Shelley was triply blessed with pocket-sized Renaissance beauty, a pretty singing voice, and perfect comedic timing. She performed in music halls as the comedienne Crazy Lilian Shelley and toured in regional revues. At the Golden Calf Shelley would often come into the audience to hob-nob with the artists, her black hair gleaming against the golden Egyptian headbands she favoured. She eventually fell out with Frida Strindberg over non-payment of fees, but her reputation as a model was established by then.

Shelley posed for two exceptional sculptures by Jacob Epstein, who recalled the sittings well. 'Of Lillian Shelley I made two studies, an early head and later an elaborate bust,' Epstein would recount decades later. 'Of the head I remember that when I was exhibiting it, the model turned up while I was in the Gallery, leaning on the arm of a gentleman who turned to me and said self-righteously, 'Yes, I can see that you have depicted the vicious side of Lillian.' I answered that he 'knew her perhaps better than I did. ... In truth I had made a head expressive of innocence and sweetness. A short time later the gentleman who had so offensively rebuked me was kicked to death in Cornwall by the miner father of a girl he had attempted to seduce.'[44]

London-born Betty May (née Golding) was not a full-fledged model, singer or dancer, but was a little of all three. She grew up in Canning Town in extreme poverty, sleeping on rags and living for a time in a brothel with her estranged father. May was a volatile, green-eyed dervish who spent her life trying to climb the ladder into proper company. She was doomed from the start.

Betty May's exotic features caught the interest of Augustus John, Michael Sevier, Jacob Epstein and the painter Jacob Kramer, among others. Kramer's 1919 painting *The Sphinx* likely shows either Shelley or May – both sported pitch-black hairstyles and headbands at the time. May claimed that she was the

sitter, but the face is too stylised to tell if it depicts her olive skin and huge, dark eyes, which in any case are closed in the portrait.

May had the beauty, the figure, the sinuous movements and the ferocious magnetism to make a success of professional modelling, and the camera loved her. But her drug and alcohol use, her predilection for violence and her dabbles in the occult all served to distance her from the acceptance she seemed to crave. She disappeared from London for a number of years before dying in obscurity.

When Epstein decorated the massive underground columns of the Cave of the Golden Calf in 1912, he created plaster sculptures in brilliant colours intended, as he put it, 'to capture the youthful and the elderly rich'. He found the London club scene personally distasteful, but was tolerant of the late-night behaviour of models such as Shelley, Dolores and May. However, he placed a much greater value on anonymity.

> *I would prefer to work from models who are not known, but often a pestiferous journalist will nose around and get on familiar terms with the models. He mentions them in the press. That very soon turns their heads, and they become characters with 'a public' … Lillian [sic] Shelley, the temperamental, was of course beautiful, and likewise Dolores was beautiful; but their devotion to art ceased when they left the model's stand. Betty May also shared in their beauty and notoriety, and I did two studies of her. The notion that I worked only from models of this kind was severely commented on in the newspapers, and one of my exhibitions was characterised, I recall, as nothing more than an exhibition of semi-Oriental sluts. How pharisaic![45]*

****

Not all the women who spanned the studio and stage at this time were a cautionary tale. Perhaps genetics helped. Chattie Salaman (née Wake) was descended from Hereward the Wake, the leader of local resistance against the Norman conquest of the eleventh century.

As was common with many well-to-do young women at the time, Salaman had a cross-cultural upbringing. She attended drama school, but it was her training at the Slade that put her in contact with the world of artists and modelling. She posed draped in orange robes for Duncan Grant's Berwick Church decorations (Grant would recall her 'kneeling on a garden dictionary' as the Angel Gabriel) and her soft features inspired works by other Bloomsbury artists, as well as

Augustus John. Later, Salaman's daughter Merula married Sir Alec Guinness, keeping acting in the family.

Another woman who successfully spanned stage and studio was the elegant Viola Tree, daughter of two thespians, Herbert Beerbohm Tree and Helen Maud Tree. Viola's quintessentially English features were immortalised by John Singer Sargent, Roger Fry and the caricaturist J.J. Binns.

She must have been too busy to sit still for long – her impressive professional credentials include numerous stage appearances and the management of the Aldwych Theatre in London. She went to America to storm Broadway and the Ziegfeld Follies, and upon returning to England, became a director, film actress, screenwriter and author in the 1920s and 1930s.

*Portrait of Iris Tree:* the poet and model burned bright on the London arts scene in the early twentieth century.

Viola had two legitimate sisters: Felicity, also an actress, and Iris, a much-sought-after artists' model. The Tree sisters also had seven half-siblings, courtesy of their father's aversion to monogamy, some of whom made a living in the creative arts.

Iris Tree may have found her sister a bit intimidating, or perhaps she was too rebellious to go straight into the family business. Instead Iris became partners in crime with her girlhood friend, Nancy Cunard. The two lived a wild early life, and Tree gained a reputation for being unbalanced, holding all-night parties with Cunard at a secret flat in Fitzroy Place. She indulged in bad behaviour with the Corrupt Coterie and was an unapologetic sybarite before the age of 20.

In 1915, an 18-year-old Tree put pen to paper to scold a much-older Clive Bell for ignoring her advances. She scrawled:

*You are a very foolish man to have rejected the steely sword-play of my glances and the passionate pressure of my hands ... Do not neglect the Chelsea embankment, you may see myself and [Augustus] John blown there with the dissolute leaves in a savage wind, black-hatted and black-kerchiff'd – And you may see a streak of orange liquid across the sky, a tangerine plume nodding over the river to remind you with a pang of the high-lights in my fringe.*[46]

Tree sat for Bell's good friend, Roger Fry, that same year. In the painting she leans back with a sidelong look, refusing to make eye contact with the artist. If this took place in the midst of rejection, Tree may have been telegraphing her reluctance to give up on Bell without a battle. One of Nancy Cunard's lovers, the writer Michael Arlen, penned *Piracy* in 1922 about the parasitic London café society, and tellingly based the character of Lois Lamphrey on Tree.

A prolific artists' model, Tree would go on to sit for Amedeo Modigliani, Wyndham Lewis, Jacob Epstein, Man Ray, Alvaro Guevara, Nina Hamnett and Augustus John. She became close to the Bloomsbury Group, which led to portraits by Vanessa Bell (Clive's wife), Duncan Grant and Dora Carrington, among others. Lady Ottoline Morrell photographed Tree at Garsington Manor and Charleston Farmhouse.

Tree never lost her sharp wit or taste for adventure. During a visit to her sister Viola in Italy she wrote of 'eating bohemian spaghetti'. She was also an accomplished poet, publishing her first book of almost 100 poems in 1920. Making it clear that she feared being shackled by the mores of the times, she wrote:

*You preach to me of laws, you tie my limbs*
*With rights and wrongs and arguments of good,*
*You choke my songs and fill my mouth with hymns,*
*You stop my heart and turn it into wood.*[47]

Twice married, Tree went on to write Hollywood screenplays, tour in theatrical productions and appear in a few films, including in a thinly veiled role as herself in Federico Fellini's *La Dolce Vita*. Through the lens of time, however, Iris Tree is best remembered as a muse to many of the greatest artists of her time – a testament to how she prevailed through all the nonsense to take a stance as a modern woman.

When the Tree sisters were still girls, a daring 27-year-old was creating a commotion that bridged art, photography, stage and fashion. Lady Constance Stewart-Richardson was a renegade aristocrat, the daughter of the 2nd Earl of Cromartie. She was a champion swimmer, a big game hunter and an avid performer of classical dance. As a noblewoman, she placed herself squarely on

A demonstration of barefoot dancing by Constance Stewart-Richardson, published in her shocking book, *Dancing, Beauty, and Games* (1913).

the wrong side of the Court of Edward VII by dancing barefoot and scantily clad in London theatres.

Just months after Stewart-Richardson attended the 1910 Chelsea Arts Ball as a cowboy, King Edward VII died of complications from poor judgement – namely, smoking dozens of cigarettes and cigars a day. By that time Stewart-Richardson's name had been struck from the royal records and she was a social pariah. This merely encouraged her to try vaudeville, and she eventually found a more open-minded reception in America.

The Russian sculptor Prince Paolo Troubetzkoy captured Stewart-Richardson's expressive figure in bronze in 1914 at a life-changing time for her. She was widowed that year by the war, and had posed twelve months earlier for a series of dramatic dance positions. She published these in a sensational book entitled *Dancing, Beauty, and Games*. Always fearless, 'Lady Connie' told an American newspaper in 1921, 'Every woman should learn to dance, and certainly dance with as few clothes on as the law would allow.'[48]

**** 

It is worth noting that models were not the only ones at the intersection of art and theatre in early twentieth century London. Artists were there too, employed to create scenery and costumes for stage productions, and not always with the best results.

Consider the lot of Alfred Wolmark, a Russian artist living in London in 1914. Wolmark was the plaintiff against Mr W.H. Baker of Regent Street. As given in court testimony, Wolmark was asked to create scenery and costumes for a play called *The Birthright*. The artist produced preliminary models, which he claimed were approved. Mr Justice Horridge, upon seeing a photograph, commented that they looked like a Futurist painting.

The defendant contended that the designs were 'of a nature not understood by the public' and denied any breach of contract. Things got worse for the artist as more witnesses took the stand. As reported:

*Mr Kenvyn, an actor, said the play was staged at his model theatre, and when the curtain went up the scene was greeted with laughter … Mr Paterson, a theatrical contractor, expressed the view that if the plaintiff's model was reproduced on the stage the audience would make rude noises, even if they did not throw things.*[49]

Alfred Wolmark was awarded a token £6 in damages for his artistic vision.

The influence of the footlights on women's fashion could be equally amusing. Witness the chanticleer hat for ladies in 1910. When this cringe-worthy fashion statement made its appearance in London, Paris and New York, it was as a tribute to the must-see play, *Chantecler*. *Chantecler* fever spawned fancy-dress parties, satires and animal-themed imitations in every corner of popular culture.

There are a number of chanticleer-hatted women pictured in 1910 photographic portraits, but apparently not in paintings. Perhaps the sitters and artists had an aversion to immortalising dead bird parts. By winter the chanticleer hat had thankfully run its course, but not before the ladies of London opened their morning newspapers and read a tongue-in-cheek poem entitled 'Chanticleer Et Al.' As reprinted in London from *The New York Times*, a wit had written:

*A chanticleer hat, with the tail and all that,*
*And the chanticleer jacket are here.*
*And similar styles from the coop and the sty*
*Are certainly bound appear.*
*In keeping with all of those fashionable fads*
*We will learn how to cackle and cluck.*
*And professors will teach us at so much an hour*
*To waddle along like a duck.*
*While the women are wearing the latest designs*
*To be furnished by rooster and hen,*
*A beard like the wattles a gobbler displays*
*Would be fetching and fine for the men,*
*But to copy the mode of the bird that we serve*
*At holiday time there's no use,*
*For the person that wears these sartorial freaks*
*Alas! is already a goose.*[50]

*Chapter 15*

# The Changing Dais

'This island seems to me a place well worth the curiosity of a man of taste, on account of the charm of the country and the beauty of the race.'
   – *The Sphere,* quoting a letter about England by Peter Paul Rubens, 1917.

Today, the tools of the modelling trade have changed and the profession has emerged from the shadows. The employment of female models has come a long way since Harry Furniss suggested that a pretty model sympathetic to a penniless artist might darn his socks, cook his chop and get him a cup of tea.

Furniss wrote that in 1904. It would take decades for unions to improve the well-being and compensation of models in London. Across the Channel, French unions had become more diligent, if sometimes excessive, in their regulation of working conditions. In 1947, British artists mulling Paris sojourns were warned by one newspaper that, 'The Models' Union fixed higher rates to-day for goose flesh on nudes posing in unheated Paris art studios.' It was well to plan ahead.

Models in London faced a challenge of a more personal nature in the early twentieth century. This was when women from all walks of life were starting to establish their own identities, but a model's identity was often tied to the artists in her sphere. This centuries-old dynamic placed the artist at the top of a hierarchy of patrons, dealers, models and commissioned sitters. Even the muses – women who achieved public recognition as partners in the creative process – were subsumed by the artist's vision.

Unsurprisingly, this aspect of the artist-model relationship has changed little over the centuries. Artists have always had a hand in how women present themselves in the creative process – from clothing, hair and props to posture, gaze and body language. Simple enough in theory, creative integrity may be tested in practice. Such was the case in early post-war London, when society portraits were the most dependable source of income for cash-strapped artists.

What was an artist to do if a wealthy client insisted on a prettified vision, compromise or stand fast? That dilemma was painfully obvious at one London gallery in 1918, when the pall of war still hung over the art market. A reviewer put it bluntly: 'The portraits for the most part had every quality save

that of sincerity … the sitters liked them because they produced in the sitters the illusion that the sitters were really what the sitters wanted to be.'[51]

Soon someone new stepped into that intimate space between artist and model – the modern fashion photographer. The fashion connection between models and popular culture had been on the rise since 1911. That was when Edward Steichen photographed models in dresses by the Parisian designer Paul Poiret. The images were published as a pictorial in the magazine *Art et Décoration*. Steichen was American and *Art et Décoration* was French, but the English took note. Fashion photography had arrived.

When famed British photographer Cecil Beaton posed a professional model in shades of red for *Vogue* magazine in 1946, he captured an iconic moment in the evolution of fashion. Beaton used the image to proclaim, 'The second age of beauty is glamour.' It was a revolutionary use of photography as a cultural force, and yet his statement seems insupportable given the diverse nature of beauty.

Thousands upon thousands of women have inspired artists with their beauty over the centuries, and very few of them have had the benefit of anything even remotely akin to glamour. Many were poor, most were nameless and no amount of research will resurrect them to a place of recognition. Rarely, an identity can be unearthed and held up to the light. And that is how this part of the story ends, with a woman who slipped through the cracks as a model: Rosalina Pesce.

Rosalina (Rosalinda) Pesce was a teenage Italian immigrant-girl living in the Montparnasse area of Paris in 1896 – the year the sculptor Louis-Oscar Roty received a commission from the French Minister of Finance to design some new coins. Roty repurposed an idea he had a decade earlier: a striding female peasant. He changed the sturdy peasant figure into a slim Marianne (symbol of the French Republic), placing a liberty cap on her head and a seed bag under her arm.

Rosalina Pesce was not a professional model; she was barely more than a child. Roty likely saw her in the neighbourhood and felt she had some of the qualities he needed for his Marianne. She reportedly was paid only about 5 francs to pose in his studio for reference photographs in mid-stride. Some publications incorrectly attributed the photographs of Pesce to Charlotte Ragot, a model for Roty on prior projects. Ragot appears to have retired from modelling by that time, but the mistake would be repeated as fact ad infinitum.

How much of Rosalina Pesce appears in Roty's final design is a matter of conjecture. The figure of Marianne is certainly more lithe than Pesce's, leading some to believe that Marianne has Pesce's face but not her body. It may be that Roty simply took creative license with the final design or used

a composite approach. One thing is not in dispute: the immigrant girl was instrumental to the creative process.

There was some backlash to Roty's depiction of Marianne, which became known as *La Semeuse* (The Sower). In the end the design prevailed on the half, one and two franc coins, and on a French stamp in 1903. *La Semeuse* became one of the most recognisable pieces of art in Europe, while Rosalina Pesce faded into anonymity and apparent poverty.

On 10 March 1935, the *Sun* newspaper of Sydney, Australia noted that, 'The model [for *La Semeuse*] died penniless a few years ago.' Although the woman is unnamed, the circumstances sound like Pesce and not Roty. The date correlates with a second news item printed nearly six years earlier in London. On 20 November 1929, the *Daily Herald* ran a tiny headline, 'Famous In Obscurity.' It was followed by a single sentence: 'Immortalised on French coins as the figure of the sower, Maria [sic], formerly one of the most celebrated of artists' models, has died in poverty and misery at La Creusot, near Paris.'

That was it – no name, no photograph, no kind words from friends or family or sculptor. If this was Rosalina Pesce, as seems likely, she lived fewer than fifty years. She was notable only in death, and barely then.

Pesce was not English, nor was she French for that matter. She would have felt lost on the streets of Soho. Nevertheless, she shares a story with countless young women of early twentieth century London. They too stepped out of the shadows, however briefly, to leave their indelible mark on art.

# Part Six

## THE AVICO SISTERS

# A Revelation

'Marietta had beautiful skin, like satin. As a child I would put my arm around her and stroke her shoulders. I remember that clearly.'
       – Christine Bassett, daughter of Gilda Avico, recollecting her aunt.

*Author's note:* The three Avico sisters – Marietta, Leopoldine and Gilda – were prolific artists' models in early twentieth-century London, but a well-kept secret in the years that followed. All three were born in the noughts of the new millennium. In another time and place they would have been characterised as steel magnolias, beautiful women of strong resolve and quiet significance. Now their story is being told after nearly a century of silence. The following account draws on historical and anecdotal research and the oral histories of Christine Bassett, daughter of Gilda Avico. Excerpts from the histories are shown as quotations.

## 1900–1909: The Beginning

The Avico family story starts in two countries 800 miles apart and meets in London on 20 May 1905. That was the day that Giuseppe Avico of Italy married Hélène Marie Genevieve Dreyfus of France. Hélène was a French teacher with the benefit of a well-rounded upbringing. She was 34 years old at the time of her marriage, one of three daughters of Louis Maurice Dreyfus, a wine importer, and Mary Anne Dreyfus (née Spillane).

Giuseppe Avico was thirteen years older than his wife – a charming man who made a living as a bootmaker in London and possessed an operatic singing voice. He reportedly had done some work as an artists' model in Pinerolo, near Turin, before emigrating from Italy. There is some indication that he may have been married once before Hélène, which would not be unusual for a man his age.

Within a year of their marriage, the couple welcomed their first daughter, Marietta, in 1906. Then came Leopoldine in 1907, Gilda in 1908, and Victor, the sole son, in 1909.

Four lively children in four years was a lot for any woman to manage as she neared the age of 40 – particularly given the economic circumstances of London

The family's mainstay and matriarch: Hélène Marie Genevieve Avico.

at the time. Fortunately Hélène had two sisters nearby: Mercedes Turner, known as Meme, and Blanche Watson. Both were married and living in London.

Theirs was an extended, close-knit family of extremes. Blanche had a single child, Carmen, while Meme had twelve children, eleven of whom survived. This gave the Avico siblings a dozen cousins to play with in their rough and tumble kingdom off Tottenham Court Road. Three of the cousins went on to become artists' models – Harold and Pauline Turner, and Carmen Watson.

From left: Leopoldine, Victor, Gilda and Marietta Avico.

Carmen was an ethereal child, a French-born blonde with a wide smile. As an adult she became the favourite model of the painter and zoologist Paul Ayshford Methuen, 4th Baron Methuen, who gave her away at her wedding, and of the renowned artist Ethel Léontine Gabain. Gabain co-founded the Senefelder Club in London to advance the art of lithography. She was a positive role model for Carmen, who posed for Gabain more than sixty times.

Leopoldine (left) and Gilda frame blonde cousin Carmen Watson, a talented model in her own right.

The newspapers called Carmen 'The girl artists keep painting, 12 hours a day for 6 years' and quoted her as saying that 'long hair, punctuality and an indefinable something are my greatest assets'. She cheerfully noted the rigours of posing, boredom and 'scrappy meals' under the melodramatic headline, 'Tragedy of an Artists' Model.'

But all that came later, well into the new century, when the Avico sisters were making their own imprint on London. First, the young Avico family would undergo trials by fire. There were difficult years ahead, but it was only a matter of time before fate intervened.

### 1910–1918: The Discovery

For the Avicos, the second decade of the new century began as a challenge and ended as a triumph. The children were growing up in a London of contrasts, where gracious residences rubbed shoulders with slums. If you were of limited means, your best chance to improve your situation was to be as industrious as possible – something that was more easily said than done.

Imagine yourself in Hélène Avico's shoes in 1910. She had four children under the age of five, few opportunities to use her skills as a French teacher, and a husband who was becoming increasingly ill. The family was crowded into three rooms in Windmill Street. As summer thunderstorms crashed over London, the weather must have seemed like an omen of things to come.

Hélène Avico was an intelligent woman. She took stock of the fact that she had become the sole source of wellbeing for her children. On 20 February 1912, she made the heart-wrenching decision to register Marietta, Leopoldine, Gilda and Victor at the St Pancras Workhouse in London. They were 6, 5, 4 and 3 years old.

Over the next few years the children would move in and out of St Pancras, as would their father. It appears that their mother would register the children during periods when she found it impossible to provide on her own, and bring them home as soon as she was able. Her husband's registrations show as a series of short and more frequent stints until he died at Hanwell Asylum on 27 October 1914.

Hélène Avico, now a widow in her early forties, did the sensible thing: she married a good man. William Callan was eight years her junior and already a father figure to the children when he and Hélène wed on 6 December 1914

Gilda (standing) with older sister Leopoldine, who offers her enigmatic smile.

('My Mum's marrying my Dad!' an excited Victor piped to a neighbour). It was a family affair, with the children standing at attention in matching sailor suits.

A photograph of Callan at the time shows a well-dressed man, solemn and relaxed – someone capable of providing the stability the children craved. But the reprieve was fleeting; by December 1917 Hélène would be a widow once again.

*It was just tragedy after tragedy. Hélène had a child by William, a little girl called Julia. I understand she had bright red hair, a lovely little girl. She died of pneumonia three years after she was born, and William got tuberculosis and died within a few months of his little girl dying. So poor grandmother, think what she'd been through. She'd struggled with a difficult husband, she'd been really strapped for cash, her children had been taken into the workhouse, her husband had died, she'd married again, her next child died, her second husband died, and there was the madness of a world war going on. It was a hell of a life if you think about it.*

Once again, it fell to Hélène to keep her family together. Within a year they would be rewarded for their resilience.

****

New Year's Day 1918 came and went in England with the war dragging on. *The Graphic* would lament in January that, despite Paris itching to 'begin again the old game of dressing up', it was impossible to imagine a return to gaiety in London. 'It is quite easy to invent a sumptuous frock', was the tongue-in-cheek advice of a fashion columnist. 'You take so many yards of magnificence, woven out of moonbeams, a star-spangled sky and opalescent sea … A day will come when our tea-gowns will be hoarded in museums, and our grandchildren will look at them in amazed wonder.'[52]

Underneath the flippant tone was a very real deprivation that was felt keenly by all who remained in London. The Avico siblings had something of an advantage here. True, they had lost two fathers, but their lives must have seemed bearable, even cheerful, after years of disruption. All four were bright, engaging children who flourished under the matriarchal influence of Hélène. If things weren't perfect for the family in 1918, they were better – and few Londoners could say that after more than forty months of war.

The sisters celebrated birthdays in quick succession that year aged 12, 11 and 10. Marietta, Leopoldine and Gilda were their mother's children, loyal to a fault and fiercely protective of little brother Victor, who had never been robust.

*To my grandmother, Victor was always her baby. He was never that well; he was very frail. He didn't appear that way when he modelled though. There was a study he posed for where he looked very handsome, very Italian. But he was never that interested in modelling, not like his sisters. He wanted to become a*

Christine Bassett, daughter of Gilda, in Nice, France, with her uncle Victor (1956).

*priest. At some point before he was ordained he decided that wasn't for him and
became a teacher. I adored him. He used to sing a lot and tell funny jokes, and
for a little girl that was lovely.*

Somehow, as a deadly influenza swept through Britain in 1918, the determined
little Avico family remained intact.

****

Suddenly the war was over. The Vicar of St Paul's noted that Christmas of
1918 was certain to be a holiday of 'unutterable gratitude'. Hélène Avico sighed
with relief; her children debated the likelihood of Christmas sweets. They
had adapted to sugar rationing along with the rest of England, and now the
shops were trumpeting their limited holiday inventories: 'We have received our
allotment of currants and raisins!' Where there were currants, could sweets be
far behind?

The economic recovery would be slow going in England, but Hélène had the
advantage of an educated eye in trying to make ends meet. Like many Londoners,
she would scour the newspapers for bargains. In between advertisements for
tuppence soups and 'Vi–Cocoa, the food beverage of war workers', Hélène read
about the proposed Fisher Act. It would eventually extend the compulsory
school-leaving age to 14, too late to apply to her brood.

The Avico children left school between the ages of 12 and 13 out of economic
necessity. Hélène may have wished things were different, but the immediate
need was to find work that would contribute to the household finances.

****

The turning point came on a chilly afternoon in 1918, during a summer when
hail the size of robins' eggs fell on London. It is easy to imagine the Avico
children flitting about the streets like fireflies that day. People hurried about
their business with no reason to notice four children among hundreds – and yet,
that is exactly what happened.

An artist, or perhaps two, came walking through Fitzrovia and spotted the
children by chance in Tottenham Court Road. This much is known:

*An artist from Saint Martin's came across the children and stood there watching
Marietta. Struck by such a beautiful child, he approached and asked to speak*

*to her mother – my grandmother, Hélène. She agreed that he could sketch Marietta. He then asked if all the children could come to his studio. This was arranged, and together with their mother they arrived at the studio. When the sketches were completed the artist showed his new-found muses to his fellow artists and they were struck by the beauty of the children.*

It is just as easy to imagine what might *not* have happened that day. If the children had decided to play indoors, their heart-shaped Avico faces would have been relegated to family photos. Or, had the London art schools bowed to pressure and moved away from classical training, the siblings' features – a fortuitous blend of Italian and French – may not have led to their steady employment.

Marietta as a newly discovered child model in London.

Then there was the family itself. The perception of models was shaded by social mores that often had little to do with art. Without the respectability associated with Saint Martin's and the Slade, it is doubtful whether Hélène Avico would have allowed her children to pose at all.

Instead, the stars aligned around a single chance encounter. Perhaps the artist in question was out for a walk with Nina Hamnett, the Queen of Bohemia, who lived in nearby Grafton Street and worked at the Omega Workshops. Hamnett was 28 at the time and could have encouraged her companion to speak to the children.

Or perhaps the girls looked up to see a giant, sad-eyed stork peering down at them, later introduced as Henry Tonks, the Slade's new Professor of Art. No one knows the identity of the artist with certainty, but for the Avico sisters, the consequence of that encounter was immortality.

### 1919–1939: The Legacy

There are few overnight successes in the art world, and even fewer for artists' models. For the first five years of their fledgling careers, the Avico sisters became steadily more sought-after as sitters. All three had developed a strong work ethic at a very young age. Marietta Avico, the oldest, had begun to model more extensively under the careful supervision of her mother.

Then, on 29 April 1923, a story in London's *Daily News* took the Avico children to a new level of recognition. 'I have found a whole colony of perfection,' gushed a reporter under the banner 'Child Faces Without A Flaw.' It was the first known mention of the extended family in the British press:

'Occasionally an artist finds a perfect human figure, face or foot and is delighted. I have discovered a whole colony of perfection. There are perfect heads, perfect figures, perfect feet, perfect colourings, and perfect hands, both male and female. You can shape the profile of Adonis from my males, and the figure of Aphrodite from my maidens. They live in Tottenham Street, off Tottenham Court Road, and in the family group are 16 living perfections.'[53]

The *Daily News* was one of the most popular newspapers in London in 1923. It must have been thrilling for Marietta, Leopoldine and Gilda Avico to open the paper and see themselves described in print as 'living perfections' – even though, with the nonchalance of youth, they thought of themselves as seasoned models by then.

****

One year earlier, in 1922, Marietta Avico had reason to grow up quickly. The 16-year-old had been modelling for the painter John William Godward for about eighteen months. They had a respectful relationship – she met his family and was sympathetic to his personal woes. Then she found herself drawn into his death.

Marietta posed for John William Godward's captivating painting, *Contemplation*, in 1922.

Godward was not a happy man. His great talent was for classic themes rendered in glorious detail. It was a style that had fallen out of favour, and Godward's return to London only made matters worse. At the age of 61 the artist was bitter and increasingly reclusive. He suffered from insomnia and a possible ulcer, and his dealer was retiring. He isolated himself as much as possible in a studio at the rear of his brother Charles's garden.

On Wednesday, 13 December 1922, Godward decided he had had enough. Despite selling a painting recently, he could see the steady march of modern art pushing him toward irrelevance. Outside, the sunshine had gone and a dreary rain was coming from the north.

When Charles returned home that evening, he heard that a delivery boy had been unable to get an answer at the studio despite the front door being open. Charles found his brother in a lavatory, a sign 'GAS' pinned to the closed door. The artist was lying on the floor, dressing gown over his head, head in a crate, with a gas ring positioned to ensure success.

Marietta Avico was called to give testimony at the Godward inquest. She described her impressions of the painter over the period of their acquaintance – a generally unhappy man, possibly in pain, who would pace his studio at night because he could not sleep.

On Tuesday, 12 December, he had instructed Marietta not to come again until the following Tuesday, as he was not feeling well. The teenager reported a telling remark he made: that 60 was long enough for a man to live.

The inquest was rapid and conclusive. On 22 December, the West London coroner returned a verdict of 'suicide whilst of unsound mind'. Godward's family had never been particularly enthusiastic about his art; now they were mortified by his death. They destroyed the artist's papers, including a possible suicide note, and did their best to forget what they saw as a source of shame.

The experience made a great impression on Marietta. No doubt the young model faced the inquest with all the contradictory emotions of an adolescent – shocked at the loss of a man she liked, ready to do her part, and a bit in awe at having her name in the papers.

These qualities of forthrightness and self-control would continue to define the Avico sisters as young women. Marietta moved on to more studio work, while Gilda and Leopoldine established their importance as life models before branching out according to their talents. As they explored different options they remained loyal to the Slade, the school that had given them their start.

In her book *Two Flamboyant Fathers*, author Nicolette Devas makes clear the importance of the Avicos as life models. 'The model sisters, Gilda and

Leo Avico, counted as a Slade institution. They stood on the throne for fifteen years and generations of students learnt to draw from their figures.'[54]

## Gilda Amy Josephine Avico (1908–2001)

Gilda Avico was the lively 'brunette third' of the Avico sisters and the youngest of the three. She is known to have sat for Ivon Hitchens and C.R.W.

Gilda enjoyed a diverse modelling career, from life classes and studio work to commercial photography.

Nevinson, among others. Nevinson was quoted by one London newspaper as saying that Gilda was lucky for him because he sold every picture of her that he painted. Small wonder: she was a beauty of perfect proportions who worked steadily as a model and gravitated toward the high-spirited Chelsea Arts Club.

London newspapers quickly realised that Gilda never took a bad photograph. Coverage of upcoming Chelsea Arts Balls showed her practising for the Club's famous tableaus – she graced the pages in fancy dress as a sun-worshipper, a clock-watcher and a mermaid in a lobster hat. Gilda's photogenic features made for an easy transition to commercial modelling, while her seemingly ageless Avico genes remained a source of admiration.

*Later in life my mother sat for a married artist who wrote to say that he had to dismiss her as a model because his feelings for her had become strong, and he didn't want anything to happen. What a lovely man. I have his letter but it is not something that should be revealed.*

Gilda had her own stories to tell. In one interview she recalled arriving at an isolated studio to model for a young artist. He told her that he had been ill, but was now well enough to work again. Instead of painting the canvas, he dabbed green, blue and red paint on his face until he 'produced a fair imitation of a Zulu in full war paint', she said, after which he 'put wild gipsy music on the gramophone' and danced until he fell down exhausted.

*My mother had an interesting life and she always maintained some connection with the arts. Her first husband, my father, Roy Wilson, was a graphic artist. When the second war began he was a conscientious objector, but once London got bombed and he felt his family was in danger, he joined the Special Forces. My mother's second husband, Joseph Eugene Nicolas – I called him Georgie – had a nightclub in Soho after the war called La Cave Club. I remember my father did a chalk drawing of Bacchus on the wall of Georgie's club. The two men were friendly.*

Gilda, like her sisters, was a woman who stood up well to adversity in public and allowed herself sorrow in private. Her first child by Wilson died at birth in 1937. Alone in her hospital bed she wept for the daughter she lost, but would rarely mention her again.

Gilda wed Roy Wilfred Wilson, father of Christine Bassett, in 1936.

## Marietta Thèrése Avico (1906–1983)

The eldest Avico sister managed to fit a modelling career, marriage, life in France and motherhood into the interwar period, in addition to her experiences with John William Godward.

Marietta's most enduring legacy as a model is arguably the work she did for Godward during the eighteen months of their acquaintance. She is credited with being the model for *Contemplation* (1922), one of the last paintings of British classicism, and very likely posed for four other works the artist completed in London: *Praxilla* (1921), *Ismene* (1922), *Crispinella* (1921) and *Megilla* (1921).

As with her sisters, Marietta found her way into commercial modelling, posing for a 1923 painting of an Irish lass to convey the charm of Irish lace at the British Empire Exhibition at Wembley. Two years later she married while still a teenager and left for France with her husband, Marcel L'Andrevie, effectively ending her modelling career.

*She was always so vibrant, it doesn't surprise me that she became a very, very young bride. Her new husband's father owned several hotels, and her husband travelled around to them for business. So there's Marietta, living in one of the hotels in France, missing her family, very bored, with nothing to do. She used to spend her time in the kitchens with the cooks, and that's where she learned to*

The model for *Crispinella* (left), painted by John William Godward in 1921, is likely Marietta (shown right, in her thirties).

*cook. And, oh, she was a wonderful cook! She had two children with Marcel, who was my godfather.*

*Marietta's husband died suddenly in France. It was quite a shock. But then, the way she met her second husband is a lovely story. It was during the next war. My mother's husband, Georgie, was working with the French to get certain men past the Germans, and sometimes the men would dine at our house in London. One young soldier was going back to Paris the next day. My mother said to him, I'm extremely worried about my sister. I've had no news of her. Could you get a letter to her? He wasn't allowed to carry anything, but he took Marietta's address in Paris. He met her, fell in love with her instantly, and they got married.*

Marietta and her second husband, Jean Lions, would eventually settle in California with their children. But before there was America or France or an end to modelling, Marietta would become immortalised for two very different reasons. Both involved Sir Nevile Wilkinson, a British officer of arms, artist, writer and expert dollhouse designer.

The Wilkinson story begins in 1907 when Marietta was barely more than a baby. That was the year that 3-year-old Guendolen Wilkinson rushed up to her father to say that a fairy had run beneath the sycamore tree in their garden. Guendolen's imagination inspired Wilkinson to create one of the world's finest dollhouses – Titania's Palace – designed to house the Queen of the Fairies together with her consort and princesses.

Wilkinson envisioned a palace that could be disassembled for transport and would travel around the world. James Hicks & Sons, Irish cabinetmakers, received the commission to build the elaborate design on a 1:12 scale. The palace's eighteen rooms were constructed of bronze and century-old mahogany and furnished with over 3,000 handcrafted works of art and miniatures. Work commenced in 1907 and finished fifteen years later.

The next part of the story has to do with Wilkinson as a painter. In 1916, as construction of Titania's Palace neared its mid-way point, Wilkinson was painting a portrait of 11-year-old Yvette Fitzjohn. Fitzjohn was the daughter of a colonel at Dublin Castle and an occasional sitter for Wilkinson. The artist would tell Yvette fairy stories to keep her from squirming while he worked. Oftentimes, her little friend Marietta Avico would be there to keep her company.

Those painting sessions, which happened simultaneously with the building of Titania's Palace, led Wilkinson to write a fairy story called *Yvette in Italy and Titania's Palace*. The book became the first in a series aimed at raising money for Wilkinson's charities. Its two main characters are Yvette, aged 12, and her friend

A peek inside Titania's Palace, which has tiny pictures of Marietta on some of its walls.

Marietta, aged 11, exploring the wonders of Italy together. The first chapter begins, 'Yvette was sitting for her portrait …'

Wilkinson brings the child Marietta alive in his prose: a practical little girl, intelligent, well-mannered and curious. Her personality comes through in the final chapter of *Yvette in Italy*, where Wilkinson explains to the girls that part of the purpose of a Preface is to make excuses for 'leaving things out that ought to be in, and leaving things in that ought to be out, and all that kind of thing'. Yvette worries about the readers: 'but however can they tell what's in or out until they've read it?'

Marietta has a solution. 'It's quite clear that the Preface ought to be at the end of the book … [we] better just say – we are very thankful for people's help who have helped, and hope they will accept this, the only intimation – I'm certain I've read that somewhere.' When Wilkinson replies that a Preface can't come at the end, Marietta says, 'Call it Afterthought, then.'[55] And so it was done.

In 1922 the two Avico-Wilkinson strands intersected. First, *Yvette in Italy and Titania's Palace* was published. That must have been great fun for the teenage Marietta, who was now modelling in London.

Second, when Titania's Palace was formally 'opened' by Queen Mary in July of 1922, a number of tiny paintings of Marietta hung on its walls. Wilkinson, who oversaw the décor of many of the rooms himself, had sought out the Avico girl who had kept Yvette company years earlier and asked her to pose.

In 1927, long after Yvette and Marietta had last seen each other, they joined Wilkinson for lunch in London. Marietta was no longer the child who watched Wilkinson paint, or the teenager who posed for Lilliputian portraits – she was a young mother. She came from France for the occasion with her 5-month-old baby in her arms.

### Leopoldine Henrietta Juliana Avico (1907–1979)

Leopoldine, or Leo as her family called her, earned a reputation for absolute professionalism at the Slade School, where she enjoyed a long tenure. Leopoldine was reserved by nature, bordering on the enigmatic. This was a valuable quality

A demeanour of quiet strength made Leopoldine a favourite model of sculptors such as Gilbert Bayes and Herbert William Palliser.

in a model, and it brought her opportunities to pose for iconic sculptures that can be seen on the streets of London today.

One of Leopoldine Avico's most majestic representations can be seen in the sculpture *The Queen of Time*, a commission undertaken by Gilbert Bayes in 1930. Towering over the entrance of Selfridges department store and framed by the twin-faced Great Clock, Leopoldine rules Oxford Street from the prow of the ship of commerce. Bayes chose bronze for her commanding figure and decorated it with Doulton stoneware.

The 11ft tall Queen exhibits all of the characteristics that made Leopoldine an extraordinary artists' model: distinctive face, impeccable proportions, regal carriage and a feeling of great strength held in reserve. There is no sign of the inscrutable smile that graces a hidden gem of a London sculpture unveiled a year earlier.

That sculpture, near Southwark Bridge, is the work of Herbert W. Palliser and is known variously as *Bacchante* and *Spirit of the Grape Harvest*. It was created in

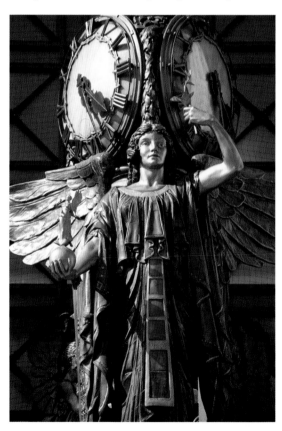

Leopoldine rules Oxford Street as *The Queen of Time* above the entrance of Selfridges.

tympanum relief circa 1928 for the portico of Vintry House. Palliser presented his model in an entirely different light than Bayes did in *The Queen of Time*.

Palliser carved Leopoldine in Portland stone, draped in grapes and flanked by goats, with doves arching overhead and the Vintner swans on each side. It is arguably one of the most beautiful outdoor sculptures in London, both gentle and provocative. When the original hall was demolished in the mid-twentieth century, the relief was salvaged and reinstalled.

In October of 1941, when *The Daily Sketch* announced Leopoldine's engagement to Henry Karl Nicholson Jones of the Royal Navy, the paper noted that the model, 'watches the busy traffic in Threadneedle-street from the top of a famous bank'. This was another reference to Leopoldine's commanding presence in London, presumably by sculptor Charles Wheeler.

As fate would have it, Leopoldine's modelling career was more enduring than her marriage. The dashing Nicholson Jones had arranged a meeting

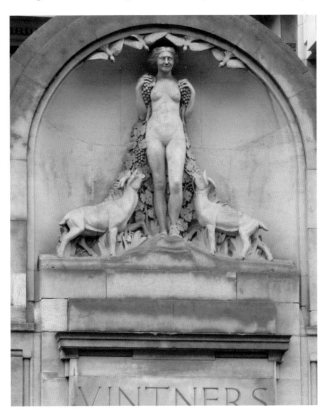

Palliser's tympanum relief (circa 1929) owes much to Leopoldine's mesmerising smile; it is now installed on Vintners' Hall, London.

with Leopoldine after he saw a photograph of her at a friend's house. Instant attraction proved no guarantee of a successful union, but the couple did welcome a son, Roger Nicholson, who would become Britain's most influential dulcimer player.

*Where Marietta was beautiful, Leo was striking. She had such a distinctive face. And she was a second mother to me. I could turn to Auntie Leo with all my little troubles. When her husband left her she was very proud, she never asked a penny of anybody. She worked hard, her place was immaculate, and she brought her son up on her own without needing any outside help at all.*

In 1937 Selfridges again turned to Gilbert Bayes for its celebration of the Coronation of King George VI and Queen Elizabeth. Leopoldine's distinctive features graced the enormous, symbolic figure atop *Let Peace Prevail*, a towering sculptural achievement that rose 75ft above the building's roof (more than twice that height above the pavement). As the winged Peace, she dominated the massive central decoration.

*Let Peace Prevail* wasn't the only contribution to the Coronation provided by the extended Avico-Turner-Watson family. Among eighteen smaller panels mounted for the occasion was one representing India by the Yorkshire sculptor Joseph Hermon Cawthra. Avico cousin Carmen Watson posed in traditional Indian dress for the female figure in that tableau.

Leopoldine Avico's lengthy career was a credit to her professionalism and her versatility as a model. As late as 1958, she added her signature to a letter requesting better compensation for models at the Slade. As she and the other twenty-four signees pointed out, the school was lax in increasing the rate of pay for figure models and head models. They respectfully requested that the Slade align its rates with other London art schools at that time.

Leopoldine signed her married name, Nicholson, but there would have been no question that she was an Avico – and that carried weight. This was a family that had inspired countless artists over decades of work. The painter Harold Speed is a case in point. He conveyed both respect and friendship for his model in the title of his regal portrait, *Miss Leo Avico*.

In one sense, the lives of the Avico sisters were broadly representative of early twentieth-century London models. At the same time, their contributions were unique. These strong, independent women left an indelible imprint on the art and architecture of London. Their legacy is that much more remarkable for having been hidden for over a century.

The enormous scale of the winged Peace, modelled by Leopoldine, is evident in this 1937 Coronation booklet.

# Compendium of Models

Each of the female models identified in this book – famous, infamous or anonymous – contributed to the arts of early twentieth-century London by choosing to act on the opportunities at hand. They range from charwomen to aristocrats, with motivations just as diverse: income, fame, love, prestige, vanity, lust, patriotism or simple curiosity. Some were artists themselves. Based on the single parity of personal choice, they have become part of this story.

**Andrée, Ellen** – (b. circa 1856 France, d. 1933). The multi-talented Andrée was an actress, comedienne and artists' model who sat for Édouard Manet, Auguste Renoir, Edgar Degas, André Gill and others. She famously posed as an absinthe drinker for Degas's reviled painting *Dans un café* (later *The absinthe drinkers*) and consequently had to contend with the public's assumption that she was an alcoholic.

**Angus (Sickert), Christine** – (b. circa 1877 England, d. 1920). Angus was an art student who became the much younger second wife of the artist Walter Sickert. She served as a model for her husband in domestic scenes. Her death from tuberculosis, shortly after the couple purchased a house in France, caused Sickert to spiral into depression.

**Asquith, Lady Cynthia** – (b. 1887 England, d. 1960). Socialite, author and personal secretary to the writer J.M. Barrie, Asquith would inherit most of his estate. She became known as an author of ghost stories and writings about the British Royal family. Later she served as an editor of anthologies. Asquith sat for portraits by Edmund Dulac, Augustus John, Ambrose McEvoy, John Singer Sargent and others.

**Aubicq, Yvonne** – (France, dates unknown). A mistress of William Orpen, Aubicq met the painter during the First World War when she was a young nurse and he was a British war artist. Aubicq is best known for her semi-draped pose in Orpen's 1917 painting *The Refugee*. The work was later renamed *The Spy* by Orpen to coincide with an outrageous story he told to a War Office official.

**Avico, Gilda** – (b. 1908 England, d. 2001). The youngest of the three Avico sisters, she reigned over life classes at the Slade for fifteen years and sat anonymously for artists such as Ivon Hitchens and C.R.W. Nevinson. Her photogenic features often appeared in newspaper coverage of Chelsea Arts Ball tableaus, paving the way for a commercial modelling career.

**Avico, Leopoldine** – (b. 1907 England, d. 1979). The middle-born of the three Avico sisters, she enjoyed the greatest longevity as a professional model. Her most iconic pose is as *The Queen of Time*, the Gilbert Bayes sculpture in which her figure towers over the entrance of Selfridges department store in London. Avico also modelled for Herbert William Palliser's *Bacchante (Spirit of the Grape Harvest)*, installed at Vintry House in 1929, as well as other sculptural works and paintings.

**Avico, Marietta** – (b. 1906 England, d. 1983). The eldest of the three Avico sisters, she opened a gateway to modelling for her siblings. Her Italianate features and form drew the attention of the painter John William Godward, who used her almost exclusively as a model from early 1921 until his death eighteen months later. Avico is also associated with Titania's Palace as a model, and as a character in the *Yvette* series of books.

**Barnes, Cissie** – (b. 1910 England, d. 1979). The daughter of a fisherman from Newlyn West, Cornwall, the teenage Barnes posed numerous times for the artist Dod Procter. Procter's painting *Morning*, featuring a dozing Barnes, was shown at the Summer Exhibition of the Royal Academy in 1927 and was awarded Picture of the Year.

**Barrett, Mrs** – (England, dates unknown). A mystery model used by Walter Sickert, Barrett was identified as a London dressmaker in the artist's 1906 note to one of his mistresses. Her identity remains a source of widespread speculation. A model identified by the artist as Mrs Barrett also appears in various Sickert works styled in a range of clothing, from affluent dress to coster (street vendor) garb.

**Barry, Iris** – (b. 1895 England, d. 1969). A renowned British film critic and curator, Barry first was a protégé of Ezra Pound and companion to the artist Wyndham Lewis from 1918 to 1921, when she bore him two children. She memorably sat for his painting *Praxitella*, a fearsome portrait exhibited in 1921 in which Barry is ensconced in an armchair looking like a giant insect.

**Beerbohm, Agnes** – (b. 1865 England, d. 1949). Beerbohm was a mistress of the artist Walter Sickert while he was married to his first wife, Nellie Cobden. Fond of fancy dress, she may have posed for Sickert for several paintings in costume, although the titles name her sister Marie. The Beerbohm family was a literary and acting dynasty that included the actor Sir Herbert Beerbohm Tree and his model-actress daughters, Iris, Viola and Felicity.

**Beerbohm, Marie** – (b. circa 1890 England, d. unknown). Marie was a great friend of the artist Nina Hamnett, with whom she spent time in Paris in the social circles of Picasso, Brancusi and other modernists. She met Walter Sickert through her sister Agnes and through Hamnett, who had a flat across the street from Sickert's Fitzrovia studio. All three women would model for Sickert from time to time.

**Bell, Vanessa** – (b. 1879 England, d. 1961). An influential painter and interior designer, Bell (née Stephen) is credited with co-founding the Bloomsbury Group with her sister Virginia Woolf. Bell modelled extensively for Bloomsbury members and achieved critical acclaim as a painter. She may be best known for the cultural community she nurtured at Charleston Farmhouse in East Sussex and for the distinctive style of decorative art she developed at Omega Workshops in London.

**Bingham, Henrietta** – (b. 1901 United States, d. 1968). Bingham was born into enormous wealth as the wild-child daughter of Robert Worth Bingham, a Kentucky newspaper publisher and politician. Her escapades personified the devil-may-care excesses of the Jazz Age. In England, where her father served as US ambassador, she took numerous lovers of both sexes and embarked on an affair with Dora Carrington, appearing as a subject in several of her paintings.

**Boreel, Wendela** – (b. 1895 France, d. 1985). Boreel was the daughter of a Dutch diplomat father and an American mother. She grew up in England and studied art at the Slade School and at the Westminster Technical Institute. Boreel became an accomplished gouache painter and etcher. Walter Sickert first noticed her at Westminster – she was his student, apprentice and mistress, and sometimes served as his model.

**Boughton-Leigh, Chloë (Ellen)** – (b. circa 1868 England, d. 1947). Ellen Theodosia Ward-Boughton-Leigh's family called her Chloë – a name that would

become associated with paintings by Gwen John. John met the Boughton–Leigh sisters, Chloë and Maude, when the three were students together at the Slade School. Chloë became John's lifelong friend and posed numerous times for her, resulting in works of exceptional sincerity.

**Carline, Hilda** – (b. 1889 England, d. 1950). Carline (m. Spencer) is known as the first wife of the artist Stanley Spencer and as a sitter for some of his most famous works. She was also a renowned painter in her own right. Her 1923 *Self-portrait* depicts her as a candid, self-possessed modern woman two years before her marriage to Spencer and the erosion of her life. Divorced in 1937, she began to paint again despite poor health.

**Carrington, Dora** – (b. 1893 England, d. 1932). An intriguing second-generation affiliate of the broader Bloomsbury circle, Carrington was the daughter of a merchant and made waves at the Slade School by cutting her hair short. Her talents as a painter and decorative artist were overshadowed by her lack of confidence and by her deep devotion to the writer Lytton Strachey – a passion that would endure until his death and hers. She is the subject of numerous Bloomsbury portraits.

**Carter, Zillah** – (b. 1905 England, d. 1985). Carter, the daughter of noted actor Hubert Carter, had some success herself on the stage and later in film. Along with other actress–models of the time, she used the London social scene as a way to network in the arts community. C.R.W. Nevinson painted a striking portrait of Carter entitled *Zillah, of the Hambone*; it was exhibited at the opening of the Ham-Bone Club in 1922.

**Cavell, Edith** – (b. 1865 England, d. 1915). Cavell became a symbol of British fortitude when she was executed by a German firing squad on 12 October 1915. The First World War nurse is credited with working with Belgian and French colleagues to help more than 200 Allied soldiers escape from German-occupied areas. Cavell is an exception as a model in that she never chose to pose for portraits. The countless representations of her in art were created posthumously in her honour.

**Chaplin, Edith Helen** – (b. 1878 England, d. 1959). Born into aristocracy, Chaplin married Charles Vane-Tempest-Stewart, Viscount Castlereagh, in 1899

and became Marchioness of Londonderry. She was appointed Colonel-in-Chief of the newly established Women's Volunteer Reserve in 1914 and became the first Dame Commander of the Order of the British Empire in the Military Division. The many portraits of her show a strong woman evolving during wartime and peacetime.

**Charlton, Daphne** – (b. 1909 England, d. 1991). Charlton was an artist and the wife of George Charlton, a teacher at the Slade School where she trained. Variously described as a gorgon and an enchantress, she is the subject of notable portraits by Mary Adshead and by Stanley Spencer, with whom she had an affair. Charlton proved to be a lifeline for Spencer after the breakdown of his second marriage – she reportedly sat for weeks for his 1940 portrait *Daphne,* wearing a hat she bought in Bond Street for the occasion.

**Chicken** – See Powell, Emily.

**Cobden (Sickert), Ellen** – (b. 1848 England, d. 1914). Ellen (Nellie) Cobden was an English novelist and the first wife of the artist Walter Sickert, whom she divorced for adultery. Cobden's father was a radical politician who raised his daughter to be a cultivated woman. Sickert commissioned two portraits of her from James McNeill Whistler: *Arrangement in Violet and Pink: Mrs Walter Sickert* and *Green and Violet: Portrait of Mrs Walter Sickert.*

**Cooper, Lady Diana** – (b. 1892 England, d. 1986). Born Lady Diana Manners, Cooper was a legendary British beauty equally at home among bohemian artists, Jazz Age swells, the Corrupt Coterie and the political elite. The youngest daughter of the 8th Duke of Rutland, she married Sir Alfred Duff Cooper, a First World War hero. Her reputation as the most beautiful woman in England made her irresistible as a sitter to artists and photographers alike.

**Cunard, Nancy** – (b. 1896 England, d. 1965). Cunard was the very definition of a rebel heiress, a fierce civil rights activist and an unapologetic participant in the fast life of London, New York and the Continent. She became known as a muse, publisher, poet, editor and newspaper correspondent. Cunard was painted by Oskar Kokoschka and Alvaro Guevara, and posed for one of Constantin Brancusi's most famous sculptures. In 1927 she set up The Hours Press in Normandy to support experimental young writers.

**Daurmont, Hélène** – (Belgium, dates unknown). Hélène may have worked as a charwoman in London after arriving from France. Together with her sister Jeanne, she posed as a model for Walter Sickert for a period of about three months in the spring of 1906. Sickert introduced himself to the Daurmont sisters after he overheard them speaking to a policeman in French on a London street – they were trying to buy coffee, having just travelled to England.

**Daurmont, Jeanne** – (Belgium, dates unknown). Jeanne, the sister of Hélène, claimed she was a London milliner. The Belgian-born sisters posed as models for Walter Sickert in the spring of 1906 at his Fitzroy Street studio. One of the best-known paintings from that time is *The Cigarette (Jeanne Daurmont)*, in which a bare-shouldered Jeanne is shown in profile wearing only in a hat. Interviewed over half a century later, Daurmont would remember Sickert as a nice man who gave her cigarettes when she grew tired from posing.

**dell'Acqua, Carolina** – (Italy, dates unknown). Walter Sickert was captivated by the landscapes of Venice, but his epiphany came when bad weather forced him to paint indoors. It was then that he started to experiment with figures in domestic interiors defined by light and shadow. During his regular returns to Venice between 1895 and 1904, Sickert's favourite models were the prostitutes La Giuseppina and Carolina dell'Acqua. In *A Marengo*, the two women are shown gossiping together on a bed.

**Dennis, Cecilia** – (England, dates unknown). The raven-haired Dennis came to the attention of the public when the artist Mark Gertler committed suicide in his studio on 23 June 1939, a half-finished portrait of her nearby. Dennis was widely quoted in the newspapers as 'Gertler's favourite model', a title she may have bestowed on herself. There is some indication that she also sat for members of the Bloomsbury Group.

**Devas, Nicolette** – (b. 1911 England, d. 1987). Devas (née Macnamara) was the daughter of eccentric Irish poet Francis Macnamara and his Anglo-French wife. The impoverished family moved frequently, eventually settling close to Freyn Court where Augustus John and Dorelia McNeill lived a bohemian, communal life. Despite a budding career as an artist, Devas chose to concentrate on writing. *Two Flamboyant Fathers* is an autobiographical account of her childhood with Francis Macnamara and Augustus John.

**Dolores** – (b. 1894 England, d. 1934). Norine Schofield was a London-born model who inherited the performance gene from her father, a professional dancer and vocalist. Her parents financed her early dance training, but it wasn't until Schofield moved to Paris under the stage name Dolores that she came into her own. Returning to London, she thrived on the bohemian scene. Her most significant contributions as a model were in sitting for Jacob Epstein, who became her friend.

**Eaton, Fanny** – (b. 1835 Jamaica, d. 1924). Eaton (née Antwistle) would not have thought of herself as a trailblazer, but her work paved the way for models of colour in the early twentieth century. Upon arriving in England at the age of 16, she worked as a servant, married, had ten children and began modelling to help pay the bills. Her Pre-Raphaelite features quickly secured her a position as a portrait sitter at the Royal Academy, as well as studio work with renowned painters such as Dante Gabriel Rossetti.

**Elvery, Beatrice** – (b. 1883 Ireland, d. 1970). Elvery was born into a well-known merchant family in Dublin and attended that city's Metropolitan School of Art, where William Orpen taught painting. She was Orpen's student and became his model and friend. The two corresponded regularly – Orpen from London, where he relocated, and Elvery from Ireland, where she lived with her husband, the 2nd Baron Glenavy. She was a fixture in Dublin's social circles of literature and art.

**Esther** – (surname, nationality, dates unknown). Esther and her sister Rebecca were reportedly half-Jewish adolescents who sat for Jacob Epstein in the 1930s. Their dusky skin, dark eyes and distinctive features place them in the category of models of colour. By some accounts, Esther performed in nightclubs and developed more of a career as a professional model than did her sister Rebecca. Beyond that, very little is known about their identities.

**Feilding, Lady Dorothie** – (b. 1889 England, d. 1939). Feilding was one of ten children of the 9th Earl of Denbigh. She volunteered as a nurse and an ambulance driver in the First World War, transporting patients from the Front to the field hospital in Veurne. She was the first woman to be awarded the British Military Medal for bravery, and received the Croix de guerre from France and the Order of Leopold from Belgium. A drawing by General Hely d'Oissel shows Lady Feilding and a dog watching a bomb explode overhead.

**Fitzjohn, Yvette** – (b. circa 1910 England, d. unknown). Fitzjohn was the young daughter of a friend of the artist Nevile Wilkinson. Wilkinson would tell her fairy stories as he painted to make her stop squirming, and that experience led him to write a fairy tale, *Yvette in Italy*. The book became a series sold for charity. In each tale, Yvette travels to a different country accompanied by her real-life friend Marietta Avico, who would herself grow up to become an artists' model.

**Forrest, Nina** – See Lamb, Euphemia.

**Fry, (Sarah) Margery** – (b. 1874 England, d. 1958). Fry was a powerful voice for prison reform and social betterment in Britain. Born to Quaker parents, she was the sister of the art critic Roger Fry and through him became friends with the Bloomsbury Group. In 1921 she was appointed one of the first women magistrates in Britain. Fry was an infrequent sitter but a compelling presence, as seen in the 1939 portrait *Margery Fry* by Claude Rogers.

**Garman, Kathleen** – (b. 1901 England, d. 1979). Garman had a reputation for scandalous behaviour and was already established as an artists' model when she met Jacob Epstein in 1921. They had three children together. Garman was witty, intelligent and charming, with a rare beauty – she became Epstein's most influential muse as his mistress and, later, as his second wife.

**Garnett, Angelica** – (b. 1918 England, d. 2012). Garnett (née Bell) was the daughter of Vanessa Bell and Duncan Grant, although she grew up thinking her father was Vanessa's husband Clive Bell. Embraced by a disparate creative group as the 'daughter of Bloomsbury,' she had an unconventional upbringing that would inform her adult work as a writer and an artist. She appears as the subject in numerous artworks and photographs that document her life.

**Germany, Grace** – See Higgens, Grace.

**Gilbert, Lilian** – (England, dates unknown). Gilbert is generally identified as the pensive young woman who served as the model for several major works by Dod Procter, including *Girl with a Parrot* (circa 1925). She was a local Cornish girl, a resident of Newlyn where Procter lived and worked. Records from the late 1920s show that Gilbert (as Mrs Brood) also modelled for Harold Harvey, another Newlyn School painter.

**Gunn Children** – (b. 1920s Scotland, d. unknown). Pauline, Diana and Elizabeth were the children of the painter Herbert James Gunn from his first marriage. That union ended badly, and the children were wrongly told that Gunn had deserted them. When he came across the girls and their nurse by chance on a London outing, he made arrangements to paint them in secret. Gunn would find renewed inspiration in his second wife, Pauline, and reunite with his children as adults.

**Hamnett, Nina** – (b. 1890 Wales, d. 1956). Hamnett was a flamboyant artist who lived an unconventional lifestyle, dividing her time between London and Paris from 1911 through the 1920s. She became friends with towering names in art, including Amedeo Modigliani, Augustus John and Walter Sickert. Hamnett exhibited at the Royal Academy and worked with Roger Fry at the Omega Workshops. The many portraits of her trace her life from glorious independence to poverty and squalor as she succumbed to alcoholism.

**Hamonet, Marie** – (b. circa 1907 France, d. unknown). Hamonet was a young resident of Pléneuf, a village on the north coast of Brittany, France. This was where the artist Gwen John travelled in 1918 and 1919 to recover from her lover Rodin's death. Hamonet frequently posed for John during this period, as did a second local child, Odette Litalien. Hamonet appears to be about 9 to 12 years old in the sketches.

**Hartland, Winifred Grace** – (Great Britain). Hartland was a 'famous artists' model' invented by two American men to make money from a purported weight loss secret. Advertisements featuring Hartland and her story ran extensively in British newspapers circa 1912–1928. Some of the early Hartland testimonials showed a young, curly-haired beauty in evening dress and tiara, identity unknown; this was later changed to an obvious sketch.

**Higgens, Grace** – (b. 1903 England, d. 1983). Higgens (née Germany) was maid to Vanessa Bell in London, and then housekeeper and cook for over fifty years at Charleston Farmhouse in East Sussex. She stayed on at Charleston beyond the death of her employer Bell to take care of an ageing Duncan Grant. An inveterate diary-keeper, Higgens wrote entries about Bell and Grant, E. M. Forster, Virginia Woolf, Lydia Lopokova, John Maynard Keynes, Roger Fry and others who made up the Bloomsbury coterie at Charleston. Several paintings of her exist from this time.

**Ivens, Frances** – (b. 1870 England, d. 1944). Ivens was a female surgeon who led the newly formed Scottish Women's Hospital for the French Red Cross at the Abbey of Royaumont in the First World War. The all-female units were founded by Elsie Maud Inglis, a pioneering physician who persevered after a bureaucrat at the British War Office told her, 'My good lady, go home and sit still.' In 1920 the war artist Norah Neilson Gray depicted Ivens inspecting a patient at Royaumont in a painting accepted into the collection of the Imperial War Museum.

**John, Gwen** – (b. 1876 Wales, d. 1939). John was arguably the most important female artist of early twentieth-century Britain. The perception of her as a meek recluse is flawed, although she may well have seemed that way in comparison to her hard-living brother Augustus. In reality, John was a confident woman who lived life on her own terms: a long-time muse to the sculptor Rodin and a masterful painter who produced scenes of quiet import. Her friends and neighbours figure strongly in her art.

**Kelsey, Marguerite** – (b. circa 1909 England, d. 1995). Kelsey was a celebrated artists' model who was unparalleled in the 1920s and 1930s for her graceful demeanour and classic English beauty. These attributes, together with her stamina in posing, brought her decades of work as a professional model. Kelsey had a sympathetic personality and often became a friend to the artists she sat for. In Meredith Frampton's 1928 painting, *Marguerite Kelsey*, the model's couturier *garçonne* style is treated as a subject in its own right.

**La Giuseppina** – (Italy, dates unknown). See dell'Acqua, Carolina.

**Lamb, Euphemia** – (b. circa 1889 England, d. 1957). Lamb (née Nina Forrest) was a popular artists' model and the wife of the artist Henry Lamb. Her husband-to-be renamed her Euphemia after meeting her at the Café Royal in London. She led a promiscuous life even by bohemian standards, and took the occultist Aleister Crowley as a lover. The slender, pale Lamb was a charismatic model who inspired works by Ambrose McEvoy, Augustus John, James Dickson Innes, Jacob Epstein and others.

**Lanchester, Elsa** – (b. 1902 England, d. 1986). Lanchester was born into an unconventional socialist family that sent her to Paris to study classical dance at the age of 10. In 1920 she debuted a music-hall act and shortly thereafter

founded the Children's Theatre in Soho. She made her West End stage debut in 1922; two years later she and her partner, Harold Scott, opened the Cave of Harmony nightclub and cabaret in London. Lanchester's portrait by Doris Clare Zinkeisen celebrates her dramatic personality and trademark red hair.

**Les Demoiselles D'Avignon (The Women of Avignon)** – (Spain, dates unknown). Pablo Picasso created one of the twentieth century's most controversial works of art when he painted *Les Demoiselles D'Avignon* in 1907. His shocking Cubist masterpiece shows five nude women staring out of the canvas – it turned the traditional dynamic of the male gaze and the female subject on its head. All five figures are drawn from anonymous workers at a brothel on Carrer d'Avinyó in Barcelona, Spain.

**Lessore, Therese** – (b. 1884 England, d. 1945). Lessore was born into a family of artists and carried on the tradition as a painter in oils and watercolours. The Slade-trained Lessore was associated with the Camden Town Group and in 1913 became a founding member of the London Group. Lessore married her second husband, Walter Richard Sickert, in 1926, becoming his third wife. She sat for her husband and took many of the photographs he used for reference.

**Leveson-Gower, Millicent Fanny** – (b. 1867 Scotland, d. 1955). 'Meddlesome Millie' was the Duchess of Sutherland and an important figure in British social reform. Her prominence as a society doyenne was eclipsed by her work during the First World War, when she organised an eponymous ambulance unit that saw active service in Belgium. She later directed field hospitals in northern France, and was awarded the French Croix de guerre, the Belgian Royal Red Cross and the British Red Cross medal. She posed in a gown for John Singer Sargent, energy barely held in check, resulting in one of his most famous portraits.

**Lindsell-Stewart, Dorothy (Meum)** – (b. circa 1894 England, d. 1957). Dorothy Lindsell-Stewart was a young typist working as an artists' model when she succeeded in crossing over to a career in theatre and cabaret as Miss Meum Stewart. She met Jacob Epstein circa 1916 when she was estranged from her husband, and bore the sculptor a child in 1918. Epstein used both Lindsell-Stewart and the child, Peggy Jean, as models.

**Londonderry, Marchioness of** – See Chaplin, Edith Helen.

**Lopokova, Lydia** – (b. 1892 Russia, d. 1981). Lopokova was a Russian ballerina of considerable talent and fame who made her first London appearance in 1918 with the Ballets Russes. She returned to London in 1921 in *The Sleeping Princess*, where she met the British economist John Maynard Keynes and married him in 1925. The oft-painted Lopokova's relationship with Keynes's Bloomsbury Group friends was rocky at first but warmed over time.

**Mackaill, Dorothy** – (b. 1903 England, d. 1990). Obsessed with the theatre from a young age, Mackaill ran away to London as a teenager to pursue her dream of becoming an actress. There she found work as a chorus girl, eventually moving to Paris and then to New York to perform in the Ziegfeld Follies. Mackaill used her comedic and dramatic talents to become a stage and cinematic success in America in the 1920s and 1930s and lived there the rest of her life.

**Mannequins (Lay Figures)** – (Great Britain). By 1929, full-sized mannequins had been in use for centuries as a tool by artists – then the British painters Walter Richard Sickert and Alan Beeton made an unusual choice. They took mannequins from the realm of props or tools and brought them into use as models. Beeton famously posed his mannequin for *Decomposing* and three companion pictures; Sickert was inspired to use his eighteenth-century mannequin for the central figure in *The Raising of Lazarus*.

**Manners, Lady Diana** – See Cooper, Lady Diana.

**May (Golding), Betty** – (b. circa 1895 England, d. unknown). May was an outrageous flapper-era singer, dancer and artists' model who tried to elevate herself above a destitute London childhood. Described by a family member as a savage child, she was sexually precocious and jumped headfirst into the 1920s nightlife of the Café Royal and other venues frequented by artists. There she met and posed for Jacob Epstein, Augustus John, Jacob Kramer and others, and later wrote a torrid autobiography, *Tiger Woman*.

**Mayo, Eileen** – (b. 1906 England, d. 1994). Mayo was an enormously versatile artist who produced works of fine art, commercial art, illustration, and coin and stamp design in three countries. She studied at the Slade School and several other institutions, and taught at Saint Martin's School of Art and Sir John Cass College. For a time Mayo worked as an artists' model for Duncan Grant, Dod and Ernest Procter and Laura and Harold Knight.

**McNeill, Dorothy (Dorelia)** – (b. 1881 England, d. 1969). The muse and soul mate of Augustus John, McNeill became his mistress within three years of his marrying Ida Nettleship. John became fascinated with McNeill, and for a while she moved into the artist's household. McNeill had four children with Augustus and raised Ida's sons after her death. Augustus John's many paintings and drawings of McNeill comprise some of his most intimate work.

**Miller, Lee (Elizabeth)** – (b. 1907 United States, d. 1977). Miller was an American photographer and high fashion model in New York City in the 1920s before going to Paris in search of adventure. There she became Picasso's lover and Man Ray's muse. While Miller is best known as a portraitist, photographer and war correspondent, Surrealism informed her most significant work. Relatively few paintings of Miller exist apart from Picasso's portraits of her, but countless photographs document her rare beauty.

**Morrell, Lady Ottoline** – (b. 1873 England, d. 1938). Morrell (née Cavendish-Bentinck) was the era's most intriguing patron of the arts, holding court at her home in London and at Garsington Manor near Oxford. Bisexual and flamboyant, Morrell was also extremely well connected – which resulted in many of the greatest artistic and literary talents of the day accepting her hospitality. Six feet tall with a piercing gaze, Morrell was one of the most prolific sitters of early twentieth-century London.

**Mountbatten, Lady Louise** – (b. 1889 Germany, d. 1965). Mountbatten was born a princess of the German Battenbergs – a surname that was changed to Mountbatten by her father in 1917 to reflect his allegiance to England. After declaring that she would marry for love, Mountbatten was thrice unlucky in love before marrying Crown Prince Gustaf Adolf of Sweden. She became Queen of Sweden in 1950. As expected of the aristocracy, she sat for eminent portraitists such as Philip de Laszlo and Salvador Dali.

**Munday, Elsie** – (b. circa 1905 England, d. 1994). Munday (m. Beckford) was the maid employed by artists Hilda (Carline) and Stanley Spencer from 1929, when they were living in Burghclere, until their divorce proceedings in 1937. She was integral to the family's life and sat for both artists numerous times. As a measure of respect, Spencer planned to provide her with her own small chapel when he built what he termed a Church-House (Chapel of Me), although the project never came to fruition.

**Naper, Ella Louise** – (b. 1886 England, d. 1972). London-born Naper (née Champion) catapulted into public controversy as the sitter for painter Laura Knight's seminal *Self Portrait* (1913). Knight's picture was called everything from vulgar to bravura to a taboo-smashing leap forward for modern women. Naper, who trained as an artist and jewellery designer, was a friend of both Laura and Harold Knight. She sat for them at their studios in Cornwall, and for her husband Charles William Skipwith Naper.

**Nesbit, Evelyn** – (b. 1884 United States, d. 1967). Nesbit was a high-profile artists' model, chorus girl and singer, and the central figure in the New York murder trial of her husband Harry Thaw. Thaw shot and killed the architect Stanford White in a jealous rage for 'devirgining' Nesbit, as she put it. Nesbit's transition from model to transcontinental superstar inspired countless young women on both sides of the Atlantic to pursue fame. Her later life was much less glamorous and she twice attempted suicide.

**Nettleship, Ida** – (b. 1877 England, d. 1907). Nettleship (m. John) was a Slade-trained artist and close friend of Gwen John, best known as the first wife of the artist Augustus John, his model and mother of five of his sons. She died aged 29 of puerperal fever, having weathered her husband's infidelities and erratic lifestyle. She was a devoted caretaker of his talent, with the result that her own talent was never fully realised.

**Orpen, Grace** – (b. 1878 England, d. 1948). Orpen (née Knewstub) was the wife of William Orpen, who painted several notable portraits of her. They were not a happy couple despite having three daughters together, and the marriage became one of convenience. The artist's 1901 oil, *The Window Seat*, although painted on their honeymoon, conveys a sense of detachment. Grace's sister Alice was more accommodating as a sitter for her husband, the painter William Rothenstein.

**Patel, Anita (Miriam)** – See Peerbhoy, Sunita.

**Peerbhoy, Sunita (Amina, Armina)** – (b. circa 1897 India, d. 1932). Peerbhoy (née Devi) was a dark-skinned Indian immigrant who met Jacob Epstein in 1924 and began modelling for him, as did her sister Miriam Patel and son Enver. Epstein chose to call the women Sunita and Anita. Sunita became a celebrated model in Britain in the 1920s and early 1930s, transcending the prejudices of the day. Her death in India was rumoured to be an assassination for spying.

**Pesce, Rosalina (Rosalinda)** – (b. circa 1881 France or Italy, d. possibly 1929). Very little is known about Pesce, apart from the fact that she was a teenage Italian immigrant girl living in the Montparnasse area of Paris in 1896, not a professional model. She was involved in posing for the figure of Marianne (*La Semeuse*, The Sower) designed by the sculptor Oscar Roty as part of the French government's commission for a new coin design. The figure, a symbol of the French Republic, became one of the most recognisable pieces of art in Europe.

**Peters, Betty** – (b. circa 1919 England, d. unknown). Peters was a strong-featured, black-skinned model who sat for Jacob Epstein and inspired a number of memorable nude studies in the 1940s. In a 1947 exhibition review she was described as living in the East End of London, 5ft 9in tall, with 'a mass of jet-black, curly hair betokening her African descent'. Peters would later say that she became close to Epstein's family and knew his children and grandchildren.

**Pierres, Stella** – (b. circa 1904 England, d. unknown). Pierres was a fledgling model and the winner of a 'Modern Venus' contest in 1924 to promote the London launch of *The Temple of Venus*, an American silent film. Pierres's measurements most closely matched those of the Venus de Milo at the Louvre Museum, as determined by a panel of female judges under the watchful eye of Jacob Epstein. Pierres never achieved top status as a model, but the competition did raise her profile and bring her at least a decade of public appearances.

**Powell, Emily** – (b. circa 1897 England, d. unknown). Powell was one of the most memorable models used by the painter Walter Sickert. She was a London teenager and sometime chorus girl, the daughter of Sickert's landlady at no. 26 Red Lion Square where he had a studio. Sickert nicknamed Powell 'Chicken' and identified her by name in the titles of some of his works. Chicken embodied what Sickert thought of as a type – the lower-middle-class Camden Town woman – that he found appealing as subject matter.

**Preece, Patricia** – (b. 1894 England, d. 1966). Preece, a painter, is something of a notorious figure in British art. A lesbian who married the artist Stanley Spencer for his money, she ruined his marriage to Hilda Carline and caused distress to his children. There has been speculation, and some substantiation, that most of Preece's signed artworks were actually painted by Dorothy Hepworth, her closeted lover. Preece's greatest impact may be as a model for Spencer, whose canvases capture the cracks in her façade before, during and after their relationship.

**Preston, Marie** – (b. circa 1885 England, d. 1962). The wife of sculptor and medallist Edward Carter Preston was a talented painter, dressmaker and costumier, and the sister of Liverpool sculptor Herbert Tyson Smith. She frequently served as a model for her husband, who posed her as the Good Housewife figure for the Anglican Cathedral in Liverpool. She may also have been the model for Britain's next-of-kin memorial plaque sent to the families of those killed in action in the First World War.

**Rebecca** – See Esther.

**Redway, Sonia** – (England, dates unknown). The odd triangle of painters that was Barbara Hepworth, Patricia Preece and Stanley Spencer all used Redway as a model. She was a native of Cookham, where the three lived, and resided there for most of her life. Redway began posing for Spencer as a girl and continued as a young woman. Little else is known about her apart from her participation in the local Maidenhead Operatic Society as late as 1970.

**Rothenstein, Alice** – (b. 1867 England, d. 1957). Rothenstein (née Knewstub) was the wife of English artist and writer William Rothenstein and often served as his model. She acted on the stage under the name Alice Kingsley. The couple became friends of Augustus John at the turn of the century, and one of Rothenstein's most famous paintings, *The Doll's House*, depicts a scene from the play of the same name. The artist posed his wife and John as Ibsen's characters at Vattetot in Normandy, where they were staying at the time.

**St George, Evelyn (and Gardenia)** – (b. 1870 United States, d. 1936). The married Evelyn St George, an American, was an inspiration to the equally married William Orpen. They embarked on a serious love affair in 1908, which led to the birth of a daughter, Vivien, in 1912. Orpen and his mistress spent time together each year on the pretext of Orpen painting an annual portrait of another of St George's daughters, Gardenia – a series of paintings that ranks among the artist's most nuanced work. Orpen's portrait of *Mrs Evelyn St George*, displays a similar depth of emotion.

**Salaman, Chattie** – (b. 1919 England, d. 2000). Salaman (née Wake) was descended from a centuries-old Anglo-Saxon family. She became a stage actress and sometime artists' model affiliated with the Bloomsbury Group through her friendship with Angelica Bell, Vanessa Bell's daughter.

Salaman posed for the Berwick Church murals painted by Duncan Grant in 1940. Her stage performances were varied and well-received, earning critical reviews for the charm, sincerity and 'unsophisticated impudence' of her performances.

**Schepeler, Alick (Alexandra)** – (b. unknown Russia, d. circa 1950s). Schepeler was one of Augustus John's primary models from 1906 to 1908. She was working as a newspaper typist when she became his mistress and muse, posing for works that are considered to be some of John's finest creations. The affair ended after the death of John's wife Ida in 1907 and the intervention of Dorelia McNeill. Schepeler may have relocated to Dublin, as there are anecdotal accounts of her in a relationship there with W.B. Yeats in 1912.

**Schiff, Violet** – (b. 1874 England, d. 1962). Violet Schiff, a musician, and her husband Sydney, a writer, had a decidedly modernist bent. They befriended Marcel Proust, Katharine Mansfield, T.S. Eliot and Wyndham Lewis, among others. The Schiffs collected illustrious acquaintances, and their house became a magnet for artists, musicians and writers. Lewis's portrait of *Mrs Schiff* (circa 1923) is an unusually respectful treatment by the often-virulent painter.

**Schmidt, Carola** – (Germany, dates unknown). Schmidt was a governess and tutor employed by the artist Edna Clarke Hall and her husband to care for their two small sons. She sometimes served as a model for her employer, primarily in domestic scenes. Clarke Hall's pencil and watercolour sketch entitled *Carola playing her violin to Justin and Denis in the barn* depicts Schmidt and her charges at Great Tomkins, Upminster Common, in 1914. *Carola by the thatched barn* (1910) shows the governess in contemplative isolation.

**Schofield, Norine** – See Dolores.

**Shelley, Lilian** – (b. 1892 England, d. 1933). Shelley's name has become synonymous with the hybrid studio-nightclub-music hall artists' model that was prominent in London from 1910 through the 1920s. She had a knack for frequenting the best places to see and be seen, singing her trademark songs at late-night clubs such as the Cave of the Golden Calf. The most famous sculpture of Shelley is by Jacob Epstein, who appreciated the vulnerable young woman beneath the high-spirited façade.

**Siddal, Lizzie (Elizabeth)** – (b. 1829 England, d. 1862). Siddal (née Siddall) was a Victorian with a medieval face that saved her from a nondescript existence. Siddal was working at a London hat shop when Walter Deverell discovered her and posed her as Viola for his painting *Twelfth Night*. She went on to model extensively for the Pre-Raphaelite Brotherhood, including John Everett Millais and William Holman Hunt, and married Dante Gabriel Rossetti. An artist and poet, Siddal continued to inspire Rossetti after her death from an overdose of laudanum.

**Sitwell, Edith** – (b. 1887 England, d. 1964). Sitwell was a critic and avant-garde poet born into one of Britain's most illustrious literary families. She became known for espousing eccentric opinions and for affecting Elizabethan dress, but she was far more than a novelty. The profound emotional depth of her poetry is a testament to her talent. Painters and photographers pursued Sitwell as a model – she memorably sat for portraits by Roger Fry, Alvaro Guevara, Wyndham Lewis, Rex Whistler and others.

**Stafford, Lottie** – (England, dates unknown). Stafford was a Cockney washerwoman and a respected model who lived in a rundown cottage in Paradise Walk in Chelsea. William Orpen's painting *Resting* (1905) conveys all the essentials about her: naturally self-assured and quietly sensual, with a graceful neck and considerable physical presence. She modelled for Orpen, William Nicholson, Walter Sickert, Augustus John and others. Little is known about her personal life.

**Stanley Smith, Ellen** – (b. circa 1884 England, d. unknown). Stanley Smith, an otherwise anonymous artists' model, was a 21-year-old woman brought to court in May 1905 on the charge of having stolen ten shillings. She was released upon proving that she was employed at the Royal Academy as an artists' model. The painter Edmund Blair Leighton appeared as a character witness for her.

**Stewart-Richardson, Lady Constance** – (b. 1883 England, d. 1932). Stewart-Richardson was the daughter of the 2nd Earl of Cromartie and more of a renegade than a noblewoman – she was a champion swimmer, a big game hunter and an avid performer of classical dance. When she began dancing barefoot and scantily clad in London theatres, the Court of Edward VII was aghast and the king personally banned her. A free spirit, she posed for some of the most admired works of the Russian sculptor Prince Paolo Troubetzkoy.

**Susie** – (England, dates unknown). Susie was a Cornish fisherman's daughter who lived in Mousehole and appeared in several paintings and a series of drypoint etchings by Laura Knight. One of the most famous portraits of her is *Susie and the Wash Basin*, which Knight completed in 1929 – earning Knight the accolade of 'most astounding' artist of the 1929 Royal Academy exhibition.

**Tree, Iris** – (b. 1897 England, d. 1968). Iris Tree was the youngest and most uninhibited of the three legitimate daughters of the thespian Herbert Beerbohm Tree. Her accomplice in her escapades was her girlhood friend, the heiress and artists' model Nancy Cunard. An unapologetic bohemian eccentric and a talented poet, Tree wore her heart on her sleeve. Her complex personality made her an intriguing model for Augustus John, Roger Fry and many others.

**Tree, Viola** – (b. 1884 England, d. 1938). Viola Tree was the multi-talented, eldest daughter of the thespians Herbert Beerbohm Tree and Helen Maud Tree. She is best known as an author and actress who had a successful stage career. Tree also sang opera, managed a theatre, appeared in films and wrote two plays, as well as an etiquette book and a biography. While her sister Iris was a much more prolific artists' model, Viola did pose from time to time, and was the subject of a portrait by John Singer Sargent.

**Villain, Augustine** – (France, dates unknown). When the artist Walter Richard Sickert relocated to Dieppe, France, at the end of the nineteenth century, it wasn't long before he moved in with Villain and her children. Villain was a native of the Dieppe fishing community and ran a fish stall. Sickert carried on a dual social life in Dieppe, living with Villain on the working side of the harbour but spending many evenings as a gentleman in the glittery casinos. The fiery, red-haired Villain, known locally as *La Belle Rousse* for her dramatic beauty, often sat for Sickert in her triple role of landlady, muse and mistress.

**Watson, Carmen** – (b. circa 1913 France, d. 2003). The ethereal, blonde cousin of the Avico family of models, Watson had success as an artists' model and continued to pose well into her later years. She became a fixture at the Chelsea Arts Balls and was the favourite model of the artist Ethel Gabain, for whom she sat many times in the guise of a young bride. By the time Watson became a real-life bride in 1940, she had posed over sixty times for Gabain.

**Woman** – (England). The term used by most London art schools on model pay receipts and related records until the twentieth century, in part to shield female life class models from insinuation by keeping them anonymous.

**Woolf, Virginia** – (b. 1882 England, d. 1941). Woolf (née Stephen) stands as a towering influence on modernist twentieth century culture despite a lifelong battle with depression that affected her ability to write. She was the first to craft narration in the form of stream of consciousness in landmark works such as *To The Lighthouse*. With her sister Vanessa Bell, she was instrumental in coalescing the Bloomsbury Group, first in London and later in Sussex. Woolf was painted many times by the artists in her sphere.

**Zinkeisen, Doris** – (b. 1898 Scotland, d. 1991). Zinkeisen is best known as a theatrical designer (both stage and costume), a commercial artist and a writer. She also cultivated a successful career as a society portraitist and as a painter of genteel pursuits. Her legacy of work includes a number of highly stylised self-portraits.

# Attributions for Headings and Images

**Cover**

Front cover images, clockwise from upper left:

*Contemplation*, 1922 (oil on canvas), John William Godward, image courtesy of Sotheby's London.

*Tony Basil sculpting Leopoldine*, private collection of the family, image courtesy of Christine Bassett.

*The Queen of Time*, photographer: Andrew Meredith, image courtesy of Selfridges & Co., London.

*King William Street, London*, photographer: Lucy Peterson, image courtesy of Lucy Peterson.

*Leopoldine, Carmen and Gilda*, private collection of the family, image courtesy of Christine Bassett.

*My Fair Lady*, 1914 (oil on canvas), Edmund Blair Leighton (1853–1922), private collection, photo © Christie's Images, Bridgeman Images.

**Chapter 1**

| | |
|---|---|
| *Heading:* | Iris Tree, letter to Clive Bell, 1915, 8.III.5, private collection of Lucy Peterson. |
| *Image p. 3:* | The Female School of Art, Queen Square: The Life Class 1868, private collection, photo © Liszt Collection, Bridgeman Images. |

**Chapter 2**

| | |
|---|---|
| *Heading:* | Anonymous, verse from 'The Goose and the Common', circa 1600s, as reprinted in *Celebrating the Commons* (Minneapolis, USA: On the Commons, 2012). |
| *Image p. 7:* | Children in a London street circa 1900, *Chronicle*, Alamy Stock Photo. |

## Chapter 3

*Heading:*    'Which Nation Has the Best Sitters', *The Bystander* (Illustrated London News Group), 12 Feb 1913.

*Image p. 11:*    Advertisement in *The Tatler*, 8 January 1913, No. 602.

*Image p. 13:*    *Three studies of a seated nude*, 1934 (crayon on paper), Mark Gertler (1891-1939), University of East Anglia, Norfolk, UK, Robert and Lisa Sainsbury Collection, Bridgeman Images.

## Chapter 4

*Heading:*    Royal Academy Archives, RAA/SEC/4/99/5, William Orpen, visitor's report on the painting school, 6 Nov 1920.

*Image p. 16:*    Harry Furniss, *Royal Academy Antics* (London: Cassell & Company Limited, 1890), 56.

*Image p. 19:*    Models at Boulevard Montparnasse, Paris, 1914 (b/w photo), © SZ Photo, Scherl, Bridgeman Images.

## Chapter 5

*Heading:*    J. Middleton Murry, ed., *The Scrapbook of Katherine Mansfield* (New York: Alfred A. Knopf, 1940), 47.

*Image p. 23:*    *Lady Ottoline Morrell*, 1919 (oil on canvas), Augustus Edwin John (1878-1961), private collection, Bridgeman Images.

*Image p. 25:*    *Les Demoiselles d'Avignon*, 1907 (oil on canvas), Pablo Picasso (1881-1973), Museum of Modern Art, New York, USA, Bridgeman Images.

## Chapter 6

*Heading:*    Smith College Library Special Collections, MS1, *Virginia Woolf Papers Series 1 (1906–1956)*, letter from Lytton Strachey to Virginia Woolf, 9 Oct 1922.

*Image p. 32:*    Slade School of Art picnic circa 1912, photo © Tate, London 2017.

*Image p. 36:*    Vanessa Bell, Quentin Bell and Julian Bell (b/w photo), Bridgeman Images.

*Image p. 38:*    *Annie Stiles*, 1921 (oil on canvas), Dora Carrington (1893-1932), private collection, Photo © Christie's Images, Bridgeman Images.

*Image p. 41:*    Angelica Garnett (sepia photo), Bridgeman Images.

## Chapter 7
*Heading:*    Oscar Wilde, *The Picture of Dorian Gray* (London: Ward, Lock & Co. Ltd., 1891), 60.

*Image p. 46:*    *Family Group: Hilda, Unity and Dolls*, 1937 (oil on canvas), Stanley Spencer (1891-1959), Leeds Museums and Galleries (Leeds Art Gallery) UK, Bridgeman Images.

*Image p. 49:*    *Portrait of Daphne Charlton,* circa 1935 (oil on canvas), Mary Adshead (1904-1995), private collection, © Liss Fine Art, Bridgeman Images.

*Image p. 52:*    *The Convalescent*, circa 1923-24 (oil on canvas), Gwen John (1876-1939), Fitzwilliam Museum, University of Cambridge, UK, Bridgeman Images.

## Chapter 8
*Heading:*    'Fine Chemicals. Government and the Duty on Alcohol', *The Globe* (Illustrated London News Group), 13 Oct 1914.

*Image p. 57:*    Suffragettes raid Buckingham Palace, May 1914 (b/w photo), London, UK, © Mirrorpix, Bridgeman Images.

*Image p. 60:*    Augustus John, c. 1907 (sepia print), Jacob Hilsdorf (1872–1916), private collection, Bridgeman Images.

*Image p. 62:*    *Portrait of Nina Hamnett*, 1917 (oil on canvas), Roger Eliot Fry (1866–1934), Samuel Courtauld Trust, The Courtauld Gallery, London, UK, Bridgeman Images.

## Chapter 9
*Heading:*    National Library of Wales Archives, NLW MS 23549C.ff58, letter from Ida John to Margaret Sampson, 1904, © Rebecca John; see Michael Holroyd and Rebecca John, eds., *The Good Bohemian, The Letters of Ida John* (New York: Bloomsbury Publishing USA, 2017), 186.

*Image p. 66:*    *The Camden Town Murder, or What Shall We Do For the Rent?,* c.1908-9 (oil on canvas), Walter Richard Sickert (1860–1942), Yale Center for British Art, Paul Mellon Fund, USA, Bridgeman Images.

*Image p. 69:*    *Ida Nettleship and Dorelia McNeill* (red chalk on paper), Augustus Edwin John (1878-1961), private collection, Bridgeman Images.

## Chapter 10

*Heading:*  'Worldly Wisdom While You Wait,' *The Graphic* (Illustrated London News Group), 19 Jan 1918.

*Image p. 76:*  *Acetylene Welders*, 1917 (etching and drypoint), Christopher Richard Wynne Nevinson (1889–1946), private collection, Photo © The Fine Art Society, London, UK, Bridgeman Images.

*Image p. 79:*  'Serve your country or wear this!' (sepia photo), English photographer (twentieth century), private collection, The Stapleton Collection, Bridgeman Images.

## Chapter 11

*Heading:*  The National Archives, KV-2-822 Cavell, Letter from Le Capitaine Beliard of the Allied Bureau to Colonel V.G.W. Kell of M.I.5., 24 Nov 1917.

*Image p. 85:*  Millicent, Duchess of Sutherland and her daughter at the first meeting of the Ladies Automobile Club, 1903 (b/w photo), English photographer (twentieth century), private collection, Bridgeman Images.

*Image p. 86:*  Recently decorated with the Order of Leopold: Lady Dorothie Feilding, from *The Illustrated War News*, 1915 (b/w photo), Belgian photographer (twentieth century), private collection, The Stapleton Collection, Bridgeman Images.

## Chapter 12

*Heading:*  The British Library, Add MS 83202 1921–1922, *Higgens Papers. Vol. v. Grace Germany's diary in Saint Tropez*, 1921. © Estate of Grace Higgens, all rights reserved.

*Image p. 93:*  *Marguerite Kelsey*, 1928, Meredith Frampton (1894–1984). Presented by the Friends of the Tate Gallery 1982. © Tate, London.

*Image p. 98:*  *Posing*, circa 1929 (oil on canvas), Alan Beeton (1880–1942), Fitzwilliam Museum, University of Cambridge, UK, Bridgeman Images.

## Chapter 13

*Heading:*  Helen Bullitt Lowry, 'The Uninhibited Flapper', *Nonsenseorship*, G.P.P. ed. (New York and London: G.P. Putnam's Sons, 1922), 69.

*Image p. 102:* Nancy Cunard (1896-1965), Everett Collection Inc., Alamy Stock Photo.

*Image p. 104:* Mrs. Fanny Eaton (coloured chalks on paper), Walter Fryer Stocks (circa 1842-fl.1903), private collection, Photo © The Maas Gallery, London, Bridgeman Images.

## Chapter 14

*Heading:*    Aner Preminger, 'François Truffaut Rewrites Alfred Hitchcock: A Pygmalion Trilogy', *Literature Film Quarterly* (ISSN: 0090-4260, Volume 35, Number 3), 170.

*Image p. 109:* *The Chelsea Arts Club Costume Ball at the Albert Hall, London, Resting between Dances* (litho), Fortunino Matania (1881–1963), private collection, © Look and Learn / Peter Jackson Collection, Bridgeman Images.

*Image p. 113:* Portrait of Iris Tree (pencil on paper), Augustus Edwin John (1878–1961), private collection, Photo © Peter Nahum at The Leicester Galleries, London, Bridgeman Images.

*Image p. 115:* George Grantham Bain Collection (Washington, D.C.: Library of Congress Prints and Photographs Division).

## Chapter 15

*Heading:*    Cecil Headlam, 'The Beautiful Women of Britain,' *The Sphere* (Illustrated London News Group), 26 Nov 1917.

## The Avico Sisters: A Revelation

*Image p. 123:* Private collection of the family, image courtesy of Christine Bassett.

*Image p. 124:* Private collection of the family, image courtesy of Christine Bassett.

*Image p. 125:* Private collection of the family, image courtesy of Christine Bassett.

*Image p. 126:* Private collection of the family, image courtesy of Christine Bassett.

*Image p. 128:* Private collection of the family, image courtesy of Christine Bassett.

*Image p. 130:* Private collection of the family, image courtesy of Gilda Swiderski.

*Image p. 132:* *Contemplation*, 1922 (oil on canvas), John William Godward, image courtesy of Sotheby's London.

*Image p. 134:* Private collection of the family, image courtesy of Christine Bassett.

*Image p. 136:* Private collection of the family, image courtesy of Christine Bassett.

*Image p. 137:* Left: *Sotheby's Belgravia, Victorian Paintings* (London: 12 June 1973); right: private collection of the family, image courtesy of Christine Bassett.

*Image p. 139:* Titania's Palace interior, © Egeskov Castle, Denmark.

*Image p. 140:* Private collection of the family, image courtesy of Christine Bassett.

*Image p. 141: The Queen of Time,* Kevin Foy, Alamy Stock Photo.

*Image p. 142: Bacchante (Spirit of the Grape Harvest),* photographer: Stephen Freeth, company archivist, The Vintners' Company, Vintners' Hall, London.

*Image p. 144: Selfridge's Decorations for the Coronation* (May 1937), private collection, image courtesy of Lucy Peterson.

# Endnotes

1. Nina Hamnett, *Laughing Torso – Reminiscences of Nina Hamnett* (Read Books Ltd., Kindle Edition), Kindle location 942.
2. Charles Booth, *Inquiry into Life and Labour in London (1886–1903)*, London School of Economics and Political Science Library Archive, digital poverty maps, retrieved 4 Aug 2017.
3. 'How a Noted Artist's Model Reduced Her Weight 36 Pounds in Five Weeks', *The Tatler* (Illustrated London News Group), 7 Mar 1917.
4. Francisque Sarcey, 'Le Syndicat Olympe', *Le XIXe Siècle*, 8 Sep 1891.
5. Harry Furniss, *Harry Furniss at Home* (London: T. Fisher Unwin, 1904), 50.
6. Mrs Frank Elliot, 'Some Types of Artists' Models', *St. James's Gazette* (The British Library Board), 21 Oct 1904.
7. John Thomas Smith, *Nollekens and His Times* (London: Richard Bentley And Son, 1895), 321.
8. University College, London Special Collections, MS ADD 250. Michael Reynolds, *The Slade: Story of an Art School 1871–1971*, 7:5.F. Models, 177.
9. George Moore, *Conversations In Ebury Street* (New York: Boni and Liveright, 1924), 151, 152.
10. Harry Furniss, *Royal Academy Antics* (London: Cassell & Company Limited, 1890), 29.
11. 'In Town and Out', *The Tatler* (Illustrated London News Group), 24 Jun 1914.
12. The Hon. Evan Charteris, K.C., *John Sargent*, (New York: Charles Scribner's Sons, 1927), 53.
13. Madame X, 'A Woman's Letter', *The Graphic* (Illustrated London News Group), 19 Jan 1929.
14. Naomi Rosenblum, *A World History of Photography*, quote ascribed to Ernest Lacan in 1852 (New York City: Abbeville Press, 2008), 209.
15. Rumer Godden, *Gone: A Thread of Stories,* (New York: The Viking Press, 1968), vii.
16. Letter from Vanessa Stephen [Bell] to Clive Bell, n.d. [1905], executor of the estates of Vanessa Bell and Duncan Grant © Henrietta Garnett, all rights reserved. Retrieved from www.tate.org 10 Oct 2017.

17. 'Art Notes', *Illustrated London News* (Illustrated London News Group), 13 Sep 1913.

18. Nina Hamnett, *Laughing Torso – Reminiscences of Nina Hamnett* (Read Books Ltd., Kindle edition), Kindle location 256.

19. Nigel Nicolson and Joanne Trautmann, ed., *The Letters of Virginia Woolf, Volume Five 1932–1935* (New York: Harcourt Brace & Company, 1982), 55, quoting a letter from Virginia Woolf to Vanessa Bell, May 1932, letters © Quentin Bell and Angelica Garnett, all rights reserved.

20. The British Library, Add MS 83219, *Higgens Papers. Vol. xxii. Diary of Grace Higgens*, 1958–1967 © Estate of Grace Higgens, all rights reserved.

21. The British Library, Add MS 83204, *Higgens Papers. Vol. vii. Diary of Grace Higgens*, Aug–Oct 1924 © Estate of Grace Higgens, all rights reserved.

22. Quentin Bell, *Bloomsbury Recalled* (New York: Columbia University Press, 1995), 178.

23. Walter Sickert, 1907 letter to Nan Hudson and Ethel Sands, quoted by Robert Upstone, ed., in 'Painters of Modern Life: the Camden Town Group', *Modern Painters: The Camden Town Group* (London: Tate Britain exhibition catalogue, 2008), 21.

24. 'What Every Woman Wants To Know', *The Sketch* (Illustrated London News Group), 1 Dec 1937.

25. Nicolette Devas, *Two Flamboyant Fathers* (London: Readers Union – Collins, 1968), 108.

26. Augustus John, 'Gwendolen John (1943)', *The Burlington Magazine: A Centenary Anthology*, Michael Levey, ed. (New Haven: Yale University Press, 2003), 75.

27. Mordaunt Savage, 'Written in Malice', *The Sphere* (Illustrated London News Group), 7 Dec 1929.

28. 'Aims and Programme of the Cabaret Theatre Club', *Cabaret Theatre Club* (Cave of the Golden Calf, 9 Heddon Street, London W.1), May 1912.

29. Lady Diana Cooper, *The Rainbow Comes and Goes* (Boston: Houghton Mifflin Company, 1958), 77.

30. Nina Hamnett, *Laughing Torso – Reminiscences of Nina Hamnett* (Read Books Ltd., Kindle edition), Kindle location 1225.

31. Elsa Lanchester, *A Gamut of Girls: Memoir* (Santa Barbara: Capra Press, 1988), 14, referenced by Dr Jaap Harskamp in 'Underground London: From Cave Culture Follies to the Avant-Garde', *Electronic British Library Journal*, 2009.

32. 'Fair Lady Duellists in Paris', *Illustrated Police News* (The British Library Board), 7 May 1904.

33. University of Victoria Special Collections and Archives, British Columbia, Canada, Or-12, letter from William Orpen to Beatrice Elvery [Bridgit], n.d.

34. National Library of Wales Archives, NLW MS 22782D.folio 81v, letter from Ida John to Augustus John, 1906, © Rebecca John; see Michael Holroyd and Rebecca John, eds., *The Good Bohemian, The Letters of Ida John* (New York: Bloomsbury Publishing USA, 2017), 273.

35. National Library of Wales Archives, NLW MSS 22789D.folio 69v, letter from Ida John to Dorelia McNeill, 1905, © Rebecca John; see Michael Holroyd and Rebecca John, eds., *The Good Bohemian, The Letters of Ida John* (New York: Bloomsbury Publishing USA, 2017), 208.

36. Nicolette Devas, *Two Flamboyant Fathers* (London: Readers Union–Collins, 1968), 85.

37. Lady Cynthia Asquith, *Diaries 1915–1918* (New York: Alfred A. Knopf, 1969), 399, 417, 475.

38. Ezra Pound, *The Selected Letters of Ezra Pound 1907–1941*, D. D. Paige, ed. (New York: New Directions Publishing, 1971), 57, 61.

39. Millicent Duchess of Sutherland, *Six Weeks at the War* (London: The Times, 1914), 21, 22.

40. 'The Woman About Town', *The Sketch* (Illustrated London News Group), 23 Dec 1914.

41. Brown University Library Archive 116015166093419, *The Tyro* Number 1, Wyndham Lewis, ed. (The Egoist Press, 1921), 2.

42. Simon Martin, *The Mythic Method: Classicism in British Art 1920–1950* (Chichester: Pallant House Gallery, 2016), 18, 19.

43. 'Artistes Wanted', *The Era* (Illustrated London News Group), 15 Feb 1913.

44. Jacob Epstein, *Let There Be Sculpture* (London: Readers Union Limited, 1942), 116.

45. Ibid., 117.

46. Iris Tree, letters to Clive Bell, 1915, 29.III.15 and 8.III.5, private collection of Lucy Peterson.

47. Iris Tree, *Poems* (London and New York: John Lane, The Bodley Head, 1920), 11, retrieved from Project Gutenberg 7 Nov 2017, #45643.

48. Library of Congress Archive, Image 47 of Chronicling America: Historic American Newspapers, 'Surprising Lady 'Connie' Richardson Startles Nobility Once More', *The Washington [D.C.] Times*, 4 Sep 1921.

49. 'To-day in the Courts: Russian Artist's Work. £6 Damages in Amusing Theatrical Claim', *Pall Mall Gazette*, 22 Oct 1914.
50. 'Topics of the Hour', *Islington Gazette* (British Library Board), 21 Apr 1910.
51. 'The Letters of Eve – continued.', *The Tatler* (Illustrated London News Group), 17 Apr 1918.
52. 'Feminine Fancies and Fashions', *The Graphic* (Illustrated London News Group), 1 Jun 1918.
53. 'Child Faces Without a Flaw', *The Daily News*, 29 Apr 1923.
54. Nicolette Devas, *Two Flamboyant Fathers* (London: Readers Union – Collins, 1968), 154.
55. Nevile Wilkinson, *Yvette in Italy and Titania's Palace* (London: Humphrey Milford, Oxford University Press, 1922), 115.

In addition to the sources cited above, I would like to acknowledge the following works that contributed to my understanding of the economic, social and cultural landscape of early twentieth-century London:

*Art Beyond the Gallery in Early 20th Century England*, Richard Cork, author
*Duncan Grant: A Biography*, Frances Spalding, author
*John William Godward: The Eclipse of Classicism*, Vern G. Swanson, author
*Mark Gertler: Selected Letters*, Noel Carrington, editor
*Some Sort of Genius: A Life of Wyndham Lewis*, Paul O'Keeffe, author

# Index